The Virgin & the Dynamo

Published in association with the Center for American Places,
Santa Fe, New Mexico, and Harrisonburg, Virginia.

The Virgin & the Dynamo

PUBLIC MURALS IN

AMERICAN ARCHITECTURE

1893–1917

BAILEY VAN HOOK

Ohio University Press | ATHENS

Ohio University Press, Athens, Ohio 45701
© 2003 by Ohio University Press
Printed in the United States of America
All rights reserved

Ohio University Press books are printed on acid-free paper ⊗ ™

09 08 07 06 05 04 03 5 4 3 2 1

This book was brought to publication with the generous financial
assistance of Virginia Polytechnic Institute and State University,
for which the publisher is most grateful.

Library of Congress Cataloging-in-Publication Data
Van Hook, Bailey, 1953-
 The virgin and the dynamo : public murals in American architecture,
1893-1917 / Bailey Van Hook.
 p. cm.
 "Published in association with the Center for American Places, Santa Fe,
New Mexico, and Harrisonburg, Virginia"—P. 2.
 Includes bibliographical references and index.
 ISBN 0-8214-1501-8 (cloth : alk. paper)
 1. Mural painting and decoration, American—19th century—Themes,
motives. 2. Mural painting and decoration, American—20th century—
Themes, motives. 3. Symbolism in art—United States. I. Center for
American Places. II. Title.

ND2607.V36 2003
753'.6'097309034—dc21
 2003043305

TO MY FRIEND AND COLLEAGUE

JANE A. AIKEN

CONTENTS

ILLUSTRATIONS

ACKNOWLEDGMENTS

This book had a long germination. I encountered many of its sources when I began researching my dissertation almost twenty years ago. That dissertation was published by Pennsylvania State University Press as *Angels of Art: Women and Art in American Society* (1996) , but I revisited many of its themes when writing this book. So I remain indebted to my dissertation adviser, Barbara Weinberg, now Alice Pratt Brown Curator at the Metropolitan Museum of Art, who was a pioneer in the reevaluation of the artistic legacy of the American Renaissance and City Beautiful movements. Another faculty member at the City University of New York, William H. Gerdts, was ever supportive and enthusiastic over the scholarly activities of his students. I cannot hope to match his and Barbara's high standards and prodigious scholarly output, but I offer this study as evidence of their continued influence.

Janet Marstine and H. Wayne Morgan read the manuscript at an early stage, and I am particularly indebted to their close readings and numerous, excellent suggestions. The best parts are due to them. Barbara Wolanin, curator, Office of the Architect, United States Capitol, and an anonymous reader for Ohio University Press also made many constructive suggestions that have strengthened my arguments. Randy Jones and George Thompson at the Center for American Places were my earliest boosters and have stayed with the project over the years. Gillian Berchowitz, my editor, and the staff at Ohio University Press, especially Sharon Rose, have been ideal collaborators.

I have benefited intellectually and conceptually from the work on mural painting done by many colleagues in the field—notably, Barbara Weinberg, Cynthia Sanford, Janet Marstine, Richard Murray, Sarah Moore, Sally Webster, Ingrid Steffenson, and Sally Promey, as well as work on public art by Michelle Bogart and Melissa Dabiakis.

I visited all of the extant sites mentioned here, and I owe debts from coast to coast. I wish to thank the staffs at the Albany Institute of History and Art, the Nelson A. Rockefeller Institute of Government (formerly the Anthony N. Brady

House), the New York State Capitol, and the New York State Education Building in Albany; the United States Customhouse and the Baltimore Courthouse in Baltimore (the latter is now the Clarence M. Mitchell, Jr. Courthouse); the Boston Public Library, the Massachusetts State Capitol, the Massachusetts Art Commission, and Trinity Church in Boston; the Walker Art Building in Brunswick, Maine; the Federal Building, Customhouse, and Courthouse and the Cuyahoga County Courthouse in Cleveland; the Iowa State Capitol and the State Historical Society of Iowa in Des Moines; the Detroit Public Library; the Capitol Preservation Committee, Pennsylvania State Capitol, and Pennsylvania State Archives in Harrisburg; the Missouri State Capitol and Missouri State Archives in Jefferson City; the State Historical Society of Missouri in Columbia and the Missouri Historical Society in Saint Louis; the Hudson County Courthouse in Jersey City, New Jersey; the Wisconsin State Capitol and State Historical Society of Wisconsin in Madison; the Mercer County Courthouse in Mercer, Pennsylvania; the Essex County Courthouse in Newark, New Jersey; the Appellate and Criminal Courthouses, the Avery Library at Columbia University, the Church of the Ascension, the Frick Art Reference Library, Helmsley Palace (the former Whitelaw Reid mansion), the New York Public Library, the New York Historical Society, and the Pierpont Morgan Library and Spanierman Gallery in New York City; the South Dakota State Capitol and South Dakota State Historical Society in Pierre; the San Francisco Public Library; Flagler College (formerly the Hotel Ponce de Lion) in St. Augustine, Florida; the Minnesota State Capitol and Minnesota State Historical Society in Saint Paul; City Hall in Trenton, New Jersey; the Library of Congress and Office of the Architect of the Capitol, Washington, D.C.; the Lucerne County Courthouse in Wilkes-Barre, Pennsylvania; the Winoma Public Library in Winoma, Minnesota; and the Mahoning County Courthouse and Mahoning Valley Historical Society in Youngstown, Ohio.

I received several travel grants from the College of Arts and Sciences at Virginia Tech to make trips to murals sites. In addition, a book subvention grant from the college, with matching funds from the university provost, brought down the cost of the publication. I want to thank Adelene Kirby, George Crofts, Lay Nam Chang, Bob Bates, Peter Graham, and Pat Hyer for help in securing those funds. In addition, the staff at the university libraries, especially Wanda Lucas and Annette Burr, greatly facilitated my efforts.

The Interdisciplinary Research Group at Virginia Tech, including Jane Aiken, Brian Britt, David Burr, John Christman, Joseph Eska, Ann-Marie Knoblauch, and Darlene Pryds read several chapters and papers on various mural topics. Their

friendly advice and encouragement, and more importantly scholarly camaraderie was immensely valuable to me.

Margaret McMahon accompanied me to many of the mural sites, most notably on a memorable trip from Minneapolis to Pierre, with stops in Laura Ingalls Wilder country and the Badlands. Her companionship and humor made traveling with car and tent a delightful journey.

My father and mother always supported my work. My mother died while I was writing this book, but her love of history and art infuses its pages. My sisters Tina Swallow and Helen Sorenson and my brother Evans Van Hook have been as close and supportive as anyone could wish.

My friends and colleagues have also provided much needed support during the writing of this book—especially Bill Aiken, Tom Carpenter and Lynne Lancaster, David Crane and Janet Niewald, Penelope Gleeson, Ann-Marie Knoblauch, Sally Cornelison, and Kristel Fuhrman.

I owe a special debt to my friend and colleague Jane Aiken, who directed the art history program and took many responsibilities from my shoulders while I was busy writing. Jane's intellectual rigor and curiosity have been an inspiration to me in the years I have known her. She has also been a good friend through personal and professional crises. I especially treasure my memories of our traveling together—the end of the day, with feet up and drinks in hand, going over the day's events, alternately gossiping, kvetching, and laughing. I have dedicated this work to her with appreciation and great fondness.

When I began my research for this book, questions about what I was doing inevitably arose in my conversations with people. When I told them that my topic was "murals in public sites in the United States at the turn of the last century," it often resulted in a look of incomprehension; then, often as not, my questioner would become animated and say something like, "You know, there are some great paintings at —— on the walls of ——"—and the person would name a post office, courthouse, or some other public building. When I questioned further, the murals invariably turned out to have been created in a 1930s Works Progress Administration (WPA) or Section project, and I would explain that, no, the murals that I was interested in were done earlier. By whom? my interlocutor would ask. Of what? When I listed names and subjects—La Farge, Blashfield, Cox, Millet, Simmons; Justice, Law, the Muses—the person's eyes would glaze over and they might politely smile.

The fact is that although the murals studied in this book adorn some of the finest examples of beaux arts architecture in this country, and most of it in public architecture, they are largely invisible to most people today. Sure, if one goes on a tour of Cass Gilbert's magnificent state capitol in Saint Paul, Minnesota, guides will conscientiously point out every painting, giving assurances that, although the visitor may never have heard the names Edwin H. Blashfield and Edward Simmons, architect Gilbert chose among the best contemporary artists to decorate his building. Blashfield and Simmons were major artists, but today only scholars, architects, preservationists, and tour guides notice, much less take seriously, these murals. (I will add one other category to that list: these paintings attract the camp appreciation of the aficionados of kitsch. The descriptions and titles of many of them, it seems, beg derision: e.g., *Apotheosis of Pittsburgh, Minnesota: Granary of the World, Passing Commerce Pays Tribute to the Port of Cleveland*.)

Our present-day attitudes—apathy, specialists-only interest, the howls of the kitsch lovers—would have shocked the muralists. Working during a prolific

period in the history of American art, the beaux arts muralists considered themselves to be major players. The explosion of art in the United States after the Civil War—self-described as an American Renaissance in the arts—was channeled by the end of the century into the City Beautiful movement: art for the people, art to beautify public spaces, art that aimed to teach by its example of beauty. This art gave its creators a status in contemporary society that visual artists had rarely achieved. Part of the painters' confidence and pride came from their sense of history: their work was the first great mural movement in the United States, and the examples from the past that they admired—Michelangelo's Sistine Chapel, the Doge's Palace by the Venetian Veronese, the contemporary examples by Puvis de Chavannes and Paul Baudry—were, they knew, acknowledged by nineteenth-century Americans to be some of the greatest art Western civilization had ever produced. As muralist Will Low said, the American artist was "heir to the ages."[1]

But the ideals that powered their art—beauty, architectural integration, decorative harmony, classicism adapted to the demands of contemporary relevance—were going out of fashion even as the muralists were painting. A new generation of painters and architects would find those ideals tiresome or pedantic or old-fashioned. Furthermore, a reinvigorated cultural nationalism that emerged soon after 1900 demanded that art in the United States somehow reflect the energies of American society—as bold, modern, and progressive, not clothed in allegory and symbol. After the hiatus of the 1920s—a decade in which few mural projects were commissioned—the WPA projects, the nation's second mural movement—embodied that new sensibility. Equally figurative, but also encompassing many of the stylistic devices of European modernism—disjointed perspective, flat color, hard outlines—the murals of the 1930s depicted U.S. realities such as farmers, mechanics, and factory workers in recognizable spaces and contexts. The Mexican muralists Diego Rivera, José Clemente Orozco, and David Siqueiros heavily influenced the U.S. murals during the Great Depression. To most artists working in the beaux arts tradition, the modernist style, working-class subjects, and militant politics were antithetical. Even more foreign to them in style and inspiration were the abstract or nonobjective murals by Ilya Bolotowsky and others; these, few in number, were more directly influenced by the European modernists. The 1930s generation, too, would be eclipsed. Even though many of its members got their professional start on WPA projects, the abstract expressionists of the 1940s became critical of the style that those projects fostered. Arshile Gorky infamously called WPA murals "a poor art for poor people."[2]

Exiled European surrealists imported a fluid and biomorphic abstract orientation that abstract expressionists adopted, but it precluded the tight figurative style and narrative of the WPA murals. With one notable exception—Pollock's mural for Peggy Guggenheim—that generation produced few examples.

More than three decades later, a new mural movement arose, especially on the West Coast in San Francisco and Los Angeles, often with Chicano artists at its core.[3] But this art—largely populist, collaborative, and community-based—was very different in its basic sensibility. Largely loosened from the academic moorings that had anchored the first and even framed the second movement, it was raw, bold, untutored, expressing the energies of a community, not of a trained artistic sensibility. These murals were on the outside walls of buildings, not on interiors, so they were by nature temporary, speaking of up-to-date community concerns. More recently, Philadelphia has sponsored an "antigraffiti" movement that is rapidly transforming the downtown area with numerous large-scale murals on the sides of buildings.

Parallel to these recent efforts—and closer to the murals considered in this book—is another new mural movement. More akin, I believe, in technique to the beaux arts murals, an early example of this style, *Into the Light* (1996), can be seen in the Gay and Lesbian Reading Room at the new San Francisco Public Library. This mural has heralded the beginnings of a new figural and allegorical style.[4] Created by Charley Brown and Mark Evans, it takes the form of a trompe l'oeil dome that seems to open to the sky. On the walls of the perimeter, below the dome, men and women are shown building a wall, and on the wall are the names of figures, mostly literary, who figure in gay and lesbian history. The sepia-colored mural blends with the rich brown of the wood and furnishings of the room. It proves that there is a continuing love of allegory and, more importantly, a desire for significant subjects in our public spaces that express some human achievement and aspiration. Since that mural was installed, numerous other interior murals have been commissioned: they constitute, I believe, a by-product of architectural postmodernism.

THIS book is an outgrowth of my previous study *Angels of Art: Women and Art in American Society, 1876–1914* (Pennsylvania State University Press, 1996). In *The Virgin and the Dynamo* I have made no effort to repeat the arguments made in *Angels of Art*. This study is a further attempt to understand what went into the beaux arts murals, why muralists painted in that style, and why they chose their particular subjects. It is an attempt to understand the historical and economic

and social contexts that produced those murals—contexts that the murals reinforced—and the ideal society that they posited. It is the nature of that ideal that is the subject of much of this book.

Often sexist, racist, and class-biased, that ideal was held by a few men who represented the economic and political hegemony of society in the United States at the turn of the last century. Often its prejudices are blatantly wrong-minded to us today. For example, despite the fact that it came at the end of a period that witnessed a great flood of immigrants from Eastern Europe, all three hundred figures that made up the *March of Progress* in John White Alexander's decorations in the Carnegie Institute in Pittsburgh were northern European or Aryan. All thirty-five of the great citizens from the state's history who witnessed the *Apotheosis of Pennsylvania* (fig. 17) in the state capitol were male (even though the symbol of the state was, of course, female). And the pioneer and soldier who were guided westward by the Spirit of Hope in Blashfield's *Dakotah* (fig. 63) in the South Dakota State Capitol were literally crushing Indians beneath their feet.

Most importantly, murals in public buildings were the sites where the dominant ideals of the social and political hegemony of this country played themselves out—and when they were conflicting, fought it out. Those examples, when viewed from today, prove of course that the ideals of our society, as reflected and reinforced in the icons of the public sphere, are not fixed but are ever-changing (as the apotheosis of gays and lesbians in a contemporary mural also attests). It is my contention that the sites where the transitions occur were the places where the ideals were most contested. Although the muralists attempted to create decorative and ideological harmonies, their murals were in fact fulcrums through which they filtered their ideas and ideals. They strove to be true to tradition and to embrace modernity, to forge a synthesis that would answer those conflicting demands. Where they failed, the tensions emerge through the cracks in the surface harmony.

I have based the title of this book on words from Henry Adams, who in his autobiography *The Education of Henry Adams* (published posthumously in 1918) wrote of the Virgin and the Dynamo as expressing contrasting aspects of Western civilization. I believe that those two images are perfectly suited to express the divergent and often conflicting energies and ideals of American society at the turn of the last century—conflicts that the murals reenact. The Virgin exemplified the past, tradition, beauty, and the elevated position that artists here dreamed for their art—a role for culture that they often identified with the feminine. The Dynamo represented the modern, progressive, urban, industrial, masculine forces

that many in the United States recognized as the face of the new twentieth century. I have reversed their order (Adams's chapter is titled "The Dynamo and the Virgin") to reflect the progression that the iconography of beaux arts murals takes from the early 1890s to the first decade of the twentieth century.

I have concentrated on murals that have survived. I am not concerned with the murals, mostly temporary, that decorated various fairs (except those at the World's Columbian Exposition, which was widely recognized as inspiring the mural movement). As the subtitle of this book indicates, in most cases I have emphasized public sites. I believe, however, that different styles and subjects of private and semiprivate commissions provided a telling contrast that put the ideology of public murals in sharper relief, so I have referred to them in passing.

I have visited all the major sites in this book, most of them more than once. As my references demonstrate, I have delved extensively into the literature and criticism of the period, as well as having read the more meager modern writings. Some artists who wrote extensively, especially Cox, Blashfield, and Low, receive more attention than most, but I believe their relative importance within the movement would warrant such attention even if they had not so often articulated their beliefs.

The book was written as a series of essays. In part I, three brief chapters present a short history of the beaux arts mural movement, 1876 to 1917, which provides a necessary foundation and context for the essays that follow. Pauline King wrote a history of the beaux arts mural movement in 1902, at what was to be the midway point in its short life. There have been sporadic attempts to chart its history since then, but no complete history has been written. Part I is not an attempt to present a complete history, but it supplements King's account and provides a sketch of what followed. Since few scholars have any knowledge of the extent of the movement, a foundation is important as a map to the arguments that follow in subsequent essays.

Part II opens with a chapter that explores the concept of "decoration," the dominant aesthetic of the mural movement, which held that murals should be integrated into the architecture so as to form a seamless whole, and in a more symbolic way reinforced the ideals the public buildings were supposed to represent. Chapter 5, "Democracy, Education, and Commerce," explores the roles that the muralists and their patrons believed public murals should hold in a democratic society. The artists held mural painting was the ultimate democratic art, and its reinforcement of democratic ideals made it doubly so. It was also a tool and a weapon for the socialization of both children and (tellingly) immigrants

into the culture of the United States, emphasizing the rightness of both democracy and capitalism. Chapter 6, "From Allegory to History," explores the various forms that the murals took, tracing the change that eventually took place, from allegorical to historical subjects. This shift registered the increasing concern that mural painting shake off the allegorical orientation of European and aristocratic art and concentrate on American history. That that history was so often safely in the colonial past demonstrated how nervous many citizens were about establishing their claim to prior occupation in the era of increasing immigration. The next essay, "Modernity and Gender" (chapter 7) explores the issue of modernity and how it affected the subjects and the reception of public murals. The increasing demand for modern subjects led artists to banish allegory and to embrace technology, and not coincidentally to focus on the male laborer as the symbol of the new age. The essay on "Ideology" (chapter 8) goes behind such obvious and outward forms to find the common ideologies behind them. A final chapter, "Eclipse," functions as an afterword, briefly charting the conditions that led to the decline and abandonment of beaux arts murals in the United States.

Although the form that this book takes makes it seem a summation, I intend it as a foundation. Much solid work has been done on mural painting by Richard Murray, H. Barbara Weinberg, Janet Marstine, H. Wayne Morgan, Sally Webster, Barbara Wolanin, Sarah Moore, Ingrid Steffensen, Francis V. O'Connor, and others, but the subject has not received the attention its position in the visual culture of the United States in the late nineteenth and early twentieth century deserves. I hope that many monographs, histories of specific projects, and broader studies will follow.

PART I

A SHORT HISTORY OF THE MOVEMENT

1 | 1 8 7 6 – 1 8 9 3 : B E G I N N I N G S

THE BEAUX ARTS MURAL MOVEMENT THAT FLOURISHED IN THE
United States was born in 1876, the year of the U.S. centennial, when architect
Henry Hobson Richardson hired John La Farge to paint the interior of his neo-
Romanesque Trinity Church in Boston (fig. 1).[1] La Farge had been one of the
first artists in three generations known to have sought European training. Unlike
most earlier Americans, he studied in France, not England, and brought a cos-
mopolitan sensibility to a country now more sure of itself and more set in its
ways than the one that greeted returning artists earlier in the century. La Farge
was a college graduate (of Saint Mary's, in Maryland), a Roman Catholic, and a
native New Yorker, and each factor contributed both to his cosmopolitanism and
to his art. He was one of the earliest American painters to be acquainted with
both pre-Raphaelite painting in England and Japanese prints from France. His
art was eclectic and he was a bit of a gentleman-amateur at first, but he gained
increasing professional status. Although his early works were mostly landscapes
and still lifes, La Farge also did figure studies, especially of lone women in land-
scape settings, to which he gave poetic identities such as *The Golden Age* or *The
Muse.* These paintings were prescient of a whole class of such subjects that would
be created by artists in the United States in the last two decades of the century. In
the almost twenty years since his return from France, many others had followed

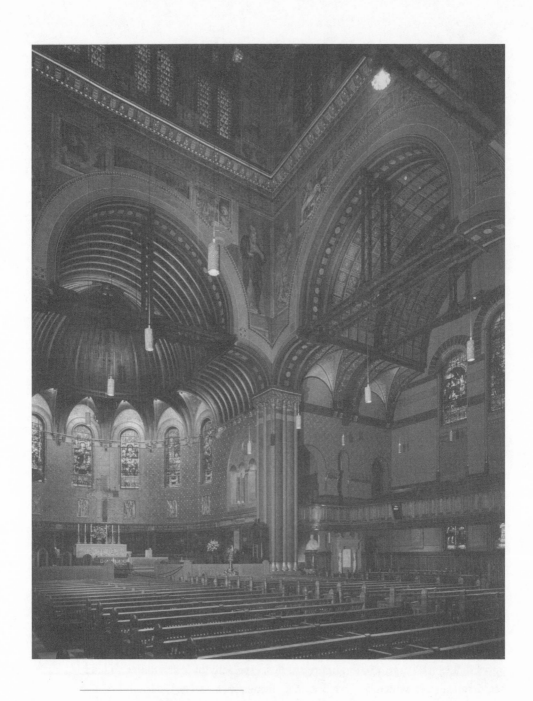

1. Henry Hobson Richardson, Trinity Church, Boston;
interior painted by John La Farge and assistants, 1876.
Courtesy John Woolf Photography.

La Farge to Europe, especially after the Civil War, which gave him an elder-brother status to the younger artists, especially the muralists.

Like La Farge, Richardson had studied in Europe, at the prestigious Ecole des Beaux Arts, where he graduated in 1865. The architect's sensibilities and sympathies were with the Young Turks returning from European study. The Trinity Church commission, his most prestigious so far, was an opportunity to give such artists a chance to demonstrate their talent and training. Trinity Church, described as a barn-like space, was a blank slate for La Farge and his team to decorate. They painted the walls of the large interior space so that the works of art and the architecture, as well as the stained glass and other decorative details, were a seamless whole. The decorations took five months and made Trinity Church an immediate architectural celebrity. This ensemble was La Farge's contribution to what would soon be recognized as an American Renaissance in the arts.[2] He would go on to become the leading muralist of the few who practiced that art in the 1880s. In the 1890s, when the movement took off, largely the result of the World's Columbian Exposition and the City Beautiful movement, he would be joined by many others, younger and inexperienced but full of enthusiasm for the potential of public murals.

There had been scant attention to large-scale mural painting in the United States up to this time. In the 1820s, John Trumbull had been commissioned to paint four large historical canvases for the interior of the rotunda of the Capitol. Trumbull had hoped to get the commission for the remaining four blank panels, but they were given to other artists, John Vanderlyn, William Henry Powell, John G. Chapman, and Robert W. Weir. All eight of the framed paintings were in fact large easel works, which were never meant to blend seamlessly into the architecture in the way that the late-nineteenth-century aesthetic would soon demand. In 1855, an Italian immigrant, Constantino Brumidi was hired to paint a trial mural. In 1856, the same artist painted the walls and ceilings of the committee rooms, and in 1862, the interior of the dome, which he did in a Baroque, illusionist style.[3] In 1861, Emanuel Leutze painted a large stereochromy, *Westward the Course of Empire Takes Its Way*, on the landing of the west staircase in the House wing.

In contrast to the illusionist style of the Capitol decorations, La Farge's intention was to follow decorative principles that had been established by Thomas Couture and Eugene Delacroix and, soon after, popularized by his contemporary, the French artist Puvis de Chavannes.[4] La Farge had known Puvis in his student days in Couture's studio in 1856. By the mid-1870s, Puvis was on the way to becoming the leading muralist in France, and some would say Europe: he had

already decorated the museum in Amiens with the first of two mural cycles and was then one of the artists painting the interior of the Panthéon in Paris. Puvis advocated that murals should be integrated into the architectural style of the building; they should echo its color and its structural devices; they should be relatively flat so as not to punch a hole in the architecture, drawing the eye across, not back into space.

For Trinity Church, La Farge's goals were in accord with the architect. Richardson's Romanesque revival style left huge blank plaster surfaces in the interior. In an early competition drawing, his intention to decorate the interior with richly painted decoration was evident. Although at one point he shifted to stained glass, he eventually returned to his original idea. La Farge was not only a close friend of Richardson's but probably the only artist in America, aside from his second teacher, William Morris Hunt, then capable of such a commission. Employing the rapid painting technique learned in Couture's studio, he and his assistants were able to paint the church quickly and cheaply (La Farge, in the interest of getting the commission, asked for very little more than the cost of materials). Richardson left the choice of subjects to La Farge, expressing only his preference for a red background.[5]

For the Trinity Church commission, La Farge hired several assistants who would later feature in the mural movement: George Maynard, Francis Davis (Frank) Millet, and Francis Lathrop, as well as the sculptor Augustus Saint Gaudens, who later joined La Farge on numerous other projects and was destined to be the leading sculptor of the beaux arts generation. The team illuminated the spaces with rich, Byzantine-style decoration—predominantly red, yet with multicolored pattern—that denied the heaviness of the structure and made the walls seem light and insubstantial. The medium was almost entirely wax encaustic.

On the tower walls, La Farge and his assistants painted the four evangelists, and in the spandrels they depicted six colossal figures of prophets and apostles. On the sides were two murals, *Christ and the Woman of Samara at the Well* and *The Visit of Nicodemus to Christ*. Pauline King, writing in 1902 about what turned out to be the first half of the movement, stated in *American Mural Painting* that La Farge's work seemed woven into one piece; the single parts, she said, were dependent on their relation to the whole. King called this approach the "true principle of decoration."[6] The *Woman of Samara* and *Nicodemus* paintings, added after the rest of the decoration was completed, were closer in spirit, however, to "easel paintings": they had faux frames; they were clearly separate from the deco-

rative detail that surrounded them; and they depicted narrative scenes as though in three-dimensional space.

As it turned out, neither Richardson's Romanesque revival nor La Farge's Byzantine-style decoration was appropriate for the coming grand projects of the American Renaissance: they would be more indebted to Italian Renaissance and classical influences. The next major milestone of the movement, William Morris Hunt's 1878 decorations for the New York State Capitol in Albany, were more prescient of future developments in mural painting. Like La Farge, Hunt, early on, had disdained the provincialism of his contemporaries and studied in France, briefly in Thomas Couture's atelier and then as an informal student of Jean François Millet, who was associated with the French landscape painters in Barbizon. Since returning to the United States in 1855, Hunt had become a very successful artist and teacher (briefly instructing La Farge). From the time he moved to Boston in 1862, he was recognized as the city's leading painter during the third quarter of the nineteenth century. Hunt was instrumental in establishing a taste for Barbizon paintings among Boston collectors, an advanced taste at the time since the style had not yet been widely accepted in France. His brother, Richard Morris Hunt, was the first American graduate of the Ecole des Beaux Arts in Paris, and both brothers moved in elite cultural circles.

The Albany project was Hunt's first mural commission. The state capitol construction was tainted by scandal, its original design by British architect Thomas Fuller remaining unfinished in 1875 after $5 million had been spent. An advisory commission, which included architects Richardson and Leopold Eidlitz and landscape architect Frederick Law Olmsted, was set up and new plans were submitted. Eidlitz, who designed the assembly chamber, was instrumental in getting Hunt the commission, perhaps, it has been suggested, to mitigate the objections of the other Hunt brother, Richard Morris (who was then the president of the New York chapter of the American Institute of Architects) to the capitol's design. At any rate, there was no official call for proposals or any competition.[7]

For his commission, Hunt was given two lunettes in the state assembly room. He suggested as a subject New York's own Niagara Falls, but the authorities wanted figures.[8] Perhaps because he was under intense deadline pressures (he had to complete the murals, start to finish, in less than four months), for the first lunette Hunt recycled sketches he had done nearly thirty years before—*The Flight of Night* (fig. 2), which showed Anahita, the Persian goddess, in a chariot made of clouds. The accompanying mural was *The Discoverer,* depicting Columbus at

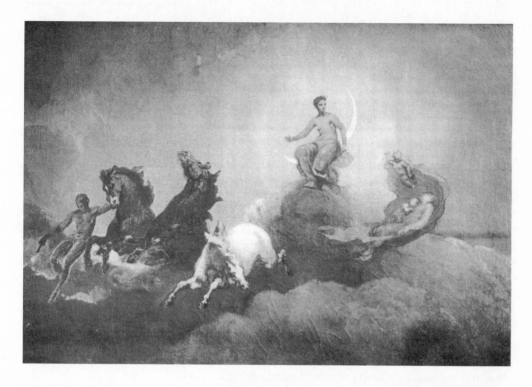

2. William Morris Hunt, *The Flight of Night,* Senate, New York State Capitol, Albany, 1878 (now covered by false ceiling). From King, *American Mural Painting,* 43.

dawn, along with Fortune and personifications of Faith, Hope, and Science. Sally Webster, the leading expert on the murals, has interpreted *The Flight of Night* as representing "barbarism and ignorance before the dawn of civilization" and *The Discoverer* as the "symbol of visionary genius and enlightenment."[9]

Together, as Webster has interpreted them, Luna (Anahita) and Fortune "are bound as symbols of man's destiny and fate";[10] in other words, Hunt established a symbolic link between the two murals and established Columbus as the icon of a new era.

Iconographically, neither *The Flight of Night* nor *The Discoverer* had any obvious relation to its location. Columbus was a New World subject, but Anahita was grafted onto the upstate New York location from ancient Zoroastrian mythology. This impulse to range far and wide iconographically has been defined and identified with the eclecticism of the American Renaissance. As documented at the 1978 "American Renaissance" exhibition, the term *American Renaissance* arose because it described the identification with the Italian High Renaissance that many cultural figures in the second half of the nineteenth century made for them-

selves. The American movement, like the High Renaissance, saw a rejuvenation of classical ideals, craftsmanship, and love of beautiful objects, and both were supported by a moneyed class. The collaborative spirit of the Italian Renaissance, its artistic unity of painting, sculpture, and architecture was a high ideal of this generation, many of whom had trained in Europe and were familiar with Old Master paintings and sculpture and architectural monuments of the past. They saw no contradiction between two very different ideas: that the ideals of the classical past and the Italian Renaissance were universal and could be translated into national or modern terms; and the notion that their generation would finally forge a uniquely American art.[11]

The American artists of the generation that succeeded La Farge and Hunt had, like them, trained in Europe, mostly in Munich or Paris. They saw themselves as end products of a great lineage of master painters, and as such they thought they had the privilege and even the right to rummage through the world's cultures for subjects. Seen less kindly, this impulse could be characterized as cultural looting, without regard for the integrity of the cultures raided or the meaning that may have been originally ascribed to a certain style or iconography. This confidence bordering on arrogance about borrowing at will from other cultures will permeate later murals, although a stricter adherence to classical and Renaissance sources will prevail than was found in the early years of the movement (La Farge, Edward Simmons, and Henry Oliver Walker being notable exceptions).

Hunt's Albany murals were much celebrated and written about; unfortunately, their end was swift and tragic. By 1880 the roof of the Senate chamber had begun to leak, the result of shoddy workmanship and shady deals. In 1882, serious structural damage began to compromise the murals. By 1888, a new ceiling was in place, forever hiding them.[12] Hunt did not live to see the ignominious end of his work; he died, a possible suicide, in 1879.

La Farge's fortunes, in contrast, rose dramatically as a result of his success with Trinity Church (although he was never a good businessman and was often short of funds). His name and reputation became largely synonymous with the infant mural movement. As the only artist in the United States with any real experience in mural painting, it was inevitable that he receive the major commissions through the 1880s.

At first, La Farge was given commissions for two more churches: Saint Thomas (1877–78) and the Church of the Ascension (1886–88), both in New York. The neo-Gothic Church of the Ascension had been designed by Richard

Upjohn in 1841; the current rector, E. Winchester Donald, who was instrumental in the decision to add the decoration, first approached architect Stanford White for advice; then, armed with a plan to enlarge the chancel and install a stained-glass window, he contacted La Farge, who by then was not only a muralist but also the leading stained-glass artist in America. When the plan proved unfeasible, La Farge was commissioned instead to paint a mural.[13] In a lunette over the altar, La Farge created a monumental painting of the *Ascension*. Christ and his apostles are set against a Japanese landscape, typical of those La Farge had seen when he visited Japan with his friend Henry Adams in 1886. The mural was received with mixed criticism. Some found the eclectic stew of Venetian color, Japanese landscape, and Raphaelesque figure style unsettling. Henry James, however, visiting much later, recorded his ecstatic response to it: a "thing of the highest distinction."[14]

La Farge's success with churches spawned several secular commissions. He again worked in New York: the Union League Club (in 1880) and the mansions of Cornelius Vanderbilt II (from 1880 to 1883) and Whitelaw Reid (from 1887 to 1888). On most projects, he had the assistance of Saint Gaudens, Will H. Low, and Theodore Robinson. For the Cornelius Vanderbilt II home, the architect, George B. Post, who had studied at New York University and had also worked in the atelier of Richard Morris Hunt, got La Farge the commission. La Farge oversaw the decoration of the entire house and painted the ceilings of the dining room and the watercolor room.

The Whitelaw Reid mansion was the southern half of the Villard Houses, designed by McKim, Mead & White, a complex that many scholars have noted as important for the future direction of American architecture. Unlike the rather arbitrary eclecticism of other, earlier, American Renaissance projects, the Villard Houses, on the east side of Madison Avenue between Fiftieth and Fifty-first Streets, were designed to be historically accurate. Based on a specific prototype, the Palazzo Cancelleria in Rome, the houses were in a unified Italian Renaissance style. In the music room of the Whitelaw Reid mansion, La Farge painted two lunettes, *Drama* (fig. 40) and *Music*. Both paintings are golden visions of young women in gorgeous landscapes thought appropriate for the festive location. As Barbara Weinberg has noted, the women do not personify drama and music, but act them out.[15] This approach will be in marked contrast to the direction taken by many of La Farge's younger contemporaries, who preferred a one-to-one symbolism and more complex allegorical programs.

During the late 1870s and the early 1880s, the United States saw an influx of

American artists who had sought training abroad. Many had trained in Munich, but more of them in Paris. Some of the Paris group had studied at the Ecole des Beaux Arts with Jean Léon Gérôme or Alexandre Cabanel, others at the privately run Académie Julian with artists such as Jules LeFebvre or Gustave Boulanger, and still others at the private ateliers of Emile Carolus-Duran or Léon Bonnat. Systematic training, with its emphasis on the figure as the foundation of painting and sculpture, distinguished the younger generation. Although their training varied, throughout this study I refer to the younger painters' murals as beaux arts. Foreign training, emphasis on tradition, figural orientation, methodical technique, symmetrical compositions, and classical ideals—all or most of which apply to the murals under discussion here—merit such a designation, although it was not often used at the time. This designation distinguishes this generation of muralists from the later movements mentioned in the introduction.

Some of these younger artists, Low, Maynard, and Millet, had worked on projects with La Farge after their training abroad, and they would become major players in the mural movement. But in most cases (Low's, for example) there would be a hiatus of about fifteen years after their return home before they got a first solo decorative commission. Some younger artists were luckier. Walter Shirlaw, a few years after he returned from Munich, painted a panel for the home of D. O. Mills in New York (c. 1881). Titled *Peace and Plenty*, it was full of putti and garlands.

Thomas W. Dewing, a former student at the Académie Julian and now a painter of decorative Whistlerian harmonies, was especially busy. He decorated the ceiling and wall panels for the Charles J. Osborn house in Mamaroneck, New York, in 1884, a frieze in the ballroom of the Baltimore townhouse of Robert Garrett in 1885, a ceiling mural for Robert Goelet in Newport in 1885, and a panel, *Days,* for Anne Cheney in 1886.[16]

Edwin Blashfield painted his first decoration, *Allegory of Good and Bad Dreams,*[17] three panels for the ceiling of the Hamilton McKay Twombly home, in 1886. In the central panel, Morning was "borne through the air on a bed of roses by a flock of cherubs."[18] Thomas B. Clarke, a collector famous for his patronage of American artists, got H. Siddons Mowbray the commission for the summer headquarters of the New York Athletic club on Travers Island in the Bronx, where the artist painted a panel, three feet by six, titled *A Month of Roses* (1888).[19] In 1892–93, Elihu Vedder, Blashfield, Mowbray, and Lathrop painted decorations for Collis Huntington's house in New York, designed by Post (Post had earlier hired La Farge to decorate the Cornelius Vanderbilt II home) (figs. 3, 4).[20]

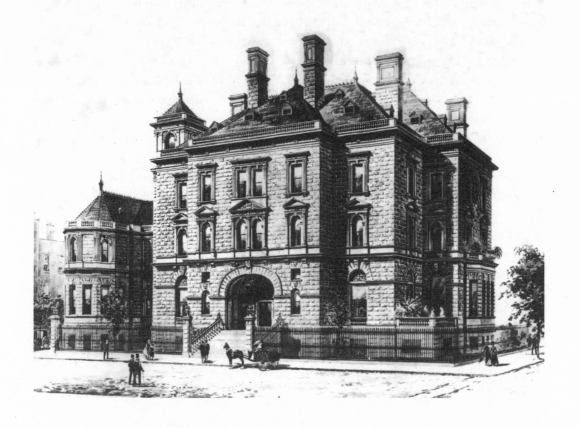

3. George P. Post, Collis Huntington mansion,
New York City (destroyed), 1889–94, drawn by Hughson Hawley.
Collection of The New-York Historical Society,
negative number 54797.

facing page
4. Elihu Vedder, *Abundance All the Days of the Week*
[The Sun and Four Seasons], decoration for
Collis Huntington mansion, 1893.
Yale University Art Gallery, gift of
Archer M. Huntington, M. A. (Hon.), 1897.

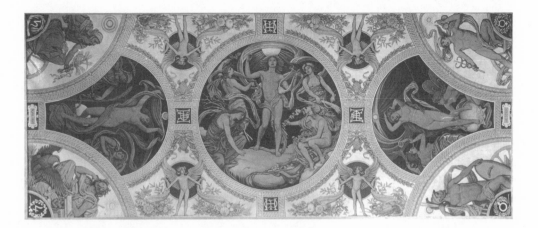

The influence of architects on the development of mural painting in the 1880s cannot be underestimated. All of Dewing's early commissions were the result of his friendship with Stanford White. Without Richardson's early support, White's enthusiastic embrace of the decorative harmony of painting, sculpture, and architecture, and especially Post's early and continued espousal of the importance of mural decoration, the movement would simply not have gotten off the ground. Only the architects were in a powerful enough position to recommend mural decoration for their buildings. In most cases, they hired their friends or colleagues or buddies from the men's clubs of Manhattan. Dewing and White were drinking companions and eventually cohorts in extramarital escapades. The list of murals executed by La Farge and Dewing constitutes more than half of the major commissions of the decade, and most were for buildings designed or added onto by McKim, Mead & White.

In addition, the influence of both Puvis de Chavannes and James McNeil Whistler was extremely important. The term *decorative panel,* often seen at the time, owed its frequent use, if not the exact terminology, to both Puvis and Whistler. The term *decorative* indicated that the artist first and foremost created a work that was unified in color and design; *panel* meant that the work was not an oil on canvas or traditional easel painting; it implied that the work's function was to decorate an interior space. Puvis exhibited *Young Girls by the Sea* in the salon of 1879 as a "panneau decoratif,"[21] and he continued to exhibit his canvases in that way in order to signal their decorative not narrative intention.

The influence of Whistler, too, was tantamount, although the artist had been an expatriate in London since 1855. Every major American painter read about, met, or, in the case of a few, such as John White Alexander and Robert Blum,

worked with Whistler. Not only was the infamous *Whistler v. Ruskin* libel trial of 1879 well publicized in the United States, but two of the artist's most radically formalist works, *Symphony in White No. 1: The White Girl* (1862) and *Arrangement in Grey and Black No. 1: The Artist's Mother* (1871), were exhibited in New York, in 1879 and 1881, respectively. As his titles indicated, Whistler—his name synonymous with the doctrine of art for art's sake—advocated the foregrounding of formal issues over subject. The emphasis on harmony of color and the strength of a work's design did much to make the moral tone of much mid-nineteenth-century painting in the United States seem provincial and old-fashioned.

In 1886, Frederic Crowninshield, a student of Cabanel and Couture, who had lived in Italy for six years and had most recently taught at the school of the Museum of Fine Arts in Boston, published a series of twelve articles on mural painting in the *American Architect and Building News*. Part history, part instruction manual, part pep talk, these articles were more important for their appearance than what they had to say, indicating the "great and increasing sympathy for decoration."[22] In 1888, Crowninshield gave a speech to the Architectural League in New York on "Figure Painting Applied to Architecture." His presentation recognized a building boom in the United States and called for architecture to unite with its "sister art" and "raise a race of mural painters who might prove the peers of the men of 1500."[23]

Crowninshield admitted that he did not make a strong distinction between the "monumental and the lower phases of decorative painting."[24] This was a distinction, however, almost one of class, that would soon be made. Artists like La Farge and Hunt, and later Kenyon Cox and Blashfield, would be hired to paint figural scenes on a monumental scale, usually lunettes or pendentives in significant locations. The rest of the building's halls and walls, whether it be library or capitol or courthouse, would be given over to "lesser" artists, or even to firms, usually local, who specialized in interior decorative painting.[25] The former were artists; the latter were craftsmen who often carried out designs that originated with someone else, sometimes an artist-supervisor like Elmer Garnsey.[26] This elevation of one class of artist above another went hand in hand with the growth of the mural movement. By 1892, critic Charles de Kay, writing about a mural by Dewing, noted that "the ceiling of the Hotel Imperial [designed by Stanford White, New York City] [fig. 41] may do something to further the employment of highly trained artists on work which is now turned over to mechanical workmen, who might as well use the stencil, so devoid are their decorations of wall and ceilings of all depth, or indeed of ordinary cleverness."[27]

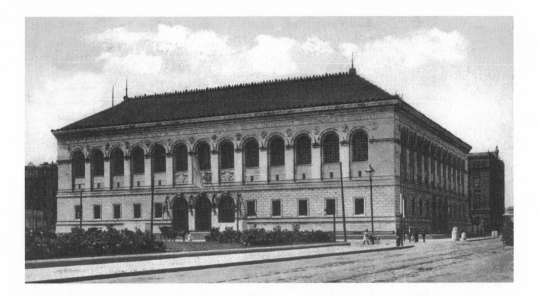

5. McKim, Mead & White, Boston Public Library, 1895, vintage postcard, date unknown.

The beaux arts muralists did, however, envision themselves as workmen, albeit on a higher plane than the commercial decorators who did the filler work between their figural compositions. They were workers who held to an ideal, intellectual and artistic, whose glorification of work was both elite and nostalgic.[28] Blashfield's friend, the critic Royal Cortissoz, who shared his ideals, called him a "fruitful worker" in the "classical tradition" who was always engaged in the "fight for beauty."[29] It was deeply rooted idealism, a desire to see the Western culture in which they had been trained survive despite the preoccupations of the technological modern age. As Sarah Burns has shown, however, they also viewed themselves as professionals in a corporate mode,[30] responsible subcontractors to their supervisor, the architect.

The ambitions toward monumental painting accorded with those of contemporary architects, the first generation that had trained at the Ecole des Beaux Arts. The architects hired artists trained at similarly prestigious schools and ateliers to supply mural decorations—artists with a strong professional reputation like themselves. In 1890, Charles McKim hired expatriate John Singer Sargent (then, next to Whistler, another expatriate, perhaps the most famous American artist), Edwin Austin Abbey, and Puvis de Chavannes to decorate the interior of his palatial, Italianate Boston Public Library (fig. 5). After the death in 1886 of Paul Baudry, who had decorated the Paris Opéra, Puvis was the leading French

muralist, given important commissions at the Panthéon and the Sorbonne. Puvis's murals were installed in Boston in 1896, but Abbey's decorations would not be finished until 1902, although the first half were installed in 1895; Sargent worked in stages, the first decorations completed in 1895, the so-called *Dogma of Redemption* in 1903. A third phase was installed in 1916, but the last would not be unveiled until 1919. *The Sermon on the Mount,* which was to be the culmination of the series, never got beyond the sketch stage. An important panel in the library's Bates Hall remained empty, although both Vedder and Whistler were considered, and Whistler actually completed a sketch.[31]

But in the early 1890s, the stature of the Boston Public Library project was the exception. The few artists with any talent or inclination toward mural painting had to be satisfied with private commissions or semipublic ones such as the new hotels or theaters in New York. In 1892, Dewing painted the ceiling of the cafe in the Hotel Imperial with *Night, Day, and Dawn,*[32] and Edwin Abbey contributed a colonial costume piece, *Bowling Green* (or *Game of Bowls*).[33] The same year, at the new Waldorf Hotel on Thirty-fourth Street, Henry J. Hardenbergh hired Low, who had had no opportunity to paint decorations since being employed by La Farge, to paint the ceiling of the ladies' reception room.

Mural painting in America got its jump-start in 1893 in Chicago (fig. 6). According to the critic Selwyn Brinton, writing fifteen years later, "the movement was already in the air and needed only a strong external impulse to focus its scattered forces together into a new and living creative element in American life. That impulse was given by the Columbian Exposition."[34] It is debatable whether, without the experiment and experience of decorating several buildings at the World's Columbian Exposition, the mural movement would have flourished as it did. The architecture of the White City inaugurated a new phase in city planning—the design of monumental cityscapes along beaux arts principles with classical regularity and detailing, wide vistas, and impressive facades. Grand interiors with mural decoration were consistent with this new architectural and civic style. An architectural harmony in public decoration signified that government and culture were unified. It projected clarity of purpose, order, and authority.

The architect Daniel Burnham was in charge of the overall architectural plan at the exposition. Burnham was a partner in the Chicago firm of Burnham and Root, a major designer of office buildings in the city (Root died in 1891, just as planning for the exposition got under way). Richard Morris Hunt, the first American architect trained at the Ecole des Beaux Arts, designed the adminis-

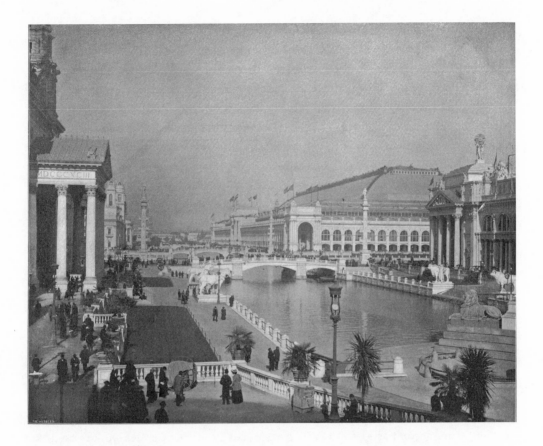

tration building. Among the other leading archi-
tects chosen by Burnham for major buildings were
George B. Post, McKim, Mead & White, Van Brunt
& Howe, and Peabody & Stearns. The architects
decided on a uniform classical style, white facades,
and cornice height for the buildings around the
Court of Honor. Burnham then hired Millet, a
Trinity Church alumnae, as director of decoration,

6. Court of Honor, World's Columbian
Exposition (with George P. Post's
Manufactures and Liberal Arts Building
in right background), Chicago, 1893.
From *Portfolio of Photographs of the
World's Fair*, n.p.

and Charles Yardley Turner as his assistant. According to one source, Turner
invented a method of spray-painting architectural elements that saved enough
money for the fair's organizers that they were able to hire muralists.[35] Few ar-
chitects, however, had designed buildings in anticipation of additional decora-
tion, and in the end it was Post's Manufactures and Liberal Arts Building that
received the most attention.

Post already had a track record in employing muralists for his designs.

He had hired La Farge and his assistants for the Cornelius Vanderbilt II home (1880–83) and was at the time of the fair constructing a Fifth Avenue mansion for Collis Huntington, the railroad magnate, that was to be decorated by Mowbray, Blashfield, and Vedder. His enthusiasm for murals may have come from his apprenticeship and association with Richard Morris Hunt. Post had worked in Hunt's atelier, and the older architect helped persuade Vanderbilt to rehire him to enlarge his earlier design for his home. Post would be a major employer of muralists in the next two decades.

But despite the ambitious plans of organizers, in 1892 there were few artists other than La Farge who could call themselves muralists. Apart from certain decorators such as Crowninshield, there were no mural specialists, and certainly none that had actually trained to be one. Millet and Turner hired J. Carroll Beckwith, Blashfield, Cox, William de L. Dodge, Maynard, Gari Melchers, Walter McEwen, Robert Reid, Charles S. Reinhart, Shirlaw, Simmons, and J. Alden Weir. Vedder was offered a job and was in Chicago for a short time, but soon left, citing a commission to paint a ceiling decoration and other murals in the Collis Huntington house in New York,[36] where Mowbray was already at work. (His biographer, Regina Soria, believes it was a loss of nerve—Vedder was afraid of being shown up by his younger colleagues).[37] Low declined because he had just received a commission for the new Waldorf Hotel.

Of the group hired, while only Blashfield and Maynard had had previous mural commissions, Beckwith had assisted his teacher Carolus-Duran on a decoration.[38] But American artists of this generation did have the advantage of European training. Whether in Munich or Paris, or as in the cases of Millet and Maynard, Antwerp, the artists had received a strong training in figure work. Especially those who had attended the Ecole des Beaux Arts in Paris, such as Cox, had had rigorous and even tedious training in antique- and life-drawing classes. Beckwith and Blashfield had studied in the independent atelier of Léon Bonnat; Low, Dodge, Weir, and Cox had studied with Gérôme; Melchers, Reid, and Simmons trained at the Académie Julian, and Shirlaw at the Royal Academy in Munich. McEwen, too, studied at the Royal Academy, and then in Paris at the Académie Julian, and Cox and Beckwith (and also Sargent) attended the atelier of Carolus-Duran. All this foreign training had turned out to be a mixed blessing since it led the painters to expect recognition and accolades that rarely came. The American matriculants at the Ecole des Beaux Arts could paint as well as their European teachers by the time they returned to America, but collectors still bought European, believing it was the real thing. There were few places to

exhibit besides the semiannual exhibitions of the National Academy of Design and the Society of American Artists. To supplement their income, most artists had to teach, illustrate, or write. They all responded eagerly to the chance to paint murals in Chicago: mural painting was both an economic opportunity and potentially a way to make their art more visible and accessible.

But few had worked on the scale necessary for a painting to be seen at a distance of more than fifty feet. The height, combined with the inexperience of the artists, presented such a problem that it was not surprising that the muralists' designs were so unambitious, and even pedestrian. In Post's Manufactures and Liberal Arts Building, where most of the murals at the exposition were located, most of the artists were assigned a dome. The design of the building meant that each artist's work would be in close proximity to that of another. Thus Weir was paired with Reid, Simmons with Cox, Beckwith with Shirlaw, Reinhart with Blashfield. Each dome had four figures. The choices were somehow related to either materials used in manufacture or to some aspect of the liberal arts. For example, Weir painted *Decorative Art, The Art of Painting, The Goldsmith's Art,* and *The Art of Pottery;* Reid painted *Iron Working, Ornament, Design,* and *Textile Arts* (fig. 7); Shirlaw painted *Gold, Silver, Pearl,* and *Coral;* and Cox painted *Metal Work, Building, Ceramics,* and *Spinning.* The most innovative, iconographically, were Beckwith's female figures holding new inventions: the *Telephone and the Ticker, Arc Light, Morse Telegraph,* and *Dynamo* (fig. 53), with a boy symbolizing Electricity in its center.[39] Like Beckwith, most of the artists chose four females, although some departed from this tradition. In most cases, the artists varied the figures' clothing, pose, gesture, or attribute, but otherwise they closely aligned them to the others in the same dome. There were also tympana by Melchers (*The Arts of Peace* and *The Arts of War*) and MacEwen (*Music* and *Manufactures*).

The exposition's buildings and their sculptural decoration were made of staff, plaster of paris combined with horsehair to create the effect of marble. With the exception of the Fine Arts Building (now the Museum of Science and Industry), they were intended to be temporary and have not survived. Except for the oil-on-canvas lunettes, which were distributed among various collections, most of the paintings that were painted directly on the plaster were undoubtedly destroyed with the structure; they exist now in rather muddy black-and-white photographs and in studies scattered in many museums.

Many of those who visited Chicago thought that the haste and inexperience showed. Samuel Isham, an artist and surveyor of American painting, for example wrote that "looked at dispassionately across the intervening time [twelve years],

7. Robert Reid, sketch for *Textile Arts,* for Manufactures
and Liberal Arts Building, World's Columbian Exposition,
Chicago, 1893. From King, *American Mural Painting,* 79.

it seems, while some of it was better and some worse, to have been as a whole rather bad."[40] Long after, the Cortissoz, too, remembered the fair with mixed feelings: "I remember the ardor . . . I remember also that their enthusiasm was not invariably equaled by their proficiency."[41]

The experience and the enthusiasm that it engendered, however, were more important than the result. The World's Columbian Exposition was a training ground where most of the artists got their first experience in mural painting.[42] And a strong community feeling was established between the artists. Most were from New York, were members of the Society of American Artists and the National Academy of Design, and belonged to the same clubs (such as the Players or the Metropolitan), but the experience of actually working together in close proximity on the same project was a new one. Augustus Saint Gaudens, in charge of the sculptural decoration of the fair, voiced his oft-quoted remark that it was "the greatest meeting of artists since the fifteenth century."[43] As hyperbolic as that claim now seems, at the time it was not so to the artists involved, and similar sentiments were repeated over the years. Those evaluations were an indication of the seriousness with which these artists took their work, as well as the scale of their ambitions.

Working all day in shared studios or up on scaffolding, they would gather in the evening. King, the first chronicler of this movement (who must have heard of their experiences from her sister Louise Howland Cox or her brother-in-law Kenyon Cox) described the fair's "beer and skittles" side: after dinner, over pipes of tobacco in a small restaurant, the talk "would run high" over mural painting and its history. "Sometimes improvised theatricals or tableaux would be the entertainment, though more often the most interesting art talk, the most brilliant joking, would be silenced while one of the assistants, a sweet-voiced young Irishman, was persuaded to sing his native Irish ballads, of which his audience never tired."[44]

Candace Wheeler described another scene of the men gathering at night, now situated in a faux hunting camp on the grounds of the fair, where they would smoke pipes and talk about art.[45] This male bonding took place in a context of macho symbols—guns and bows and the like. Whether the art talk was on the site or in a restaurant or at the hunting camp, it was the talk of male artists about art that focussed mostly on females. It was not just that the history of allegory and symbol in Western art was predominantly gendered as female, but that their own work had increasingly been orientated toward the female figure. The circumstances of their training, of the reception of their art upon their return

home, of the turn toward decorative art, of the demands that their art be whole-some and pure—all these made the female gendering of their creations seem inevitable.[46]

Not present at the pipe-smoking among the male symbols of the hunt were the muralists who decorated the Women's Building: Mary Cassatt, Mary Fairchild MacMonnies, Amanda Brewster Sewall, Lucia Fairchild Fuller, Rosina Emmet Sherwood, and Lydia Field Emmet. Cassatt did not return to the United States, but she sent to Chicago, from Paris, her mural *Modern Woman*. McMonnies came only to oversee the installation of her companion piece, *Primitive Woman*. Neither were the others part of the artistic bonding at the Manufactures and Liberal Arts Building: they were effectively segregated at the Women's Building and had few opportunities to paint subsequent murals. Cassatt and MacMonnies would not create any others. The movement would be predominantly male, with only Violet Oakley emerging as an exception, and her work was largely confined to Pennsylvania. The mural movement became an old-boys club, with artists net-working and recommending each other for jobs. (Because it reflects the male hegemony of the art world, throughout this study I refer to the artist as male.)

But the monumental aspect of mural painting also may have militated against women artists. Huge spaces to be decorated, scaffolding to be put up, crews to be supervised, and so on made the muralists' function seem closer to the architects' role than to traditional easel painting. Symbolically, the big brush can be viewed as a phallus, an instrument of power and status, not to be wielded by women. There were other issues, such as climbing scaffolds in the long dresses of the period.[47] In addition, big mural paintings were also mostly public works, created during a period when most women were restricted to the domestic sphere, and most women artists were specialists in portraiture. In that case, the studio was an extension of the home, a private, not public, sphere.

The fact that most of the early creations were symbolic or allegorical and the later ones historical further exacerbated this situation. The difficulties of a female artist, segregated as "other" because of her sex, to function as both creator and creation has been explored by Griselda Pollock and Rozsika Parker.[48] When the subjects shifted to history, women seemed not to be perceived as appropriate creators since the incidents that were celebrated largely excluded them. From the beginning of the movement and through its eclipse, female images were destined to be the majority of those created, but only rarely were women the creators.

2 | 1893–1903: EARLY PROGRESS

THE IMPACT OF THE WORLD'S COLUMBIAN EXPOSITION ON developments in the mural movement, and more widely on what would be known as the City Beautiful movement, was enormous. The White City provided the example, the rationale, the theoretical underpinnings, as well as the talent that would dominate public art and architecture for the next generation. It was a vision of what public art and architecture could be in the United States, and it foretold both its successes and failures. It was both grand and grandiose, portentous and pretentious, ambitiously complete but woefully inadequate for representing a wider, more inclusive culture. It was a top-down movement in which a group of self-appointed elites determined that modern architecture and city planning would be guided by the principles of classicism, which they believed were as viable in the 1890s in America as they had been in ancient Rome or Renaissance Italy. The architects, sculptors, and painters would assume the guise of reformer and educator, convinced that classicism's principles made it perfectly adaptable to a modern democracy on the verge of enormous changes. They sought to erase the fissures of modern society, between rich and poor, urban and rural, native-born and immigrant, educated or not, by smoothing over the tensions into a vision of harmony and grandeur.

The founding of the Municipal Art Society in New York in April 1893 was one of the most important developments to come out of the World's Fair. Architect and exposition alumnus Richard Morris Hunt was elected president, and nearly one hundred members signed the society's initial roll, including Low, Cox, La Farge, Blashfield, Millet, Dewing, and Maynard. Inspired by the communion of architecture, painting, and sculpture seen at the fair and impatient to incorporate the ideas evolved there into civic planning in New York, the society soon sponsored a competition for the decoration of one of the courtrooms of the new criminal courts building in lower Manhattan. That same spring, the architect Henry Van Brunt, in an article entitled "The Columbian Exposition and American Civilization," articulated the spirit of the movement when he declared that "to decorate Architecture has ever been, and must ever be, the highest function of sculptor or painter. Painting, sculpture, and architecture are in their best estate and are enjoying their highest opportunities when they are working together."[1]

Simmons won the commission for the criminal courts building, later claiming that he got his entry together in the weekend before the Monday they were due in April 1894. Simmons had earlier designed a memorial window at his alma mater, Harvard, but his only other decorative commission was one of the domes at the Manufactures and Liberal Arts Building. A scion of one of the most famous families in America, related to Ralph Waldo Emerson, Simmons had actually lived as a child in the Old Manse in Concord, the house built in the eighteenth century by the Rev. William Emerson. After a few years out west, he went to Europe, where he studied at the Académie Julian and the Ecole des Beaux Arts in Paris. He spent almost a decade and a half in France and England. Loquacious, sociable, and self-depreciating, Simmons seems to have been a charmer. He was always looking out for the opportunity to advance his career. Perennially short on funds, he saw the monetary and professional possibilities in mural painting at the White City. The Municipal Art Society competition, the first major one since the exposition, was a way to separate himself from the nearly indistinguishable pack that had painted murals there.

All forty-seven entries from the competition were exhibited for several weeks at the Architectural League on Fifty-seventh Street. Simmons's winning entry depicted Justice, accompanied by two small boys representing Condemnation and Acquittal (fig. 61). To left and right of the central mural were panels depicting, respectively, three women as the Fates and three males representing Liberty, Equality, and Fraternity. Evidently the Municipal Art Society had some problem convincing the city to accept their grand gesture, but the murals were installed in the Oyer and Terminer Courtroom and formally dedicated in November 1895.[2]

Although La Farge's decorations for Trinity Church were wax encaustic and Puvis had worked in oil and wax, by far the most common kind of mural produced during this period was with the French technique that Simmons used—*marouflage,* or painting with oil on canvas and then attaching the canvas to the wall with red and white lead. The artist usually began from scale drawings, but given the advantage of modern technology, the moderns, unlike their Renaissance forefathers, who squared up their drawings, often took photographs of their studies. As Sally Webster has documented, William Morris Hunt had his cartoons made into glass slides that were projected onto the surfaces of the lunettes.[3] The artist and his assistants could then trace the outlines onto the surface with chalk or charcoal and then apply color.[4] An ingenious method, it nevertheless necessitated working at night. Many artists would repeat this method during the American Renaissance. Blashfield even applied actual photographic reproductions to the canvas to determine what was the correct scale for the figures (fig. 8).[5] A few muralists, however, resisted such a methodical approach. Alexander, for example, in his Carnegie decorations in Pittsburgh, drew and painted directly on the canvas with minimum use of preliminary studies.

Early the next year, in an article titled "The Outlook for Decorative Art in America," the artist Frank Fowler cited the Municipal Art Society competition as evidence of an increased interest in mural painting: "This was the first effort of the kind ever made here and it attracted much attention." He mentioned as further proof the commissions for decorations at the Plaza, Imperial, Waldorf, Savoy, and Fifth Avenue Hotels.[6] Fowler's article was one of many in the mid-1890s after the World's Fair that heralded the growth of mural painting in the United States. Cortissoz, in *Century Magazine* the same year, also cited the Municipal Art Society competition as a beginning, "a case for rejoicing," since it showed that the movement was "gaining in impetus."[7]

Another important commission chronologically straddling the Municipal Art Society competition was the decoration of the Walker Art Building at Bowdoin College in Brunswick, Maine. The building was designed by Charles McKim, the architect of the Boston Public Library, who had commissioned its murals from Puvis, Abbey, and Sargent and thus was one of the pioneering architects in the United States in the use of mural decoration. The Walker Art Building was in the form of a Greek cross with a dome in the center. Only one mural, for the pendentive facing the entrance, was originally planned, and Elihu Vedder obtained the commission in 1892. At some point, it occurred to the benefactors, Mary and Harriet Walker, or to McKim, to have the other lunettes in the dome painted. There is no record of why La Farge, Cox, and Abbott H. Thayer were chosen, but

8. Edwin Blashfield at work on *Wisconsin,* c. 1912.
From Blashfield, *Mural Painting in America,* opp. 28.

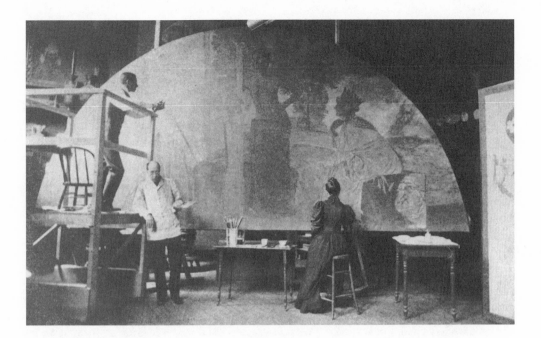

they were hired without consultation with Vedder, who was in Rome, already working on his contribution, *The Art Idea.* Vedder was not even notified.[8] The other three artists decided they would paint the cities that had affected the course of Western art: La Farge, *Athens* (fig. 9), Cox, *Venice,* and

9. John La Farge at work on *Athens* for Walker Art Building, Bowdoin College, Brunswick, Maine, c. 1894. From *World's Work* 21 (March 1911): 28.

Thayer, *Florence.* According to Vedder, his mural "already composed, had perforce to be Rome. Fortunately, the 'Art Idea,' for want of a better name, suited this scheme admirably."[9] When Vedder arrived in Brunswick in September 1894 to supervise the installation of his mural, the works by Cox and Thayer were already in place. La Farge's mural, although probably finished earlier, for unknown reasons would not be installed until 1898.

The next major milestone in the burgeoning mural movement was the decoration of the Library of Congress (fig. 10). General Thomas Lincoln Casey, who replaced the architect Paul J. Pelz in 1892, supervised the decorations, and his son Edward P. [Ned] Casey took over after his death in 1896. No specific appropriation from Congress covered the cost, but evidently the library had come in sufficiently under budget that the elder Casey could set aside a fund for the decoration of the interior with murals and sculpture, no doubt influenced by the increasing notice of and enthusiasm for decoration. Nineteen artists were commissioned to paint more than a hundred murals.[10] General Casey chose the

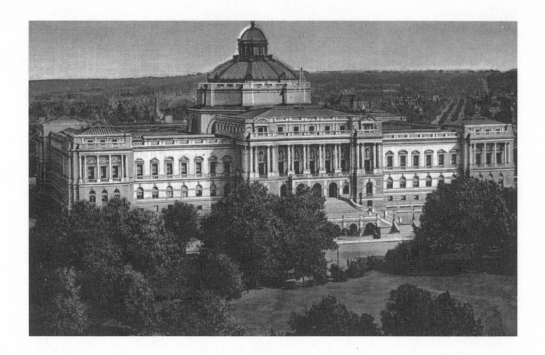

10. Paul J. Pelz and Thomas Lincoln Casey, Library of Congress, Washington, D.C., 1896, vintage postcard, date unknown.

painters himself. He or Bernard Green, the building supervisor, wrote letters to each, explaining the situation, making a proposal, and sending measurements of the spaces to be decorated.[11] Ned Casey supervised them from the time they were commissioned.

The most prominent location, that of the dome collar in the reading room, went to Blashfield, who in April 1896 was first to finish any of the murals. In an idea akin to that in the Walker Art Building, Blashfield's figures in *The Evolution of Civilization* represented the stages of human intellectual development. In a great circular band, he painted twelve figures holding their contributions. Egypt, for example, held a tablet of hieroglyphs and some papyrus books; Judea, portraying religion, was shown as a woman praying next to a stone pillar on which was inscribed "Thou shalt love thy neighbor as thyself"; and so on, through Greece (philosophy), Rome (administration), Islam (physics, the Middle Ages, modern languages), Italy (the fine arts), Germany (the printing press), Spain (exploration), England (literature), and France (emancipation). Finally came America, with science, which was shown as a ruddy male engineer with dynamo and book (fig. 54).[12]

The other eighteen artists received more or less major figural commissions.

In addition, Garnsey was hired to supervise all the spaces in between the major commissions, a role he was often to assume for subsequent sites. The results were a mixed bag, an assortment of styles and subjects giving little sense of an organizing principle. Apparently, each artist was given his space to decorate without there being much consultation or supervision to assure a cohesive style or subject.

On the main floor at the entrance to the reading room are Vedder's monumentally formed and symmetrically designed, yet small-scaled, aspects of government, *Good Administration, Government,* and *Peace and Plenty,* accompanied by *Anarchy* (fig. 43) and *Corrupt Legislation.*[13] Close by were Alexander's panels titled *Evolution of the Book* (fig. 29), which were not only less allegorical and more narrative but also less rigidly symmetrical, their sharply receding perspective indebted to Degas; they were thus more akin to modern or Japanese design principles than Vedder's academic designs. Walker's *Lyric Poetry* was monumental, flowing, and elegant. Opposite, Charles Sprague Pearce's scenes depicting aspects of *Religion, Labor, Study, Rest,* and *Recreation* were brightly colored yet heavier and more earthbound.

On the second floor, Reid's *Five Senses* and Frank Benson's *Three Graces* and *Four Seasons* (fig. 42) were impressionist in color and brushstroke, the figures depicted—light, elegant women—being supposedly appropriate to the identities named in the titles. Nearby, Shirlaw's branches of science (*Zoology, Physics, Mathematics, Geology, Archaeology, Botany, Astronomy,* and *Chemistry*) and George Barse's aspects of literature (*Lyric Poetry, Tragedy, Comedy, History, Love Poetry, Tradition, Fancy,* and *Romance*) were curvy, art nouveau pinups—women wearing or holding oblique references to the materialist weight of subject matter to which they had been assigned. A similar lightness characterized Maynard's eight *Virtues,* although the background color was a deep Pompeian red. Far from them stylistically, although more closely aligned in subject, were Cox's *The Arts* and *The Sciences* (fig. 55), lunettes with a classical severity of color and design. In the companion space were lunettes by Melchers, *Peace* and *War,* in the form of processions (quite close to the artist's World's Columbian Exposition murals). Other artists who completed murals included William de L. Dodge, his brother Robert, Carl Gutherz, Walter McEwen, Simmons, and William Van Ingen. William Dodge created one of the more bizarre contributions, *Ambition,* a circular ceiling panel in the Northwest Pavilion. Ambition, astride a winged horse, is flying high above, unattainable, as those striving for her reach up desperately and fruitlessly. The themes were repetitive, but taken individually many of the designs were satisfying, and even beautiful.

As at the exposition, the atmosphere at the Library of Congress was evidently festive and communal and called forth comparisons with the Renaissance. When he visited the site in the summer of 1896, the artist and critic William A. Coffin found that "the artists, like the workmen, were in overalls, and the atmosphere of the place seemed impregnated with the spirit of art and labor. It was something as it must have been in Florence or Venice in the Renaissance."[14] The Library of Congress had also won a race of sorts, since the building was open and the murals completed before those at the Boston Public Library, even though the Boston murals had been commissioned a few years earlier.

Although often cited as further evidence of growth in the mural movement, and as a hit with the public, the decorations at the Library of Congress were seen by many people as an example of what not to do in the future.[15] The analogy made most frequently—a very modern one—was to a department store with many different products whose only shared characteristic was the building that housed them.[16] Despite such recognition that the result was not wholly a success, the appellate courthouse in New York repeated many of the mistakes of the Library of Congress, albeit on a much smaller scale. This was ironic, given that the commissions for the appellate court were partly the result of the recent formation of "The Mural Painters, a National Society," later the National Society of Mural Painters.

Founded in New York in March 1895, with John La Farge as president, the society symbolized the new professionalism and specialization bred by the World's Columbian Exposition and evident in many disciplines at the end of the nineteenth century (the sculptors had already banded together in a National Sculpture Society in 1893). The Mural Painters wanted to foster cooperation between architects, contractors, and muralists. They drew up a constitution, including such practical propositions as formulating codes for competitions, holding exhibitions, creating educational propaganda, advocating recognition of the position of the muralist, and urging decoration of public buildings. The constitution's preamble stated that the society's end was to "promote the delineation of the human figure in its relation to architecture, whether rendered in pigment, stained glass, mosaic, tapestry or other appropriate media, and at the same time to foster the development of its ornamental concomitants."[17] The society then existed primarily to reinforce the hierarchy of figure over ornament, which distinguished this generation of muralists from the architectural or ornamental decorators that preceded them.

Joseph Lauber, chairman of the Committee on Civic Buildings for the society,

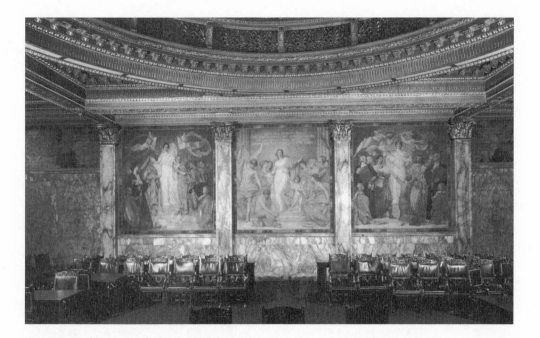

visited cities where opportunities for mural paint-
ings existed. He did not spark any interest until
James Brown Lord gave them the appellate court-
house commission in 1898. Lord, who apparently
was chosen without competition to be the archi-
tect, perhaps by the justices themselves, was a
member of several societies that promoted the
new architectural philosophy of a building united
by an integration of painting and sculpture.[18] Lord

11. James Brown Lord, east
courtroom, appellate courthouse,
New York City, 1898, showing
Edward Simmons, *Justice of the Law,*
Henry Oliver Walker, *Wisdom of the Law,*
and Edwin Blashfield, *Power of the Law.*
Courtesy of Frank Paulin.

worked closely with the society, which prepared a program for the courthouse
that was then approved by the architect and the building committee.[19] According
to King, the artists formed a committee to agree on the scheme of decoration.
Each of them submitted a rough draft and then a sketch in color. If any artist re-
fused to agree with the majority, he had to retire his commission. The prime
spaces in the courtroom (fig. 11) were given to three artists who had had major
roles in the decoration of the Library of Congress: Simmons *(Justice of the Law),*
Walker *(Wisdom of the Law),* and Blashfield *(Power of the Law).* Cox painted the
courtroom frieze, *The Reign of Law,* and Lauber painted panels that depicted ju-
dicial and other virtues. The entry hall was given to Maynard, Willard Metcalf,
Mowbray, Reid, and Turner.[20]

The effect of the entry hall, although rich and luminous, was akin to the panoply of decorations at the Library of Congress. The differences in styles, while not as obvious as those at the library because they were on a smaller scale, were grating. The courtroom space at least had a focal point in the wall, with its three large, square murals. Years later, one of the participants, Cox, wrote that of the six painters who contributed to the main room, each felt the human figure was necessary, but that if alone and in charge, each would instead have chosen some ornament. Cox went on to say that at the time he was writing (1917), no architect would ask two different painters to cooperate in the decoration of one room.[21] Indeed, the lessons of the Library of Congress and the appellate court were such that this approach would not repeated. Never again would so many artists be hired for so many different spaces in such close proximity. There would be a clearer distinction between murals and "mere" wall decoration. Someone, usually the architect, would have the final say as to choice of artist and subject and guarantee that the result be, as much as possible, a cohesive and comprehensive whole.

New York, where the mural painters' society was headquartered, was the city where the most private and semipublic spaces like hotels and theaters were decorated. The 1892 Waldorf, and its 1897 addition, the Astoria, employed a number of by then recognized names in the field. Low had decorated the "Marie Antoinette ladies parlor" with *Homage to Woman* (or *Birth of Venus*) (fig. 12);[22] Fowler painted the ballroom ceiling of the Waldorf in 1892. In 1897, Blashfield painted the Astoria ballroom with a mural seventy feet by forty-six feet, its two panels titled *Dance* and *Music*.[23] Low did twenty additional spaces, fourteen oval panels depicting different nations and the musical instrument they are known for: for Russia, bells; for Italy, the cello, and so on, as well as six semicircular lunettes (each twelve feet long), with two panels depicting Apollo and the Muses and their like—*Music of the Sea, Music of the Woods, Music of Peace,* and *Music of War.* Low covered more than a thousand feet of canvas in six months.[24] Alumni from the World's Columbian Exposition (Maynard, Simmons, and Turner, as well as Crowninshield, and Fowler) also worked there.

The murals that Blum designed for the Mendelssohn Glee Club in New York in 1895 were similar in style to the Waldorf decorations. *The Moods of Music* (fig. 26) and *The Vintage Festival,* huge rectangular panels, each fifty feet by twelve feet, decorated the walls on either side of the stage. The images on both took the form of processions, full of dancing figures, nymphs, satyrs, and musical instruments—figures thought to be appropriate for a concert hall.[25] King said

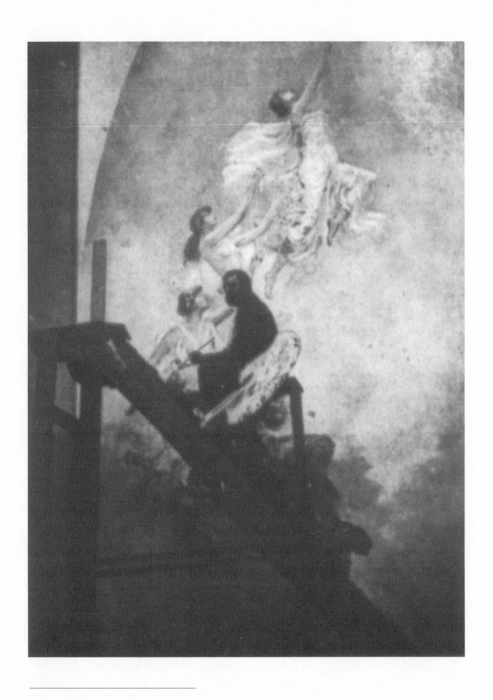

12. Will H. Low at work on ceiling, *Hommage to Woman*,
Waldorf Hotel, New York City, c. 1893.
From *McClure's Magazine* 5 (September 1895): 294.

Blum's task was to create paintings "suitable in theme and character to an environment intended to heighten the charm of the musical occasions for which it was designed"; it also had to harmonize with the hall's architecture.[26] In a review of the decorations, the critic Cortissoz spoke of one of the murals, probably *Moods of Music*, as "the illustration of a musical idea, a kind of chastened rhapsody, in which the bright-eyed, smiling maidens hover between the ebullient expression of the maddest enjoyment and languor and delight in sweet sound." *The Vintage Festival*, in contrast, was relatively sober and stately.[27]

The murals that adorned spaces in banks were very different in style, subject, and intent. Millet and Blashfield both painted semicircular lunettes on opposite ends of the huge main banking room for the Bank of Pittsburg (Pittsburgh) in 1897. Again, architect George B. Post was probably instrumental in the decision to include them. According to Charles Caffin, Millet's *Thesmophoria* (fig. 13) embodied Agriculture since it depicted a procession of women clad in white chitons walking behind a priestess in honor of Demeter.[28] Blashfield, in contrast, allegorically represented Manufacturing,[29] painting *Pittsburg Offering Her Iron and Steel to the World* (fig. 59). Rather than the gentle right-to-left movement of Millet's maidens, the figures in Blashfield's work were strongly centralized and symmetrical, with the staunch figure of Pittsburgh presiding over a forge, accompanied by industrial figures. In the foreground, a caption, embedded in a stanchion, read: "The City of Pittsburg offers her Iron and Steel to the Commerce, Industry, Navigation, Agriculture of the World."

Other commissions for commercial structures followed. In 1900, Thomas W. Dewing painted *Commerce and Agriculture Bringing Wealth to Detroit* for the State Savings Bank in Detroit, designed by Stanford White. Dewing's longtime patron, White's friend Charles Lang Freer, who was on the bank's board, paid for the mural.[30] Blashfield and Mowbray painted murals for the headquarters of the Prudential Insurance Company in Newark, again a building designed by Post. Blashfield decorated the boardroom ceiling with *Industry and Thrift Leading the People to Security*, with lunettes representing *Thrift Driving the Wolf from the Door* and *Prudence Binding Fortune*. Mowbray supplied additional lunettes—two large and three small.[31] Frederick Dielman's painted murals for the Evening Star building in Washington, D.C. (1901). In 1902, the Citizens' Savings and Trust Company in Cleveland, whose building was designed by the local firm of Hubbell & Benes, commissioned Cox to paint *The Sources of Wealth* and Blashfield to paint *The Uses of Wealth* (aka *Capital, Supported by Labor, Offering the Golden Key of Opportunity to Science, Literature, and Art*) (fig. 39). In 1904, Albert Herter painted

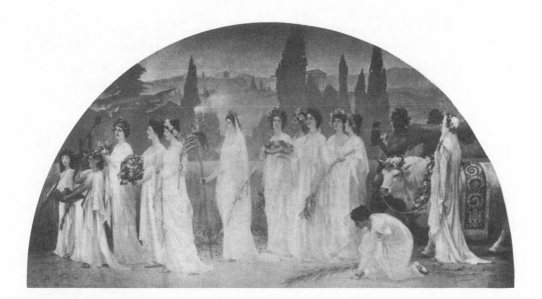

three huge, semicircular lunettes for Dann Barber's National Park Bank in New York: *Agriculture, Commerce,* and *Industry.*[32]

13. Francis D. (Frank) Millet, *Thesmophoria,* Bank of Pittsburg, Pittsburgh, 1897 (perhaps destroyed with structure). From King, *American Mural Painting,* 154.

McKim's Boston Public Library was completed in stages. Abbey was commissioned to paint a frieze around the book delivery room. He considered painting something from Shakespeare, and even illustrating Hawthorne; another possibility was devoting a panel to each of the greatest writers of various countries. He settled on a medieval subject, the Holy Grail, as a legend common to all West European countries.[33] The first half of *The Quest and Achievement of the Holy Grail* (fig. 27) was installed by 1895, the second half in 1902. The narrative unfolded over a series of panels that encircled the room. Critical opinion on them was divided. While the technique was praised, many thought that Abbey had violated principles of decoration in painting a narrative at all, and a costume drama at that, reminiscent of the artist's illustrations. But others saw the deep-red color and sweeping lines as a rich accompaniment to the dark wood of the room and as a method of pulling the viewer across, not into, the space.

Puvis's murals *The Muses of Inspiration Hail the Spirit the Harbinger of Light* (aka *The Muses Welcoming the Genius of Enlightenment*) (fig. 28) on the second-floor loggia, with accompanying panels, *Sciences* and *Letters,* met similarly divided opinion. While no critic went so far as to give them a negative review, a palpable

disappointment was apparent in most discussions. Most reviewers noted that the murals were done toward the end of the artist's life. Puvis died in 1898, and this was the only site he did not visit personally. Low remembered that Puvis liked to plant himself at the site and wait for inspiration, so it is perhaps understandable that the Boston murals were not up to his finest work.[34]

John Singer Sargent painted *Triumph of Religion,* the murals on the third floor, between 1895 and 1919. He had some experience with mural painting, although long in the past, having assisted his teacher Carolus-Duran in decorating a ceiling in the Luxembourg Palace.[35] Sargent's initial decorations were installed at the north end of the hall in 1895 (fig. 32). They depicted pagan gods, such as Astarte and Moloch, amid a bewildering amount of detail, much of it gilded in three dimensional relief. The work that came to be known as *Frieze of the Prophets* was more freely painted; both starker and statelier, it became the most popular part of the cycle.[36] King said that "Sargent is entirely the brilliant painter, whose manner is familiar through the magnificent series of portraits which has made him famous." She noted their "striking originality." But others expressed a kind of mystified reverence, and it was with an audible sigh of relief that the critics greeted Sargent's 1903 installation, *The Dogma of Redemption.* Caffin felt that Sargent seemed to have realized he had overdone the literary allusiveness since the symbolism of the *Dogma of Redemption* was relatively simple.[37] *Synagogue* and *Church* were the last decorations to be installed, in 1919. As Sally Promey has recently documented, an important section was left unfinished, its planned Christocentric iconography criticized by Boston's Jewish community.[38] A fourth artist, Whistler, was commissioned to paint a mural for the reading room, but it was never done.[39] A relative unknown, the British artist John Elliott, supplied *The Triumph of Time* (1901) for the children's reference room.

Several articles and publications around 1900 summed up the achievements of the mural movement since 1893. In January 1899, *Scribner's* included an article, probably by the architect Russell Sturgis, titled "Mural Paintings in American Cities" that listed almost a hundred works by thirty-six artists.[40] In 1902, King published *American Mural Painting,* the first extended study of the movement, ranging from Trinity Church through the appellate courthouse.

King's book appeared just after the installation of the murals that were, we can see in retrospect, the harbinger of the new direction that mural painting in the United States was to take. The enlarged Massachusetts State Capitol reflected a regional chauvinism that was soon to inflect state commissions. All of the artists chosen, Reid, Simmons, and Walker, had worked on the appellate court-

house; but perhaps more importantly, they were Massachusetts natives. None, however, resided in the state. The choice of Simmons resulted in a protest about the artist-selection process. Before Reid was hired, but after Simmons's commission was announced, a group of Boston artists, including Frank Benson, who had painted murals at the Library of Congress, and Edmund Tarbell complained that the commission had been given to Simmons without a competition. Furthermore, "Mr. Simmons had spent many years in Paris and was a resident of New York." The Committee on the State House responded by promising to advertise the commission and invite submissions.[41] Apparently an act was proposed in the Massachusetts House of Representatives to sponsor a competition, but it was never passed—or, more importantly, funded—and the competition never took place. The artists were appointed: Simmons retained his commission, and Reid and Walker were hired.

The issue of competition versus appointment was a sticky one, bound to raise heated opinions on each side. As might be expected, generally it was the lesser-known artists who seem to have preferred competitions, and in the early days they were more common since few artists had the experience, much less the expertise, of mural work. Eventually, those who had already made their reputations resented competitions since they usually had to work up designs at their own expense. An anonymous article on the proposed Massachusetts State Capitol project laid out the argument against the open competition that was being considered, preferring a limited competition: "Successful artists cannot afford to go into competitions without compensation." Furthermore, it stated, the sketches usually submitted were not enough to give a good idea of the final result and were no indication that the competitor was up to the large scale of mural painting. The writer suggested inviting "a few well-known men to offer their designs and to compensate them for their labor."[42]

Blashfield once polled his fellow muralists and found Low, Millet, and Cox against competitions. Millet cited Edward Deming's murals for Morris High School in the Bronx, sponsored by the Municipal Art Society in 1906, as reason not to have a competition; presumably he thought they were evidence that the judges had not realized from the competition sketches that the artist was not up to the large scale.[43] Blashfield's 1913 *Mural Painting in America* offered an extended argument against open competitions and in favor of the kind of limited competitions that the anonymous writer on the Massachusetts State Capitol commission preferred.

The commission for the Massachusetts State Capitol was one of the most

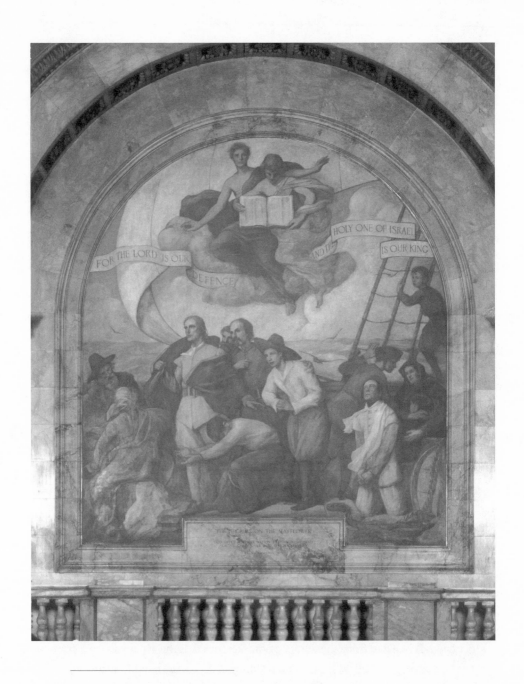

14. Henry Oliver Walker, *The Pilgrims on the Mayflower,*
November 9, 1620, Massachusetts State Capitol, Boston, 1902.
Courtesy Commonwealth of Massachusetts Art Commission.

important in the mural movement since it marked a change in terms of what was deemed an appropriate subject for public murals. In 1900, the state legislature had mandated scenes from Massachusetts history.[44] Reid received the commission for the mural above the grand staircase, *James Otis Arguing against the Writs of Assistance before the Court of Appeals,* which was flanked two years later by *Ride of Paul Revere* and *The Boston Tea Party.* Four lunettes were painted over the memorial hall, two by Walker *(The Pilgrims on the Mayflower, November 9th, 1620* [fig. 14] and *John Eliot Preaching to the Indians)* and two by Simmons *(The Battle of Concord Bridge, 1775,* and *Return of the Battle Flags in 1865).*

If the shift from private to public murals marked the first phase of the mural movement, then the shift from allegory to history signaled the second. Allegory was a ready solution in the early years of public murals; the artists had trained in ideal, academic modes and they admired their Renaissance forerunners, who employed allegory, as well as did their contemporary, Puvis. But the use of allegory was increasingly criticized as imported and not uniquely national; in addition, both the democratic nature of the genre and its didactic potential was often cited, and historical episodes seemed doubly appropriate. The major commissions after the turn of century most often employed either history or a hybrid of history and allegory.

Baltimore, which had its own Municipal Art Society, established in 1899, was the site of several major mural projects, history being the favored mode. For the Baltimore Courthouse, designed by Wyatt and Nolting, a local firm, Blashfield and Turner (a Baltimore native) initially received commissions. La Farge, after his success with the Minnesota State Capitol, would later be asked to paint additional murals. Turner painted a series of panels depicting scenes from colonial history, *The Burning of the Peggy Stewart* (fig. 36) and *The Barter with the Indians* in the second-floor hallway (Turner, together with Frank Millet, would soon be the leading specialist in historical murals). Blashfield, who did two courtroom murals, solved the problem of reconciling his devotion to ideal subjects with the increasing sentiment in favor of history: he painted *Washington Laying Down His Commission at the Feet of Columbia* (fig. 52) and *The Edict of Toleration* (1902). In the former, Washington, clad in uniform, laid his sword at the feet of an iconic, monumental female representing Columbia, who occupied the exact center of the composition. In this center section were also female figures representing the Virtues and carrying emblems of War, Peace, Abundance, and Glory. On either side, separated by columns, were other colonial figures in military uniform.[45]

The mural was often reproduced, and Blashfield's compromise between allegory and history was often cited.

Five years earlier, in an article on mural painting, Blashfield had called municipal art "a decoration and a commemoration," saying "it must beautify and should celebrate."[46] But his solutions, more often than Millet's and Turner's, were compromises with history. The symmetrical balance and idealizing icon decorated and beautified while Washington and Lord Baltimore are commemorated and celebrated.[47] Blashfield was the consummate professional, reinventing himself when necessary, confronting and accommodating change and always coming out on top.

Since they all wrote for popular journals and gave lectures as well as painted, Blashfield, Cox, and Low were on the way to being major spokesmen for the mural movement. Artists who gained a reputation more as critics than as artists included Caffin and William A. Coffin (1855–1925). Critics like Royal Cortissoz and architects like Russell Sturgis (1836–1909) also reported frequently on mural painting during this period. Sturgis edited *The Field of Art* in *Scribner's Magazine* from 1897 to his death in 1909.

Blashfield, Cox, and Low all shared the experience of study in Paris—Blashfield with Léon Bonnat, Cox independently with Carolus-Duran and then at the Ecole with Gérôme, and Low first with Gérôme and later with Carolus-Duran. All three were idealistic and ambitious in terms of their hopes for mural painting and their roles within the movement. Blashfield was by far the most successful and, it could be argued, the most talented. A professional who always got his work done on time, Blashfield labored on producing just the right decoration for every site. He also kept up a voluminous correspondence, often with the architects and commissioners, asking them the most obscure questions, engaging their interest, and presumably ensuring their appreciation for his work. He often sent sketches or drawings as tokens of his gratitude for their help. An artist often called upon to write or speak on the mural movement, Blashfield's discourse was elevated and portentous, yet with a sharp and even cunning inclusion of details, citing the commercial value of mural painting since it draws the public to a particular site. Blashfield's *Mural Painting in America* (1913) summed up the ideals of his long career (although the book would function as a near epilogue to the movement, there is no indication that Blashfield understood that it was actually drawing to a close). An avid committee member in various arts organizations and a supporter of standards and ideals in the arts, Blashfield enthu-

siastically entered into activities to support U.S. troops in World War I, design-
ing posters and other propaganda materials.

Cox was a more reticent sort. Even more idealistic than Blashfield, Cox was
without the other's social skills and probably suffered a loss of commissions as
a result. He wrote long and serious essays on the visual arts, and his art, like his
criticism, focused on "the classic point of view," and that phrase in fact became,
in 1911, the title of his best-known book. Cox's work shows far less variety than
Blashfield's. He relied almost entirely on seated, central, iconic female figures
flanked by appropriate allegories. Cox was a draftsman par excellence, however,
and his work often has beautiful passages despite his overall lack of imagination.

Low's writings were more focused on the mural movement in the United
States. Although he did write on other subjects, most notably a serialized history
of nineteenth-century painting in *McClure's* (1896), his essays on mural painting
such as "National Expression in American Art" (1901), "Mural Painting: Modern
Possibilities of an Ancient Art" (1902), and "The Mural Painter and His Public"
(1907), are invaluable for their presentation of contemporary arguments for the
art. Low was, as Wayne Morgan has noted, a bit of an operator, and he was not
afraid to use his pull to get commissions. Any modern appraisal of his art, how-
ever, shows it lacking the quality of Blashfield's and Cox's painting. His drawing
and his sense of color were not equal to theirs. Low was an entertaining writer,
however, publishing two books of reminiscences, a *Chronicle of Friendships* (1908),
which included memories of a close relationship with a fellow artist in France dur-
ing his student days, a cousin of Robert Louis Stevenson, and *A Painter's Progress*
(1910), the record of his Scammon Lectures at the Art Institute of Chicago.

Cortissoz (1869–1948) became an admired colleague of Blashfield, Cox, and
Low. He was an enthusiastic supporter of the mural movement from its incep-
tion as a public form. Having trained as an architect in the firm of McKim, Mead
& White, Cortissoz was close to Charles McKim. He became an art critic in 1890,
first for the *New York Commercial Advertiser* and then, for more than fifty years, at
the *New York Tribune* (later *Herald Tribune*). He also regularly wrote for *Harper's
Weekly* and *Century*. He was a staunch defender of the classical tradition and was
seen as increasingly conservative after the advent of modernism. Before 1917,
however, he was one of the best-known and most prolific critics of his time.

Caffin (1854–1918), a graduate of Oxford, emigrated from England in 1892.
In 1897 he wrote the essays on painting and sculpture for Herbert Small's hand-
book to the Library of Congress. He also wrote for a wide spectrum of popular

literate magazines, including *Harper's Monthly,* the *Critic,* and the *Bookman,* as well as art periodicals such as *International Studio* and *Arts and Decoration.* He was prolific, publishing eighteen books, including several surveys (*The Story of American Painting* [1907] and *The Story of French Painting* [1911]). Caffin was a supporter of the City Beautiful movement and a consistent voice for antimaterialism and for art that embodied spiritual characteristics. It is not inconsistent then that along with his enthusiastic advocacy of mural painting, Caffin would become a foremost supporter of Alfred Stieglitz and the pictorialist movement in photography.

3 | 1903–1917: GOLDEN AGE

THE RHETORIC ASSOCIATED WITH THE CITY BEAUTIFUL MOVEMENT had heated up at the end of the century. Blashfield had issued several ringing endorsements of municipal art, praising its democratic nature, its educational purpose, and its commercial benefits. After the turn of the century, such arguments started to bear fruit. For a brief period of less than ten years, the movement flourished, powerfully fueled by idealism from one end and the recovered economy from the other.

One of the most powerful arguments articulated in favor of public mural decoration in the United States was its intrinsically democratic nature: it was accessible and available to all. Another was its power as an educational tool, especially attractive in an era of unsurpassed immigration. Murals could be a way to teach, to give the foreign-born populace an infusion of national ideals, and so assimilate them. It is not surprising, therefore, that in 1905 the Municipal Art Society directed its attention to two of the city's newest high schools. Responding to the new emphasis on history, Deming supplied *Governeur Morris Addressing the Constitutional Convention* and *Treaty between the Indians and the Dutch at the House of Jonas Bronck in 1642* (1905) for the Bronx high school. Turner painted *Opening of the Erie Canal* and *The Marriage of the Waters* for DeWitt Clinton High School

(1906) (fig. 37) on Manhattan's west side. Two years later, at George Post's City College of New York, Blashfield painted *The Graduate* (1908).

Aside from these commissions, the Baltimore Courthouse, and the Massachusetts State Capitol, most of the major commissions after 1900 were for sites further west. Many states had outgrown the capitols that served them through territorial status and early statehood. They were eager to align themselves with the triumph of the White City in midwestern Chicago, to express like cultural ideals and civic aspirations through architecture and artistic splendor. A kind of chauvinism marked them as they sought to build architectural symbols as ready-made signifiers of cultural and civic prestige.

The Minnesota capitol in Saint Paul, designed by noted architect Cass Gilbert (fig. 15) and one of the finest beaux arts buildings erected during the heyday of the City Beautiful movement, was one of the showcases for mural painting. Gilbert claimed that the building was the best work he had done.[1] The architect had his start in New York with the firm of McKim, Mead & White, but moved to Saint Paul in 1882 to set up his own office. When he got the federal commission for the Custom House in New York in 1899, he moved his family and office back there, but divided his time between New York and Saint Paul. Gilbert was one of the most powerful architects of the period, and his desire to have murals in his buildings and his friendships with some of the painters were important factors in the commissioning process.

Gilbert took members of Minnesota's Board of State Capitol Commissioners on a tour of important murals in New York, Boston, Baltimore, and Washington, D.C. The composition of this board of commissioners is interesting. Eleven men were members of the board over a fourteen-year period. As Neil Thompson has documented, none of the original seven commissioners were born in the region but came from the East. Although they had spent an average of thirty-three years each in the state, only one had been educated there. None had attended college and only one had finished high school. There were two lawyers, two businessmen, one farmer, one realtor, one insurance broker, one grain shipper, and one wholesale grocer. All had experience that marked them as successful and all presumably had the necessary political ties.[2]

Gilbert's sympathies were with the idealists in the mural movement. His choices were seconded by the board, but in most cases the choice of artists was his.[3] He was also protective of the artists' professional integrity. To prevent interference from outsiders, even the commissioners, he made each artist an adviser on a "board of design," which would act as arbiter in case problems or conflicts

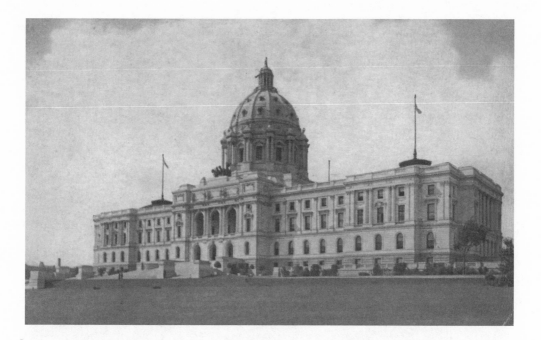

arose.[4] Gilbert gave pride of place to Simmons, whose four lunettes, *Civilization of the Northwest* (fig. 45), decorated the rotunda. Blashfield did two murals for the senate chamber, *Minnesota, Granary of the World* and *The Discoverers and Civilizers Led to the Source of the Mississippi.* Cox and Walker were given lunettes over stairways that mirrored each other across the rotunda. Cox's *Contemplative Spirit of the East* was one of the artist's stiffest and most academic compositions. He even admitted being "rather disappointed in my own lunette."[5] Walker's *Yesterday, Today, and Tomorrow* was light and elegant in comparison and done in the modern French style, not the classical mode favored by Cox. Each of the concepts, Yesterday, Today, and Tomorrow, was personified by a female figure.

15. Cass Gilbert, Minnesota State Capitol, Saint Paul, Minnesota, 1904, vintage postcard, date unknown.

The critics admired most of all the lunettes by La Farge in the supreme court. La Farge took as his subject different phases of the history of law; he featured Moses (fig. 16), Confucius, Socrates, and Raymond of Toulouse. One critic said La Farge represented history "in more or less symbolic manner" and added that "no definite story is told, but a general truth about the temper of the times and the people is worked subtly into all the elements of the painting."[6]

Gilbert was an able administrator and businessman, but he was often sorely tried by the demands of special-interest groups. Minnesota citizens wrote him

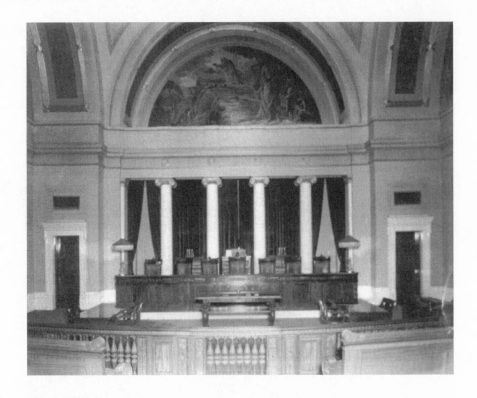

16. John La Farge, *Moral and Divine Law,* supreme court,
Minnesota State Capitol, Saint Paul, 1904–5.
Courtesy of Minnesota Historical Society.

offering paintings that were too big for their homes, and Civil War regiments
and the Roman Catholic Church lobbied for paintings of particular historical
subjects. Channing Seabury, the chairman of the board of commissioners, told
of listening to speeches by a group of veterans from the Minnesota Third Regi-
ment for several hours.[7] Gilbert satisfied the desires of the building committee
as well as other constituencies for historical subjects, but he relegated—one might
even say exiled—them to the governor's reception room (fig. 33). Large panels,
closer to easel paintings than mural paintings, by Millet, Blashfield, Howard Pyle,
Douglas Volk, Stanley Arthurs, and Rufus Zogbaum recorded events from the
state's history, most of which depicted battle scenes from the Civil War, a rare
subject for any of the civic buildings of this era. Although historical subjects had
become increasingly important after the turn of the century, most localities,
perhaps in a desire to put the conflict behind them, chose subjects more safely

in the past, and especially those from the colonial era. It may have been the relatively brief history of the state that argued for subjects from the more recent past.

The class differentiation between muralists and commercial decorators, noted earlier, was an important aspect of the project. When the names of the artists were published, some local sources complained that local talent had not been sought, and some even sued the commissioners.[8] Gilbert had little patience with such provincialism. For his building, he simply wanted the best that could be hired, he said, and for him that meant the most recognized experts in large-scale, ideal, figural decoration whose talent and experience had prepared them for his momentous commission. He wrote to Seabury that the attorney general should agree that the board "has authority to employ 'experts,' and that in making a contract with an 'expert' they are fully within their legal authority."[9] Garnsey was commissioned to design and oversee the secondary decoration, and some of the criticism was muted when a local firm was hired to do the painting and decorating of the halls and the areas around the murals. It is important to note, however, that Gilbert and the board figured the prices to be paid to both the muralists and the commercial decorators in terms of square footage, even though the amounts differed greatly, from $4.00 per square foot to about $50.00 per square foot.[10]

The process produced many personal and professional conflicts. La Farge quibbled endlessly about money and deadlines. Simmons, in the throes of a divorce and in ill-health, desperately argued for an advance. In an effort to hurry Simmons along, Gilbert even suggested he move from Paris to Saint Paul and use the rotunda as his studio.[11] Impatient with delays, Gilbert wrote to the artist in Paris in 1904: "You must bear in mind that this is State work, and that their procedure must be governed by considerations that might not weigh if they were acting for themselves individually." He chastised Simmons, writing that his "long absence had seriously embarrassed" him, "personally and officially." "I would be less than frank," he wrote, "if I did not tell you plainly that I think you should have given me better treatment, under the circumstances."[12]

Although La Farge's Minnesota murals were so universally praised that they brought the artist an additional commission for the Baltimore Courthouse, Gilbert evidently had had enough of the temperamental artist. Like a director swearing that he will never again work with difficult stars, Gilbert never again commissioned some of the muralists he had worked with at Saint Paul. When he hired muralists for his next major project, the Essex County Courthouse in Newark, New Jersey (1906), Simmons and La Farge were conspicuously absent.

For that site, Gilbert—who was personally close to many of the leading muralists —used his influence to appeal to them about their initial estimates for decorating the courthouse: they were too high, he said. The estimates had come in at $130,000, and Gilbert insisted only $80,000 was available.[13] The reliable and capable Blashfield received the most important commission, for four massive female figures that graced the pendentives of the grand dome, *Wisdom, Knowledge, Mercy,* and *Power.* In the courtrooms, both allegorical and historical subjects were painted, but New Jersey history was a close second: Cox's *The Beneficence of the Law*, Low's *Diogenes in Search of an Honest Man*, Maynard's *The State Supported by Liberty and Justice,* and Walker's *Power and Beneficence of the Law* were almost matched by Turner's and Pyle's paintings of seventeenth-century colonial history and Millet's depiction of an early protest against Britain in the eighteenth century.[14]

Minnesota excepted, the Pennsylvania capitol, in Harrisburg, was the most ambitious in the amount of decoration planned. The capitol was designed by Joseph M. Huston, a Philadelphia architect. From the beginning, Huston was in favor of including murals in the capitol, and Caffin, the critic, gave him credit for murals being included. He quoted Huston as believing that "every great building erected by and for the people should be a monument of the natural union of the sister arts, sculpture and painting."[15] In his competition sketches, reproduced in local newspapers in 1903, Huston included murals from other locations to give a sense of what they might look like. He even envisioned the capitol as a "palace of art."[16] Huston had visited the Boston Public Library, the Library of Congress, and the appellate courthouse, and he realized that unity between the decorations was an important objective.[17]

To execute the murals, Pennsylvania, like Massachusetts, another eastern state, was able to hire professionals who happened to be natives of the state. For the most important commissions, that of the lunettes and pendentives beneath the dome, Huston hired Edwin Austin Abbey, long an expatriate in England but a native of Philadelphia; eventually Abbey would be hired also for the house of representatives, the senate chamber, and the supreme court. John White Alexander, who also was commissioned, was born in Pittsburgh, but Alexander eventually resigned and devoted his time to his murals at the Carnegie Institute in his native city. (The murals in the location assigned to Alexander, the senate corridor, were not completed until 1970). William B. Van Ingen, an alumnus of the Library of Congress but more importantly another Pennsylvania native, in the south corridor painted fourteen lunettes celebrating the religious development of the state.

The commission for the governor's reception room was given to Oakley, who created *The Founding of the State of Liberty Spiritual* (fig. 34). Painted in the illustrative style of her teacher Howard Pyle, Oakley's mural cycle was based on the rise of religious liberty in England, the life of William Penn, and the formation of the Society of Friends. It was the largest public commission given to a woman up to that time. Huston wanted it to "act as an encouragement of Women of the State."[18] Oakley came from a family rich in artistic talent: both of her grandfathers were associates of the National Academy of Design. She trained at the Arts Students League and in Paris at the Académie Montparnasse. The most decisive influence on her work, however, was Pyle, whose class at Drexel University she attended in 1897. Oakley followed Pyle's example and went into illustration. Although born and raised in New Jersey, she shared a house outside Philadelphia with Elizabeth Shippen Green and Jessie Willcox Smith, fellow students and illustrators. Oakley received the commission for the governor's reception room in 1902; the paintings were completed in 1906.

The Historical Society of Pennsylvania drew up a list of sixteen subjects for Abbey, ranging from #1, Penn's Treaty with the Indians, to #16, Meade at Gettysburg, but it is not known whether the suggestions were ever forwarded to Abbey.[19] Abbey, however, responded to the change in civic mood that now desired history. Soon after he received his commission, it was announced that he would select the subjects, that they all related to Pennsylvania's history, and that the topics were secret.[20] He was going to decorate the dome with religious subjects and other sites in the capitol with the industries of Pennsylvania. In the course of the negotiations, however, it appeared that, for lack of funds, he would paint only the lunettes under the dome. Afraid that there would be no place for Pennsylvania industries, Abbey opted to do them under the dome.

Abbey used the combination of local and ideal that Walker had used in Boston and Blashfield in Baltimore (Blashfield would also use it in Minnesota and Iowa). He painted four scenes under the dome that pointed to Pennsylvania resources. First—rather oddly, since it did not seem to fit thematically with the others—in *Spirit of Religious Liberty* he depicted religious liberty; then came coal, in *Science Revealing the Treasures of the Earth;* iron, in *Spirit of Vulcan;* and oil, in *The Spirit of Light.* Abbey used female allegorical figures in all of the dome lunettes except *The Spirit of Vulcan.* In *Science Revealing the Treasures of the Earth* (fig. 56), for example, Fortune and Abundance accompanied a female Science. That mural is noteworthy for including male workmen. Science is winged and the female allegories are transcendent figures, clothed in draperies and floating above the earth, while the male workmen are stripped to the waist, muscular and heroic

in their labors. On the pendentives between the lunettes, *Art, Religion, Science,* and *Law,* Abbey painted four representative female figures in gold medallions.

Abbey decorated the house chamber with *The Apotheosis of Pennsylvania* (fig. 17). The mural depicted about thirty-five of the state's most noted citizens, all male, arrayed on steps, drawing the eye toward the female icon of Pennsylvania. Union soldiers came in on a stage on the left, with miners on the right. On the ceiling he painted *The Hours*—twenty-four female figures, ranging from brightly lit nudes to women in transparent drapery and, the garments becoming ever more opaque, dark cloaks.[21] Abbey died in 1911, and subsequently an assistant finished *The Reading of the Declaration of Independence* under the supervision of Abbey's friend John Singer Sargent. Oakley was given the large part of what remained of Abbey's commission. She painted nine murals and sixteen additional panels. The murals, *The Creation and Preservation of the Union,* were installed in the senate chamber in 1917, and the panels, known as *The Opening of the Book of Law,* took up residence in the supreme court in 1927.[22]

The other major project in Pennsylvania was the decoration of the Carnegie Institute in Pittsburgh, a commission given to Alexander for the then enormous sum of $175,000 (how much he actually received is not known). The project involved decorating more than five thousand square feet of space. Alexander, although he had painted the *Evolution of the Book* for the Library of Congress, had not been active in mural painting since then so the choice must have been, at least in part, because he was born in Allegheny City, across the river from Pittsburgh (it is now part of the city). Perhaps more importantly, Alexander was also a childhood friend of the director of the Department of Fine Arts at the Carnegie, John Beatty, and had worked with him on selecting artists for the Carnegie International exhibitions.

At the time, the commission was the largest yet given to an American artist.[23] Called *The Crowning of Labor* (1905–8), the decorations were to span three floors. On the first floor, male workers toiled in a smoky locale—one not clearly identified, but it stood for Pittsburgh's steel industry (fig. 58). This depiction of toil was placed at the base of the building because labor and industry were the foundation of Pittsburgh's and Pennsylvania's economy. The second floor contained the *Apotheosis of Pittsburgh* (fig. 57)—the apotheosis being represented not as a female figure, as tradition would have it, but as a male (variously identified as a portrait of either Andrew Carnegie or Alexander himself) in medieval armor.[24] Alexander surrounded the knight with female figures representing the arts and graces of life that successful industry was believed to have brought. The knight,

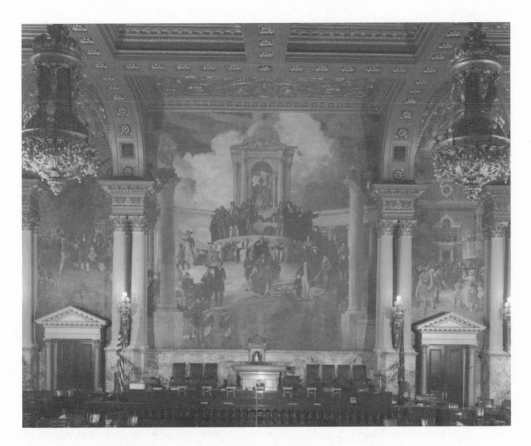

of course, represented the Christian, Anglo-Saxon
background from which Carnegie and most late-
century industrialists, as well as Alexander and
most of the muralists, came. Alexander repeated
this ethnocentric approach on the landing of the
third-floor staircase, where he depicted *The March
of Progress*. There are more than four hundred
17. Edwin Austin Abbey, *Apotheosis of
Pennsylvania*, House of Representatives,
Pennsylvania State Capitol, Harrisburg,
1911. Courtesy of the Pennsylvania
Capitol Preservation Committee.

figures, and all are white and appear to be northern European, notwithstanding
that Pennsylvania's steel industry in fact included many Slavs. The rest of the
third floor was to depict the different departments of the Carnegie, but in 1915
Alexander died, leaving that floor unfinished. And so it has remained: Alexander
was the only artist to work on the Carnegie decorations.

Like Abbey at Harrisburg, Alexander chose to represent the higher things of
life as rarefied females. In Harrisburg, this was done with hieratic figures against
a gold background; in Pittsburgh, it was done with floating, waspish females

against a nebulous setting. It is noteworthy, however, that the representation of male workers in Pennsylvania's industries struck a chord with audiences tired of colonial history. These figures elicited praise for their modernity, industry, and technology, being subjects that observers identified with the new century. The shift from allegorized history to allegorized modernity marked a major turning point in the mural movement.

There were three other statehouse commissions during this period: Iowa (1905), Wisconsin (1908–17), and South Dakota (1910). The Iowa capitol interior, in Des Moines, was largely of an earlier period, having decidedly Victorian designs. When it was remodeled after being partially burned, new murals were commissioned. Blashfield's large painting over the staircase, *Westward* (fig. 46), adapted to the older architectural context. According to the artist, the painting was "a symbolical representation of the Pioneers led by the spirits of Civilization and Enlightenment to the conquest by cultivation of the Great West."[25] Under the dome, in eight separate panels, Cox depicted stages of *The Progress of Civilization: Hunting* (fig. 35), *Herding, Agriculture, The Forge, Commerce, Education, Science,* and *Art.*

In Des Moines there were also six mosaics by Frederick Dielman, showing the functions of government. Dielman had supplied two mosaics, *Law* and *History,* for the Library of Congress (Vedder, too, had done a mosaic of Minerva there). Mosaics were not common for public spaces during this period, even though the Mural Painters had included them in their founding statement, so those at Des Moines were conspicuous exceptions. Typically, in mosaic work an artist would do the designs, a firm would supply the glass pieces, and the artist would then supervise their placement according to the design. The strong outlines required of mosaics were evidently thought close enough to the technique of mural painting that mural painters got the major commissions. Cox, for example, would later design mosaics for the Wisconsin State Capitol.

South Dakota had been admitted into the Union only in 1889. In 1904, Pierre was chosen as the capital, and the state capitol was begun there in 1907. The design by C. E. Bell and M. S. Detwiler was far more modest than Gilbert's at Saint Paul or the later project by Post at Madison. But despite its relatively small scale, ambitions were high. According to an account published the year the murals were installed, 1910, "no sooner was it determined to erect a new capitol, than the people of artistic taste and temperament began to agitate for a decorative scheme for the interior befitting the wealth and dignity of the state and illustrative of its best culture"; it was not an easy matter "in a frontier community where very little of true art had yet found a place."[26] Newspapers, literary clubs, and women's

clubs took up the cause. The Federation of Women's Clubs, meeting in Pierre in 1908, adopted a resolution calling for mural decorations in the capitol and favoring "a small amount of decoration of the highest order rather than to accept anything less than the best." The capitol commission decided to advertise for the submission of decorative designs. W. G. Andrews, of the Andrews Decorative Company, of Clinton, Iowa, who acted as an agent to secure commissions for muralists to accompany decorations by his firm, submitted a package deal to the state's building commission. His proposal was accepted, largely because he had already secured decorative proposals by Simmons, Charles Holloway, and Blashfield.[27]

Simmons supplied four circular panels in the pendentives under the dome. Each panel depicted a Greek goddess: in *Love of Family,* Venus; in *Wisdom, Industry, and Mining,* Minerva; in *Agriculture,* Ceres; and in *Live Stock,* Europa. Simmons also painted a lunette over the staircase, *The Advent of Commerce,* showing a white trader dealing with Indians, which he said dated to the era of the Lewis and Clark expedition, which had camped near Pierre.[28] The lesser-known Holloway supplied the other figural decorations: *The Peace that Passes Understanding* in the house of representatives; *The Louisiana Purchase* in the senate; *The Mercy of the Law* at the supreme court. Blashfield painted *Dakotah* (aka *The Spirit of the People*) (fig. 63) in the governor's reception room. As usual, Blashfield traveled to the site to see his panel installed. He wrote his wife that "the canvas looks well"; the capitol, he said, "is not unhandsome," but he was astonished that Pierre was so small.[29]

Post's state capitol in Madison was the third capitol in that city, replacing one destroyed by fire. We have already seen that Post was one of the architects most supportive of mural paintings. Among his buildings already decorated by murals were the Collis Huntington house (1893), the Bank of Pittsburg (1897), the Prudential Insurance Company (1901), the Cleveland Trust Company (1903), and the Great Hall at City College (1908). Post died in 1913, several years before the capitol opened, but he had personally chosen the muralists. The decorations at Madison exemplified the split between the two schools of mural painting—the ideal allegorical and the historical. Of the former were two murals by Blashfield and four mosaics designed by Cox. Decorating the dome, Blashfield's circular *Resources of Wisconsin,* with its gigantic iconic and symbolic figure of the state, covered the entire thirty-four-foot diameter. It represented Wisconsin as female, and other female figures, accompanying her, hold up "specimens of the productions of the State, lead, copper, tobacco, fruit, a fresh water pearl, etc";[30] all the figures were wrapped in the United States flag. Another representation of

Wisconsin by Blashfield hung in the assembly chamber: in his now typical blend of the allegorical and the historic, a rectangular panel more than thirty-five feet long, showed a seated, iconic Wisconsin surrounded by allegories and historical figures such as explorers and civil war soldiers. Cox designed mosaics for the pendentives under the dome: *Legislation, Government, Justice,* and *Liberty.* In the first two, representative male figures were used, in the latter two, females.[31] Alexander was originally supposed to supply a mural for the senate chamber, but he backed out, and Cox, after lobbying for the commission, won it by default. He produced a scene symbolizing the new Panama Canal, *The Marriage of the Atlantic and the Pacific* (fig. 64), a subject far from Wisconsin but national in scope.

The other murals were from the historical wing of the movement. In the hearing room, Turner painted four illustrations of transportation in Wisconsin from colonial to modern times. The last in the series depicted a railroad, steamship, and airplane. Murals that Millet was commissioned to do before his death on the *Titanic* in 1912 were given to Herter, who painted representational incidents from history, titled his pieces *Roman Law, English Law, American Law,* and *Local Law.*[32] Elmer Garnsey did some of the secondary decoration, and a New York firm, Mack, Jenny & Tyler, was hired to do the rest.[33]

For the new federal building in Cleveland, architect Arnold W. Brunner (1857–1925) designed a courthouse, post office, and customs house (fig. 18). The project was completed in 1910—the first public building in what was intended to be a comprehensive overall plan. The plan had been designed for the city by Burnham, Brunner, and John M. Carrère; it was submitted in 1903. The federal building was to sit at the end of a proposed mall extending down to Lake Erie, and the architects recommended that the classic style be adopted for all the buildings, which were eventually to include a library, courthouses, the city hall, and a railroad station.

In the preceding decade, Brunner had commissioned Blashfield to decorate the Adolf Lewisohn House in New York with murals depicting Music and Dance. His federal building in Cleveland was decorated with several courtroom murals more appropriate to the public sphere: a fiery rendition titled *The Law,* by Blashfield, and a relatively staid and hieratic *The Common Law,* by Mowbray (fig. 19). Low painted *The City of Cleveland, Supported by Federal Power, Welcomes the Arts Bearing the Plan for the New Civic Center* (fig. 20) for the appraiser's office. For the custom collector's office (now a judge's chamber) Cox created an oval panel, *Passing Commerce Pays Tribute to the Port of Cleveland,* as a pairing reminiscent of Jupiter and Danae.[34]

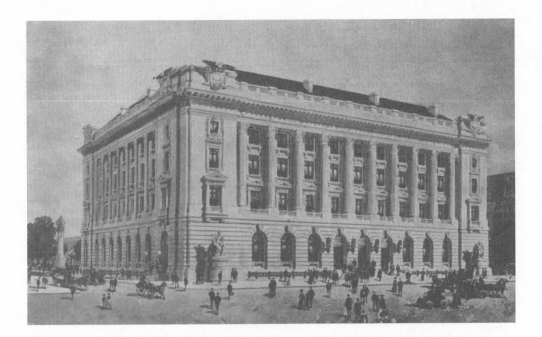

18. Arnold W. Brunner, Cleveland federal building, Cleveland, 1910, vintage postcard, date unknown.

In the post office of the federal building, Millet painted a series of thirty-five panels illustrating the history of mail delivery, the scenes ranging from North China to West Africa and to the pony express.[35] Millet's decorations were unique among the first tier of beaux arts muralists in that they were designed as a series of panels, each with what amounted to a historical genre scene with relatively small-scale figures. They followed a similar commission for the United States Custom House in Baltimore (1908) in which the artist painted eighty-seven panels on the history of shipping (fig. 50).

Millet was one of the most interesting figures in the mural movement. He had been a drummer boy in the Civil War, a student in Antwerp, a secretary to Charles Francis Adams Jr. (then the commissioner of Massachusetts to the Vienna Exhibition), a war correspondent, a painter of classical and restoration genre, a frequent visitor to England, and the director of decoration for the World's Columbian Exposition. His early murals were allegorical or classical (e.g., *Thesmophoria* in the Bank of Pittsburg); however, his later commissions were either historical scenes or carefully rendered panels like those in Baltimore and Cleveland. For both commissions, Millet was meticulous in his attention to archaeological and historical accuracy in depicting costumes, technology, and settings. Millet carved

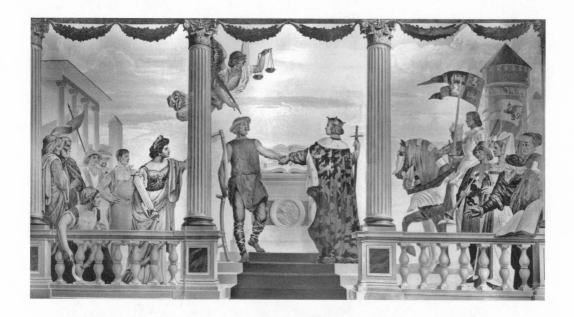

19. H. Siddons Mowbray, *The Common Law*, Cleveland federal building, c. 1911. From the Henry Siddons Mowbray and Mowbray family papers, 1872–1976, Archives of American Art, Smithsonian Institution.

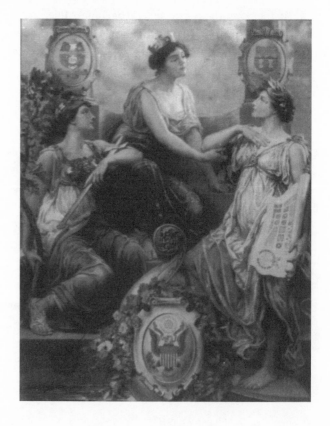

20. Will H. Low, *The City of Cleveland, Supported by Federal Power, Welcomes the Arts Bearing the Plan for the New Civic Center*, Cleveland federal building, Cleveland. Photograph by P. A. Juley, New York, New York, 1909. Will H. Low Collection, Albany Institute of History and Art Library.

a unique niche for himself with these designs, neatly solving the problem of allegory versus history and decorative versus illustrative.

It was Millet's expertise at handling large projects that probably won his appointment as director of decoration at the Hudson County Courthouse—in itself a relatively small project. Wealthy counties at this time wanted to hire national reputations to glorify their new buildings, a trend for which the decoration of the Essex County Courthouse in Newark had been a harbinger. In 1903, in Jersey City, not far from Essex County, the freeholders of Hudson County wanted to rival Gilbert's courthouse then under construction. They appointed local architect Hugh Roberts (1867–1928), the brother-in-law of a state senator who was also the corporation counsel for Jersey City, a situation that created some hard feelings among other architects. Roberts designed a beaux arts building similar to the Essex County Courthouse, and it was reported that he wanted to hire the same muralists, too. However, unlike Gilbert, he was not involved in the final decisions, but engaged Millet as director of decoration to hire and supervise the muralists. Millet, in turn, commissioned four of the other muralists from the Essex County Courthouse: Turner, Blashfield, Cox, and Pyle.[36]

Blashfield supplied four pendentives, each showing a female figure of Fame holding a medallion commemorating a great man from New Jersey's history. In *Liberty* and *Law,* Cox painted grisselle tympana, plus six judicial virtues. Turner, Millet, and Pyle opted for a more straightforwardly historical approach, all depicting scenes from American colonial and federal history that had occurred close to Jersey City.[37]

It was not unusual for large projects to spawn smaller ones. In Cleveland, in close proximity to the new federal building, the Cuyahoga County Courthouse (fig. 21), designed by Wilson & Schweinforth, was dedicated in 1913. Across the grand entrance space, two historical murals were installed: *King John Signing the Magna Carta at Runnymede* (1913)—painted, appropriately, by British muralist Frank Brangwyn—and *The Constitutional Convention* (1915), by Oakley (fig. 22)—her only major mural outside of Pennsylvania. In a nearby courtroom, Turner painted two scenes from colonial history. A few years after the capitol in Des Moines was completed, the Polk County Courthouse in that city was finished. The classic revival-style building was designed by the Des Moines firm of Proudfoot & Bird. Simmons, also responding to the new taste for historical decoration, painted a lunette depicting the women of the county giving a flag to local troops at the start of the Civil War.[38]

Other smaller places with big ambitions were Wilkes-Barre and Mercer, in

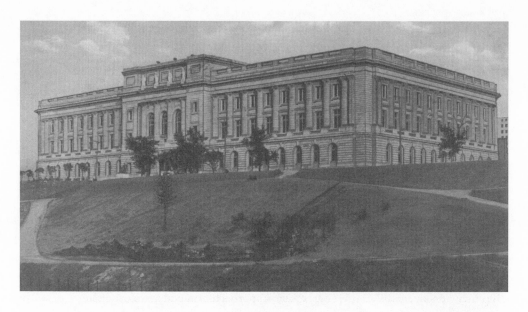

21. Wilson & Schweinforth,
Cuyahoga County Courthouse,
Cleveland, 1913, vintage postcard,
undated.

Pennsylvania, and Youngstown, in Ohio. I find it interesting that those three places, so relatively close geographically, should have their county courthouses within a few short years graced with murals by some of the leading artists of the day. They could certainly afford to do so since coal mining and steel industries made it a prosperous area. It may have been the influence of the Brunner building under construction in nearby Cleveland that inspired them; or it may have been the success of the Wilkes-Barre courthouse, moving architect Charles F. Owsley to commission murals for the courthouses he designed for Youngstown and Mercer.

An architectural competition held in 1899 for the Luzerne County Courthouse in Wilkes-Barre was won by F. J. Osterling, of Pittsburgh, out of twenty-five entries. The project was plagued by litigation over several issues—the need for a new building, the site, the cost, and the choice of architect. In the end, Osterling's design was finished (1909) by McCormack & French, a local firm. Some of the major names of the mural movement—Cox, Blashfield, and Low—were paired with virtual unknowns like William T. Smedley and Charles L. Hinton. The commission shows formal and informal networking among beaux arts muralists. Smedley was married to a Wilkes-Barre native, and he and Low had conferred with French and the county commissioners. Low suggested his friends Blashfield

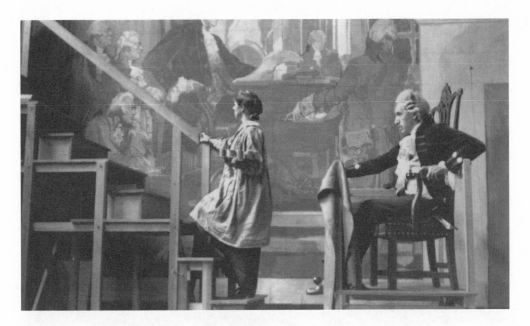

and Cox. Hinton was a neighbor of Low's in Bronxville, New York.[39] Four courtrooms were decorated with works that were rather like easel paintings in size and location; a strict border separated each painting from the rest of the room it occupied. Low supplied *Prosperity under the Law,* Cox, *The Judicial Virtues,* Hinton, *The Symbols of Life,* and Smedley, *The Awakening of a Commonwealth.*

22. Violet Oakley at work on *The Constitutional Convention* for the Cuyahoga County Courthouse, Cleveland, c. 1915. From the Violet Oakley Papers, 1841–1981, Archives of American Art, Smithsonian Institution.

In Owsley, Boucherie & Company's Mahoning County Courthouse in Youngstown (1910), Blashfield designed pendentive murals under the rotunda, painting powerful female figures for the Law in remote antiquity, classical antiquity, the Middle Ages, and modern times (fig. 23). The representative figures were given, respectively, staff and lamb, fasces and codex, mitre and crosier, and constitution and ballot box, akin to the similar figures in Blashfield's Essex County murals. Each female figure is accompanied by a young child holding an appropriate attribute. Lesser-knowns Arthur D. Willett and Vincent Aderente (frequently Blashfield's studio assistants) did courtroom murals, as did Turner, who painted *First Trial in the County.*

For the courthouse in nearby Mercer County, Pennsylvania (also designed by Owsley [1912]), Simmons painted four pendentives, all with female figures, in

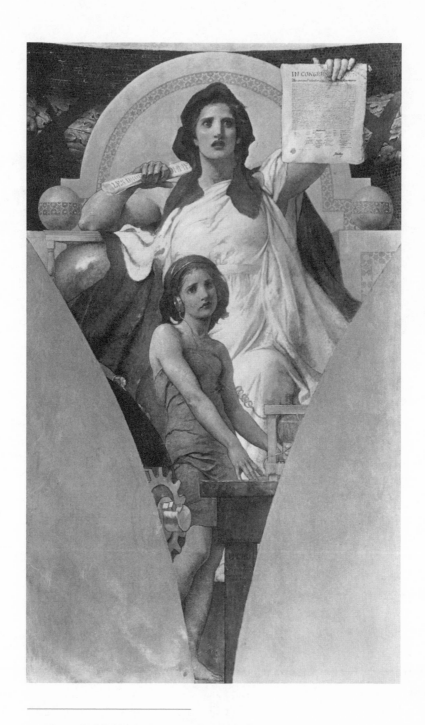

23. Edwin Blashfield, *The Law in Modern Times,*
Mahoning County Courthouse, Youngstown, Ohio, 1910.
From Cortissoz, *The Works of Edwin H. Blashfield,* n.p.

Guilt, Innocence, Power, and *Justice.* Two of Blashfield's principal assistants executed other murals (since Blashfield had painted the pendentives for Owsley in Youngstown, he may have recommended them for the job): Alonzo E. Foringer painted *Civil Law* and Aderante produced *Criminal Law.* The firm of W. A. Andrews (mentioned above) again acted as agent and did the secondary decoration.

The murals for the council chamber in the new city hall in Trenton, New Jersey, designed by Spencer Roberts, was on the same scale as many of these smaller commissions. Somewhat surprisingly, given its proximity to New York, the commission went to a relatively young painter, Everett Shinn, who was a member of the "Eight" or "Ash Can school." In contrast to his easel work, Shinn's only experience with murals was in decorating theaters, where he had created lively rococo designs. Given the Trenton location, however, and the city's dominant industries, steel and ceramics, Shinn had to alter his usual decorative iconography. Rejecting a suggestion that he paint "Washington Crossing the Delaware," Shinn depicted workers in the two dominant industries, laboring heroically amid fire and smoke (fig. 38). Shinn's decoration was one of the most important of the period: he decisively rejected both allegory and history in favor of an iconography recognized as distinctively "modern."

Other commissions worth noting were Mowbray's paintings in deliberate imitation of the fifteenth-century Italian artist Pinturicchio for the University Club (1904) and his later decorations for the Morgan Library (1905–7) and its addition (1928); Cox's *Light of Learning* for the Winona (Minnesota) Public Library (1910); Van Ingen's paintings on the theme of law for the Federal Building in Chicago (1909); Low's murals in Albany, New York, for the legislative library in the state capitol (1914–15), and thirty-two panels for the rotunda of the New York State Education Building (1913–18) on the subject of *The Aspiration of Man for Intellectual Enlightenment and the Results of His Attainment.* Murals continued to be installed temporarily in the buildings of fairs and expositions—notably, the Panama Pacific Exposition of 1915, which featured murals by Simmons, Brangwyn, William Dodge, Reid, and Childe Hassam, among others.[40]

World War I put an end to the building boom of the early twentieth century, but there are some notable late examples of beaux arts mural designs. Deserving mention are Blashfield's and Melchers's decorations for Cass Gilbert's Detroit Public Library (1921–22); Blashfield's *Alma Mater,* for the Massachusetts Institute of Technology (1923); the murals by Brangwyn, N. C. Wyeth, and Melchers for Tracy & Swarthwout's Missouri State Capitol (1922); and Sargent's extensive program for the rotunda and areas around the grand staircase of the Museum of Fine Arts, Boston (1917–25).

There was a certain group cohesion among the mural painters of the period. The major artists that I have discussed were aware of each other's work through illustrations in the popular and art press. Many were members of the National Mural Society. They also exhibited their decorations in New York before sending them to the site.[41] Some muralists went out of their way to visit other sites. For example, Blashfield visited Alexander's decorations in Pittsburgh and Abbey's in Harrisburg, two locations in which he had not received a commission. The muralists exhibited a friendly camaraderie and spoke frankly to each other about the vagaries of their commissions. Low, for example, wrote to Blashfield denigrating Wilkes-Barre as a "coal hole"; the room he was assigned in the Essex County Courthouse in Newark was "ghastly," he reported.[42] Sometimes the painters spoke favorably of each other, as when Low recommended Blashfield and Cox for Wilkes-Barre;[43] but sometimes, too, they were unkind, if honest. Simmons, for example, advised Gilbert against hiring Cox "on the ground that while his work was fine it had no great inventive quality." When Gilbert asked other artists about Cox's work, they recommended Mowbray instead (Mowbray was unavailable, so Cox got the commission anyway).[44]

An important manifestation of the muralists' beliefs and friendships took place when the American School of Archaeology (later to be named the American Academy in Rome) was founded in 1894. Mowbray, in Rome doing his research on Pintoricchio for the University Club murals (commissioned by McKim) was its director in 1903–4. Millet served briefly from January 1912 until his death, on the *Titanic,* in April.

In 1913, Blashfield published *Mural Painting in America,* which both recapitulated and codified the philosophy he had been articulating for twenty years. Blashfield believed that mural painting was the arena in which artists in the United States were able to distinguish themselves from European artists. He laid out carefully the relationship that he believed should exist between architect and painter. Blashfield argued that mural painting was the ultimate democratic art, for the people, of the people. Although always advocating the ideal over narrative, Blashfield called on muralists to celebrate the national and local history that their regional patrons demanded. He was optimistic, cheery, and full of promise, although at times pedantic and repetitive when articulating his ideals.

It is ironic that his polemic was published the same year as the Armory Show, which has been seen in retrospect as the birthplace of modernism in America and the death knell of the kind of painting that Blashfield and his contemporaries advocated. But it was not modernism alone that spelled the end; there were, in

fact, few major commissions in the years after Blashfield's book was published. Architects were moving away from the beaux arts tradition that Hunt, Burnham, Post, McKim, Mead & White, and Cass Gilbert represented. In addition, World War I meant the end of City Beautiful aspirations, both economically and psychically. Although works were sporadically commissioned, there was a hiatus in large-scale public mural projects. In less than twenty years, a new generation of artists, again funded by the government, would inaugurate a movement different in style, subject, and mindset from their beaux arts predecessors. But those forerunners had established a tradition of large-scale projects, government patronage, democratic ideals, and American artistry that facilitated the birth of the next phase of mural decoration.

PART II

ASPECTS OF THE MOVEMENT

4 | DECORATION

Painting Subordinated to Architecture

AT THE TURN OF THE CENTURY FROM THE NINETEENTH TO THE twentieth, the word *decoration* was often used interchangeably with *mural*. Since that time it has acquired some baggage, implying superficial, or trivial, or not very serious, but to beaux arts muralists, the associations of *decorative* were just the opposite. As artists trained in the great academies of France and Germany, American muralists believed that to paint epic themes in vast architectural public spaces was the greatest role any artist could have. They looked to the past, especially to the Italian Renaissance, as having established mural painting as a high art form, and Michelangelo, Raphael, Titian, and Veronese were to them decorators in the highest sense. Those artists and their baroque successors had decorated monumental spaces with paintings of magnificent proportions, works that seemed to speak great thoughts and embody universal ideas.

The mural movement became part of the larger City Beautiful movement that was launched by the World's Columbian Exposition.[1] Preceding but often intersecting the City Beautiful movement was another, less public and less official, development, the emergence of an American Renaissance in the arts of painting, sculpture, and architecture, as well as the "secondary" or "decorative" arts. The American Renaissance flourished partly as a result of the European training that many artists received, which had definitively set them apart from the preceding

generation. In addition, the artists and architects that they emulated, especially those of the Italian Renaissance, strove for an interaction and harmony among the visual and plastic arts. Architecture was always the dominant partner in this relationship since the choice of architect preceded decisions about pictorial and sculptural decoration. The muralist Will Low in 1901 gave a succinct statement of the goals of the muralist that explored the aesthetic then popular:

> The decorative painter must respect and consider the architect's work, must not by line or color detract from the constructive features of the room where his decoration is placed, must study the effect so that his work can be seen at the proper distance, and must not allow the scale of his figures or objects represented to conflict with the scale of moldings, capitals or mod-eled ornamental work. He must adopt a tone in harmony with the general color of the room and in consonance with the degree of light which falls upon his work; and finally, his composition must be simplified so that its meaning is apparent at the first glance, a painted rebus difficult of compre-hension being abhorred of the gods—the architects in this case.[2]

Low's statement of the aesthetic principles then in vogue reveals a formalism rarely associated with this generation of artists. If the purpose of the work was first and foremost to decorate, embellish, and harmonize with the architecture, then content was necessarily secondary. However, architectural harmony and order had meaning beyond strictly formal principles. Classicism and its restraint had many ideological layers. The public structure—statehouse, courthouse, city hall—that the murals decorated became a symbol of government's support of both democracy and culture. The white monumental structure in a municipal center became a symbol of order and stability, an endorsement of the status quo. Grand edifices symbolized the strength of whatever policies the government endorsed. The seamless architectural whole became a symbol of social cohesion, while it also established a hierarchy in which the grandest and noblest buildings are those erected by the state, cementing its power, but at the same time reinforc-ing the democracy that had licensed it. They also spoke of pride and confidence in those institutions and were meant to foster a chauvinistic and patriotic en-thusiasm.

This was somewhat ironic, given the disengagement of many muralists from current affairs. Apart from their business dealings, they were often otherworldly, speaking the idealistic language of beauty, nobility, strength, and high moral pur-

pose. They were comfortable articulating their ideals and they were certainly comfortable talking about their art, especially in terms of form, proportion, and scale. They rarely, however, in either private correspondence or public posing, came down on one side or the other of the momentous events of those years— the increasing industrialization of the country, the often violent labor disputes, the concentration of capital in a small number of individuals, the Spanish-American War, and other issues in foreign policy.

Lofty aspiration, however, often collided with the everyday realities of being a muralist in the United States in the late nineteenth and early twentieth centuries, with issues such as who was in charge of the project, what kind of architecture they were decorating, when the decision to include murals was made, what hiring procedures were followed. Low's flip yet wholly serious obeisance to the architect made sense since the architect often determined not only how many murals would be included in the new building, but who painted them. Permeating his writings, as well as those of Cox and Blashfield, there is a strange humility, as though the artist was afraid to break any rules. Muralists were performing a balancing act. The muralist had to subjugate his personality to the architect and still retain the prestige of artistic identity and individuality. How to call attention and simultaneously deny it?[3]

Voicing the gendered power relations of the period, critic Charles Caffin explained the relationship of architecture to painting as a man to a wife.[4] The maleness of the architect was also signified by the energetic role constructed for him in the United States during the Gilded Age. In the bifurcation of spheres between the sexes, men had charge outside the home, women within it. Likewise, with the progressive, modern direction the country was taking in the early twentieth century, when major cities began building skyscrapers, the architect was perceived as a mover and shaker. Artists, who had always occupied an ambivalent and largely unappreciated position in American society, now had the opportunity to attach themselves to men like George Post and Cass Gilbert, whose architectural styles were perceived as symbolizing power and growth.

Samuel Isham claimed that architects usually directed the choice of whether or not to have decoration and who to hire, and that seems to have been the case early on.[5] The more famous the architect the more choice he was given, or took, on the question of who was commissioned to do mural work. Such was their power and prestige that Henry Hobson Richardson, at Trinity Church, Charles McKim, at the Boston Public Library, Gilbert, at the capitol in Saint Paul and the

courthouse in Newark, Arnold Brunner, in Cleveland, and Post in Madison and elsewhere seem to have had their choices rubber-stamped by whatever committee was nominally in charge.

Architects naturally had favorites, and there is a pattern discernible in their choices. McKim hired La Farge for houses; he hired Abbey, Sargent, and Puvis for the Boston Public Library, after considering Vedder and Thayer, and Cox, Thayer, Vedder, and La Farge for the Walker Art Center; and he took on Mowbray to decorate the University Club and the Morgan Library. Gilbert, for his Essex County Courthouse in Newark, hired many of the same artists as those he had employed on the state capitol in Saint Paul: Blashfield, Cox, Walker, and Pyle; he conspicuously ignored its perceived slackers, Simmons and La Farge, replacing them with Millet and Low. He returned to Blashfield fifteen years later for the Detroit Public Library. Post hired Blashfield, Mowbray, and Vedder for the Collis Huntington House, Blashfield and Mowbray for the Prudential Building, Blashfield and Millet for the Bank of Pittsburg, and Blashfield for City College. He hired Blashfield, Cox, and Millet for the Wisconsin State Capitol, but Millet died before he began the commission (Post tried to get Mowbray, but he was turned down).[6]

A consideration of decorative harmony in terms of who was in charge of ensuring it, rather than those of aesthetic theories, moves one from a rarefied realm to the world of politics and economics. At some public sites, as we saw in chapter 2, political concerns held sway. At the state capitols in Boston and Harrisburg and the courthouse in Baltimore, local natives were chosen to paint murals. For the Massachusetts State Capitol, the commissioners seemed to have chosen not only among the Massachusetts natives—Reid, Simmons, and Walker—but among those who had recently painted decorations at the appellate courthouse in New York. In Jersey City, likewise, the names were chosen from among the muralists for the nearby Essex County Courthouse—Millet, Pyle, Cox, Turner, and Blashfield. Among the muralists that Gilbert recommended for the Detroit Public Library was city native Gari Melchers.[7]

In the course of awarding contracts for the capitol at Saint Paul, there were evidently rumblings about the New York residency of so many of the muralists. The chairman of the Board of State Capitol Commissioners, Channing Seabury, wrote to Gilbert: "Up to this time, we are justly chargeable with 'playing into the hands of a New York ring,' which has been already asserted. Not all the artistic ability in the U.S. is centered in New York City, although I am free to admit that a good share of it is. We have now employed [sculptor Daniel Chester] French,

Garnsey, La Farge, Blashfield, Millet and Volk, on our artistic work,—7 men—
every one of them a resident of New York City. We must not keep this up for-
ever." Gilbert wrote a terse annotation on the letter: "I don't know of a 'ring'
never heard there was one and don't believe there is."[8] He evidently took Sea-
bury's point, however. In a subsequent letter, he said that Low, Turner, and May-
nard were possibilities for additional decorations, but noted that all were "New
York men."[9]

Increasingly as the mural movement grew, the choice was treated like a busi-
ness venture. W. T. Andrews, who ran an Iowa company specializing in decorative
painting, acted as an agent for muralists. He got them major commissions, and
as part of a package deal his decorators received the jobs in secondary decora-
tion. Andrews got Blashfield and others the South Dakota commission and also
lobbied (though unsuccessfully) for Blashfield in Utah and Montana.[10] He was
responsible for bringing Simmons the commission for the Mercer County Court-
house, where his firm did the secondary decoration.

At more minor sites, choices seemed to be the result of networking among
artists. William Smedley was primarily an illustrator and portrait painter, but his
"in" for the Luzerne County Courthouse may have been that he was married to
a Wilkes-Barre native. He in turn recommended his friend and fellow Bronxville
resident Will Low, who then recommended his friends Cox and Blashfield, with
whom he had worked on numerous projects, including the Essex County Court-
house.[11] The other artist who worked at that site, Charles Hinton, was a Bronx-
ville resident and Low's student.

The architect was also most often in charge of overseeing the decoration,
although sometimes he delegated that role to an artist; an example of an overseer-
artist was Frank Millet, who held that job at the World's Columbian Exposition,
the Baltimore custom house, and the Hudson County Courthouse. Caffin, the
author and critic, criticized the tendency of architects to assume responsibility.
Complaining about the "department store" tendencies then in vogue, he said he
found that a master decorator like John La Farge produced the most unified
designs.[12]

There was much criticism about the cacophony of decorations at the Library
of Congress, and in retrospect some artists voiced the same opinion about the
appellate courthouse in New York. Blashfield later said that the artists had smoth-
ered the building to give Uncle Sam his due.[13] Although, for that project, La Farge
was nominally an arbiter, he did not design the decorative scheme or oversee the
installation. Mowbray later wrote that "the whole should have been given to one

man, instead of dividing it up among four, and in this way, perhaps, some of its tawdry, over decoration might have been avoided. The worst instance of this division was in the court room itself, on the east wall, where there are three distinct pictures, by as many artists. It is like having three speakers on the same platform."[14] This aesthetic and administrative position became commonplace. For example, the author of an anonymous article on the Massachusetts State Capitol Commission in 1901 advocated that all five panels be given to one artist.[15]

Most contracts with muralists specified the places to be decorated, and many cited the square footage. In most cases, the artists were in essence subcontractors of the architects. This corporate, professional role was one that has been identified by Sarah Burns, in her recent study *Inventing the Modern Artist,* as having been assumed by some American artists in the late nineteenth century. She noted that artists like Cox and Low staked claim to an identity that was eclectic yet professional, solid, competent, and orderly; they were workers who could cooperate on sites like the World's Columbian Exposition and the Library of Congress. Groups like the National Society of Mural Painters and the National Sculpture Society furthered the perception of artists as professionals. They spoke for their members, establishing policies on competitions, contracts, and the relative responsibility for commissions.[16]

This professional role meant that the discourse surrounding murals was as often articulated in terms of cost as creative value. Gilbert wrote to the Board of State Capitol Commissioners that he found "that figure subjects painted by the best artists have averaged in cost from $40 to $60 per square foot, and in one or two cases have cost $65 a square foot." He later proposed proportionally splitting the $100,000 allocated between the supreme court (La Farge), the senate (Blashfield), and the rotunda (Simmons) and calculated it as $39.30 per square foot.[17] All the artists thought they were making concessions. Eventually they were paid slightly less: La Farge, $40,000 (for four lunettes); Blashfield, $25,000 (for two lunettes); Simmons, $33,000 (for four pendentives).[18] The painters who supplied historical panels for the governor's reception room received $3,000 apiece. Elmer Garnsey, who supervised or painted most of the secondary decoration (fig. 24) received $125,000 for mostly nonfigurative work. Gilbert negotiated well for the muralists, and other architects (e.g., Post) were similarly sympathetic. Blashfield received only $5,000 for his Wilkes-Barre panel, but he was able to get $15,000 for one lunette in Madison a few years later.

The terms of the Saint Paul contracts to artists stipulated that they would

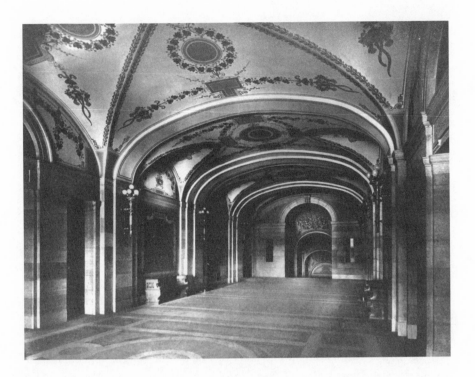

24. Elmer Garnsey, detail, Minnesota State Capitol, Saint Paul, c. 1904.
Courtesy of Minnesota Historical Society.

get 15 percent of the total when sketches were approved, 25 percent for the car-
toons, 50 percent when the pictures were in place, and 10 percent when everything
was finished and approved.[19] Since it was a government job, Gilbert felt the artists
should be bonded, to assure "guarantee of faithful performance."[20]

The terms for the journeyman artisans who decorated the areas other than
the major mural locations was considerably less: they were paid by the day, with
union regulations specifying terms of employment. A 1902 letter of agreement
between the Association of Interior Decorators and Cabinet Makers of the City
of New York and the New York District Council of the Brotherhood of Painters,
Decorators and Paper Hangers of America was mailed to the press and for-
warded by Gilbert to Seabury, with a handwritten note that it had bearing on the
capitol commission. It stipulated terms of employment and lists the following
wages: decorators and gilders, $4.00 a day, painters $3.50, varnishers $3.25 a day.[21]

The class differentiation persisted as the movement gained momentum, and the split between artist and artisan widened as the muralists gained in reputation and status.

The architect also got a cut. Post, who designed the Manufactures and Liberal Arts Building at the World's Columbian Exposition as well as the Bank of Pittsburg and the Wisconsin State Capitol, answered Gilbert's question about whether the "ordinary charge of the [architect's] profession of the 5% commission on both sculpture and decorative painting" was just. Post defended the policy, citing the large amount of decorative work done in his practice and the amount of time it took: "I can only say that there is no part of the work connected with building that has required as large an expenditure of my personal time as Architect to secure a proper result as in the work of sculpture and mural decoration." On mural painting, he was even more emphatic: "If the architect does not give the matter constant and unremitting attention during the whole progress of the work from the making of the original sketches to the completion of the paintings on the walls the result as a whole is inevitably disastrous, the work does not hang together and it is entirely unsatisfactory."[22]

The precise sequence of when and how the paintings were applied to their architectural support varied. If the painter was lucky, he was hired at an early stage and had a chance to visit the site before he was called upon to submit sketches of preliminary designs. In some cases, as in the Walker Art Building, the artists had to fit their ideas into preexisting spaces, but at least they had the opportunity to view them. Often the site was not finished and muralists had to work primarily from architectural drawings. Then the artist received copies of the architectural plans, the dimensions of the space to be decorated, and the distance at which it would be viewed. Perhaps he would also receive samples of paint or pieces of marble. Sometimes, as in the Pennsylvania State Capitol at Harrisburg, the dimensions would be changed and the artist (Abbey) would have to begin again. Other times, like at the Minnesota State Capitol at Saint Paul, the artist (in that case, Simmons) would be given the wrong dimensions and had practically finished before he had to begin again; or after the artist was finished, as in the case of Puvis at the Boston Public Library, he would find that the color scheme was different than he had thought. It seems that only an artist with the reputation and clout of John Singer Sargent could demand substantial alterations to the spaces he was hired to decorate. In the Boston Public Library, Sargent moved and altered the appearance of the moldings to restructure the viewer's experi-

ence of his mural cycle. In the Museum of Fine Arts, Boston, the walls surrounding the stairs were completely redesigned to his taste.[23]

Sargent was the grand exception. Often the muralist worked in a space that was neither large enough to include his entire canvas nor for him to get a good distance from it. When Robert Blum painted his two decorations for the Mendelssohn Glee Club in New York, *Moods of Music* and the *Vintage Festival,* he could unroll only one-third of his canvas at a time in his studio. Obviously the scale in a small studio could be skewed, and it was difficult to get a true sense of how the decoration would look. Cortissoz wrote of the problem that a muralist like Blum had, working in a room one-tenth of the size of the interior that the mural would decorate so that "the figures magnified to proportions beyond those which they will assume."[24] Even with the use of such modern devices as lantern slides to project cartoons onto the larger surface, the problems of distorted scale were difficult to overcome when, as was most often the case, the mural was painted in the artist's studio not in situ.

When the mural was finished and sent, most muralists hoped be present to supervise its installation. Blashfield and Cox seem to have been particularly conscientious about visiting every site, but this was not always possible for the muralists. Some sent emissaries. La Farge, for example, sent his secretary Grace Barnes to Saint Paul when his murals were attached to the lunettes in the supreme court there. When the artists did not visit, often criticism focused on the mural's lack of decorative unity with its surroundings. For example, the colors in Mary Cassatt's *Modern Woman,* for the Woman's Building at the World's Columbian Exposition, "were seen as too intense, clashing with the overall ivory and gold tonalities of the interior," while the wide border was "too strong a framing device."[25]

An artist able to travel to the site could sometimes make necessary adaptations. Abbey, for example, found that the multitude of holes in the *Quest for the Holy Grail,* made by nails that had held the canvas in place in his studio, oozed the white lead that had been applied to the back of the canvas as an adhesive. As to color coordination, ideally the muralist would have correctly keyed the major tones and shades of his decoration to the marble or other material of the site. Alexander, in his Carnegie Institute murals, painted green and red accents to match the marble. Simmons's murals under the dome in Saint Paul are predominately blue to coordinate with the blue molding around the paintings. Abbey designed much of the architectural molding in the interior of the Pennsylvania State Capitol and painted his lunettes under the dome in red, blue, and gold to echo

Although Puvis has since been closely identified with symbolism in France, in the United States it was his technique, more than his content, that was followed. It was enough that Puvis's subjects *appeared* to embrace profound ideas, universalizing and arcadizing such notions as work and leisure, the arts and culture. Frank Fowler later spoke of a "cult of Puvis," and during the early years of the movement in the United States this description was very apt.[37] Even the supreme classicist Cox painted his *The Arts* and *The Sciences* in the Library of Congress in the pale tones of Puvis. Other artists at the Library of Congress, especially Melchers, were even more indebted to his aesthetics.

Pauline King, who chronicled the early part of the mural movement in her groundbreaking *American Mural Painting* (1902), was in thrall to Puvis and his decorative principles. King said that to Puvis "the composition must be adapted first of all, to the place it is to occupy when completed, and to be adapted so perfectly that the public cannot imagine, the main idea being accepted, another arrangement for the ensemble and another grouping for the figures."[38] She wrote that the principles of decorative art "may be described baldly as resulting in a manner of execution that does not attempt to disguise the fact that the painting is on a solid wall and a level surface, and which works toward the end of perfect harmony in design, color, and form between the finished picture and its architectural environment."[39] For example, at Rouen there is no one-point perspective in Puvis's staircase mural *Inter Artes et Naturum* (fig. 25). A series of trees, as well as the figures in the foreground, are vertical accents that anchor the foreground to the picture plane and create a rhythm that leads the eye across, not into, the painting.[40]

Puvis's subjects were allegorical, or symbolic in the widest sense. In the Rouen mural and in *Sacred Grove* at the Sorbonne, the figures do not stand symbolically in a one-to-one relationship to a complex allegorical program. It is more the mise-en-scène: it is the arcadian simplicity of the figures' garb, the peaceful landscape, the lack of complex architecture or cultural context, the figures' poses and activities that convey the allegory. Although the overall subject is important, many of its components seem iconographically, although not formally, arbitrary and interchangeable. Aimée Brown Price, who has written extensively on Puvis, describes his decorative aesthetic as functioning "to create a sense of physical insubstantiality and psychic distance. It thereby enhances the significance of certain subject matter, helps suggest various levels of signification, or produces some ambiguity of meaning which exerts its own peculiar attraction and, too, may serve the interests of the subject matter."[41]

Despite sometimes complex allegorical pro-
grams, beaux arts muralists asserted time and
again that their subjects were not as important as
the design and color, and Puvis was the source
often quoted for this approach.[42] One critic com-
pared Blum's Mendelssohn murals (fig. 26) to Puvis
in this regard: "structural lines are carried out in so
subtle a way that they are felt rather than seen, the
space is admirably balanced, and the whole alive, full, significant in masses and
details, heads, figures, patches of sky as well as of ground. In a decoration the
subject chosen seems almost of secondary importance when this most essential
result is achieved."[43]

*25. Puvis de Chavannes, reduced
version of Inter Artes et Naturum in
Musée des Beaux-Arts, Rouen, c. 1890–95.
All rights reserved. The Metropolitan
Museum of Art, New York, gift of
Mrs. Harry Payne Bingham, 1958. (58.15.2).*

The architect Russell Sturgis expressed the same opinion about mural paint-
ing when he wrote:

> If one has a wall to decorate, the first idea of the true decorator is to invest
> it with splendor or with delicate strength of color. . . . Little may he care
> what the subject of the painting or mosaic may be. According to the re-
> quirements of the epoch of community in which he lives, it may be a pro-
> cession of saints or a dance of bacchanals; the primary object which he has
> in view is to procure a most enjoyable and delightful piece of color—and
> other things are of secondary importance.[44]

To an extent that has rarely been acknowledged for artists who were basi-
cally conservative and academic, muralists at the turn of the century were for-
malists. Believing that the muralist was primarily responsible for beautifying the
architectural space, they were concerned more with color and design than sub-
ject. In fact, reading contemporary accounts by the muralists and their critics is

26. Robert Blum, detail of *Moods of Music*, Mendelssohn Concert Hall, New York City (now owned by the Brooklyn Museum of Art), 1895. From Blashfield, *Mural Painting in America*, opp. 60.

often to find echoes of the radically formalist stance of other late-nineteenth-century artists such as Paul Gauguin or Maurice Denis. William A. Coffin, the critic and former student of Bonnat, for example said in 1896 that before anything else the decorations in the Library of Congress are "spots of color."[45] Cox wrote a thirty-page manuscript on "The Making of a Mural Painting" in which he did not mention subject or content. Such ideas, recognized as formalist or protomodern when coming out of more progressive mouths, were the expression of a widespread appreciation for decoration among a broad spectrum of artists, American and European, conservative and progressive, in the late nineteenth century.[46]

What distinguished the muralists in this country from their progressive French contemporaries, however, was that the aim of all this harmony and color was often discussed in terms of "beauty." For example, one anonymous critic in 1896 stated that "the end of art is, first of all, to beautify something, and only secondarily to represent something."[47] Speaking of Blashfield, Homer Saint-Gaudens, the sculptor's son, stated that a work must first have beauty and then may have significance.[48] Beauty could mean myriad things, but richness of color and simplicity of design seem to have been its most important characteristics. This aesthetic orientation was reinforced by this generation's exposure to the works and philosophy of Whistler, who also advocated placing formal qualities over subject and whose devotion to "beauty" in art was legendary. "Beauty" became a major aspect of the rhetoric of mural painting. Cortissoz argued that Blashfield thought his art was "forever enlisted in what he called 'the fight for beauty'—beauty of form, color, relations, proportions." The construction of decoration as equated with beauty, with allegory and with femininity, soon became understood.[49]

The decorative aesthetic that Puvis's murals embodied was fully in place by the mid-1890s. The murals by Puvis and Abbey in the Boston Public Library provide case studies in the attitudes of critics. The criticism of not being sufficiently decorative (i.e., not creating a relatively flat surface that echoed the design elements of the architectural space) was aimed at Abbey's *Quest for the Holy Grail* (fig. 27) in the book delivery room. Abbey, although an expatriate in London, was close to many of the major players in the mural movement, including Blashfield and Sargent. He was known for his illustrations—carefully delineated costume pieces full of color and movement. Before the Boston commission, he had done only two works in oil, although one, *Bowling Green,* was a decoration for a Manhattan hotel.

27. Edwin Austin Abbey, from *The Quest for the Holy Grail,* Boston Public Library, 1895–1902. From *The Craftsman* 16 (April 1909): 8 (location misidentified in the caption).

The Holy Grail was painted as a series of fifteen panels—fifteen episodes—that spanned the entire perimeter of the room. The panels were set apart from each other with moldings. An interpretation was written by Abbey's friend Henry James in 1895, probably after James saw the decorations in England. A more extensive exegesis was published in 1904 by Sylvester Baxter so that the viewer could follow the story in word as well as pictorially. Abbey himself said that his idea was to "treat the frieze not precisely in what is known as a decorative fashion but to represent a series of paintings, in which the action takes place in a sort of procession (for lack of a better word) in the foreground. The background is there all the same but I try to keep it without incidental interest. Galahad's figure, in scarlet, is the brilliant recurring note, all the way round the room."[50]

Abbey's choice of a medieval subject was unusual in the beaux arts mural movement, which overall had a classicist bent. Later examples by other artists were usually rooted in history, not literature; King John and the Magna Carta, for example, became a popular subject after 1900. Abbey was following the same preferences that directed many of his illustrations. What the critics found fault with—and this is indicative of the strong decorative orientation of the early mural

movement—was not the medieval subject in a building whose inspiration was decidedly the Italian Renaissance but the inclusion of narrative, which they believed counter to decoration.

The critic for the *New York Herald Tribune,* Royal Cortissoz, found Abbey's decorations "wholly suited to please because they are decorative"; he admired the way "they seem to grow out of the spaces in which they have been placed."[51] In this opinion, however, Cortissoz was in the minority. Even though Abbey seemed at pains to keep the action of the decoration close to the surface of the picture plane, others found both the narrative and the illustrative style incompatible with the aims of decoration. Isham, an artist and author of a survey of American painting (1905), complained that "the effect was felt to be not so entirely and completely satisfying as that of the other work in the library." He called attention to its "disquieting effect"—that it was not flat like a tapestry "but had atmosphere and depths of transparent shadow as pictures should, but as decorations, as a rule, should not."[52] Garnsey, who often worked as supervisor of secondary decoration (notably at the Library of Congress and the Minnesota State Capitol [fig. 24]) said that the frieze was divided arbitrarily. Caffin also found fault with Abbey on this account: Abbey had ignored the function of the frieze, "which is to counteract the various interruptions down below of windows, doors and fireplaces by an effect of continuity and unity, and whereas he might have treated the space as a continuous whole or obtained a similar effect by dividing it into a series of panels that should succeed one another in a rhythmic sequence, has chopped it up into a variety of different measurements."[53]

In contrast, Puvis's murals, which were not thought to be his best work, mainly since he was too ill to travel to Boston to view the site, were nevertheless praised for their decorative principles.[54] He painted panels that were installed on the landing of the main staircase, the kind of space he was familiar with from Amiens, Rouen, and Lyons: *The Muses Welcoming the Genius of Enlightenment* (fig. 28). Leading up to this work were panels devoted to poetry, philosophy, history, and the sciences. The writer and aesthete Ernest Fenellosa found Puvis the antithesis of Abbey, but he blamed both for their shortcomings. Abbey leaned too far toward the "pictorial," a word often used as the opposite of decorative since it implied the illusion of a three-dimensional space and sometimes a narrative. But while Abbey was too pictorial, Puvis was devoid of deep thought. He summed up their relation by saying that Abbey went too far toward expression and Puvis too far toward decoration.[55]

With Puvis in vogue early in the mural movement, often the colors of mural

28. Puvis de Chavannes, *The Muses of Inspiration Hail the Spirit, the Harbinger of Light* (a.k.a. *The Muses Welcoming the Genius of Enlightenment*), Boston Public Library, 1895–96. From King, *American Mural Painting, 95.*

paintings were pale. The paintings by Blashfield, Cox, and Melchers in the Library of Congress were in the pale tonalities of Puvis. There were naysayers among the muralists, however, when it came to such pale color. La Farge, interestingly, given his direct knowledge of and friendship with Puvis, always painted in a richer and at the same time more naturalistic palette.[56] Cox was early attracted to Puvis, but then began to believe that his pale tones were not suited for the ornateness of American beaux arts architecture; instead, he turned to the Venetians as models.[57] In preparation for his Walker Art Building mural, *Venice,* Cox traveled to Venice in 1893 to soak up the atmosphere. There he developed an appreciation for Veronese, who along with Titian and Giorgione became his role models.[58] But he was not consistent, returning to the tones of Puvis for the Library of Congress, perhaps because he was in the midst of many artists, but then backtracking to Venetian color. It is interesting that both the most naturalistic and the most classicist of beaux arts muralists rejected Puvis. Puvis's mannered figural style and overly pale tonalities were ultimately not up to the boisterous strength and rich coloration of beaux arts murals in the United States.

Even more than color, however, it was the design of the mural that unified it with its architectural surroundings. King stated that "the special points to be observed by the decorator may briefly be noted as the choices of pattern, design, or composition which shall, in line and mass, have a particular fitness for the architectural position."[59] To accentuate the design, the muralists often created a bold contour line around their figures, not always visible to the naked eye but clearly present with the aid of binoculars. These contours assured that the figures would be distinctly readable from a distance. They also created a pattern, or rhythm, across the surface.

The artists also used other decorative devices to lead the eye across the canvas. In Blashfield's *Evolution of Civilization* at the Library of Congress (fig. 54), it was the wings on each figure, overlapping to form a ribbon of white. His composition for *Minnesota, Granary of the World* in Saint Paul was praised for including a cord in the hands of the symbolic figures, the "graceful Sylphs"; the cord literally tied the figures to the center figure.[60] For *Westward* (fig. 46), Blashfield wrote a long explanation of how he had achieved a decorative composition:

> Considered technically, the dominant motive . . . is the festoon or Roman garland. This is carried out by the planes of light color commencing at the top with the group of spirits, carried downward by the white bodice of the girl gathering flowers, onward through the mass of light in the center, to the white overdress of the girl leading the child and finally toward the right and upward, in the figures of the farmer girl and the spirits of Steam and Electricity. The dark accents in the composition are furnished by the three men grouped together and the skirt of the flower-gathering girl.[61]

Blashfield usually avoided the creation of an overt narrative. Narrative, with its usually attendant three-dimensional space, threatened the unity of the mural with the architecture since it was perceived as punching a hole in the wall, and hence undecorative. Even paintings that were not technically narratives but that nonetheless were perceived as being in historical sequence walked a fine line between decoration and illusion. Alexander's lunettes at the Library of Congress depicting the *Evolution of the Book* (fig. 29) were cited as too "illusionist." In those panels, a figure in the foreground usually established the picture plane and the space moved rapidly back in depth so that the viewer's eyes were drawn sharply back. One critic noted that "Mr. Alexander is not essentially a mural painter, and he does not express himself naturally in decorative compositions. His panels were painted not so much with relation to their architectural setting as in relation to

29. John White Alexander, *The Manuscript Book,* from *The Evolution of the Book,* Library of Congress, Washington, D.C., 1896. From King, *American Mural Painting,* 187.

each other and as a result they are most satisfactory when considered as pictures rather than decorations."[62]

Most important, *decorative* was synonymous with figures that were ideal, allegorical, or symbolic —which in essence implied a lack of narrative. A symbolic, ideal, and decorative composition, much more often than historical scenes, played itself iconically across the foreground and used formal elements to echo the architecture. Not coincidentally, "decorative" or "ideal" works, with their two-dimensional compositions, included more female iconic figures, whereas historical scenes, which tended more toward the three dimensional, most often imaged males. Women could function as decorative elements in a way that men in late-nineteenth-century America could not.[63]

SHAPES AND COLORS

One of the first and most important considerations for a muralist upon receipt of a commission was the shape of the space that was to be decorated. Shape was seen as partially determining whether a work would be ideal or historical. The most common were the semicircular lunette and its smaller sibling the

30. Edwin Blashfield, "Showing Various Shapes of Panels", 1913. From Blashfield, *Mural Painting in America*, opp. 6.

From a photograph, copyright by Curtis & Cameron

See illustration facing page 14

I. Wide pendentive.

II. Narrow pendentive.

III. Depressed lunette.

IV. Portion of collar.

V. Lunette.

VI. Square.

VII. Dome crown.

VIII. Rectangle with rounded ends.

tympanum (always semi-circular in these beaux arts buildings), but there were also rectangular panels, domes, dome collars, tondos, friezes, and pendentives of many shapes and sizes. Obviously, different shapes required different treatments.

The first shape and location that many of the muralists experienced was the dome. Many of them cut their teeth at the Manufactures and Liberal Arts Building at the World's Columbian Exposition, where the eight sail-vaulted domes (each resembling a sail with four fixed corners) were by far the most common commission. It may have been lack of experience, reinforced by beginner's trepidation, but most of the dome designs there were pedestrian. Each artist chose four figures, usually female, which were placed in the four corners of the dome (fig. 53). The artists varied their poses slightly and gave each a different attribute to express their meaning. In most cases, the center of the dome seems to have been left blank, as it was in the baroque period, to create the illusion of opening up to the heavens (Blashfield even painted birds flying across the sky).[64]

After Chicago, Blashfield received the commission for the dome collar and crown at the Library of Congress, which was the most visible and important space in that building. He painted the *Evolution of Civilization* as a series of twelve figures, male and female, representing the great societies and epochs of the past and their major contributions to Western civilization. He created a decorative rhythm that reinforced the circular direction of the dome collar by carefully repeating certain elements—the cartouches that identify the figures are topped by palms, the streamer that lists their contributions, and the wings and painted mosaics that form the background. Not visible to the naked eye but clearly to be seen in the studies were strong contours that made the forms stand out even from a great distance; these contours further reinforced the decorative rhythm. The figures were unified with the architecture in the way their verticality reinforced the ribs, and their seriality and motif repetition, especially of vegetation and stone blocks, echoed the circularity of the dome. By making those four figures frontal and dressing them in lighter clothing, Blashfield also oriented the dome's cardinal points.

The Library of Congress commission seems to have made Blashfield something of a dome specialist, and he later painted the dome crown of the Wisconsin State Capitol with a symbolic representation of the state. In addition, he became the most important painter of pendentives. In the Essex (Newark), Mahoning (Youngstown), and Hudson (Jersey City) county courthouses, he painted massive female figures as Wisdom, Mercy, Power, and Knowledge (in Newark), Law in

different eras (in Youngstown), and Fame holding medallions of four men from New Jersey's history (in Jersey City). Blashfield used various devices to accent the much wider space at the top than at the bottom of the pendentive. For example, in Jersey City he used the wings of the figures of Fame; in Newark, atop the Virtues he painted banners identifying the figures.

Simmons's pendentive murals beneath the dome of Gilbert's Minnesota State Capitol are the site of an unfolding symbolic narrative, *The Civilization of the Northwest* (figs. 45, 62). In shape, the panels are a cross between lunettes and pendentives. When given the same kind of space at Post's Wisconsin State Capitol, Cox found a different solution: he designed four mosaics, representing *Legislation, Justice, Government,* and *Liberty,* closely aligning each in pose and gesture. Both solutions respected the architectural site. Simmons's figures stay close to the picture plane and, although they depict a sequence of symbolic episodes, move the viewer's eye around the dome. Cox, on the other hand, accentuated the solid mass of the arches in Post's rotunda at Madison.[65]

Other artists painted round medallions in the pendentives, punctuating instead of echoing their shape. Edward Simmons painted four female goddesses in circular medallions on the pendentives under the dome in the South Dakota State Capitol, representing Venus, Ceres, Europa, and Minerva as different aspects of the state's identity. The goddesses were painted against a uniformly gold background, which matched the gold tints of much of the rest of the dome. Each of Simmons's compositions contained white, but they were also accented variously by red, yellow, blue, or green. Different from the rigid verticality in Abbey's figures in a similar location under the dome at Harrisburg, Simmons used some compositional line in each medallion, such as the curve of the back of Venus's body, to reinforce the circular nature of his chosen format. This compositional unity was further enhanced since that circular line, the half circle, was the mirror image of the curved line of the arch.

The background of both Abbey's and Simmons's circular medallions was gold, a formal device that relates them more to medieval art, with its hierarchical flatness, than to the more naturalistic colors and background of the Renaissance. As seen in the *Holy Grail* murals at the Boston Public Library, Abbey often directed his art toward medieval sources. Simmons was more typical of the movement as a whole at this late stage in its development. A few, like Cox, stubbornly clung to the letter of Renaissance sources or, like Millet, developed a unique, nonfigural iconography rigid in its archaeological accuracy. But others took the color and design of the architecture as a cue and then played with the possibilities.

31. Kenyon Cox, *Venice,* Walker Art Building, Bowdoin College, Brunswick, Maine, 1894. From King, *American Mural Painting,* 163.

The lunette was the most decorated shape. It was common in grand interior spaces and was sometimes seen in a rotunda, as in Harrisburg. Mostly it was to be found in courtrooms and assembly chambers for the state houses and senates, libraries, and banks. Some artists painted a procession, as Millet did in *Thesmophoria* in the Bank of Pittsburg and Melchers did in *Peace* and *War* in the Library of Congress. But not everyone agreed that processions were appropriate to lunettes. Garnsey, the decorator, believed that "the lunette form especially demands balance of pattern and stability of design. Its decoration should not appear as a procession that moves across it, emerging apparently . . . from the frame at one side to disappear at the other."[66]

As Garnsey implied, a composition that turned the eye toward the center, the highest point of the work, was often preferred to a procession. This frequently required a central iconic figure to pull the composition together. The tallest figure or the one standing most upright in the center encouraged a hierarchical reading since it was the figure to which others related, usually in a symmetrical arrangement, the left mirroring the right. This was a favorite approach of the most academically and classically aligned artists—Cox, Vedder, Mowbray, and Blashfield. Invariably, the central figure was a monumental female (representing, in Cox's work, for example, Venice [Bowdoin] [fig. 31] and an Art or Science [Library of

Congress] [fig. 55]), and the rest of the figures were grouped in a precise sym-
metrical arrangement around her. In Cox's *Venice,* the central figure represented
Venice, the Renaissance city; of her two foci, Mercury, representing Commerce,
was on her right, and Painting was on her left, all against a shallow background,
with sails in the left background and a winged lion in the right background.
Commerce and Painting literally tilt toward or look toward Venice.

This kind of arrangement, symmetrical/rigid, harmonious/ unimaginative,
balanced/frozen was the paradigm of an academic composition. Cox would
continue this compositional arrangement throughout his career. His *Contempla-
tion of the East* in Saint Paul, *The Beneficence of the Law* in Newark, and *Light of
Learning* in Winona, Minnesota, all had a central female figure, identified re-
spectively as Justice, Law, and Learning, with one or more figure on either side,
each of which was given an identity that contributes to the overall interpretation
of the allegory. Vedder, a former student of the French academician François
Picot, himself a student of Ingres, also favored highly balanced compositions.
His *Rome,* at the Walker and his five lunettes at the Library of Congress all fea-
tured symmetrically placed females to which the other figures related, each care-
fully echoing the poses of their adjunct on the other side of the composition. In
Rome, the central figure, Nature, is accompanied by Knowledge, Thought, and
Soul on her right, and Love, Color, and Form on her left.[67] This composition
was Renaissance in its allusions since it referred to the Sacra Conversatione: the
usually centered and enthroned Madonna and child commune in silent reverie
with the saints on either side of them. Other academically inclined artists such
as H. Siddons Mowbray, Low, and Blashfield variously used this format.

Of the lunettes, La Farge's decorations were in a class by themselves, in both
design and subject. He eschewed the precise symmetry of artists like Mowbray
and Cox and often painted a deeper, more naturalistic space—for example in
murals such as *Drama* (fig. 40) and *Music* at the Whitelaw Reid home in New York
and in the *Ascension* in New York's Church of the Ascension. In *Athens* (fig. 9) at
the Walker Art Building, a half-draped figure, perhaps Nature, was slightly off-
center, turned to face the standing figure of Pallas Athena on the left; on the right
sat a personification of Athens, creating a relatively asymmetrical composition.

Even more so in Saint Paul, La Farge's designs on the history of law for the
supreme court (fig. 16), while still respecting the integrity of the architecture,
especially through color, were varied each to each in terms of composition.
La Farge did not hesitate to create striking landscapes behind the main figures.
In *The Recording of Precedents,* for example, Confucius is off-center and the figures

32. John Singer Sargent, *The Dogma of Religion* and
The Frieze of the Prophets from *The Triumph of Religion,*
Boston Public Library, 1895.
From King, *American Mural Painting,* 125.

in his Library of Congress panels, which were similarly tall and narrow, to ac-
commodate one figure.[74] It is when a panel is rectangular, however, that the
most compositional and iconographic variation is found. Although it was gener-
ally thought that the rectangular panel was best for historical scenes, some per-
sisted in creating symmetrical, ideal scenes when given that format; examples
were Cox's *Judicial Virtues* and Low's *Prosperity under the Law,* both in Wilkes-
Barre, Pennsylvania. Others compromised between the two approaches. In the
Cleveland federal building, Mowbray painted *The Common Law* (fig. 19) as a sym-
bolic reenactment of a historical evolution, with an imaginary meeting of one
lone workman and a royal figure in the exact center of the composition between

two imaginary columns. To left and right are the observers, and above is a fore-shortened angel.

Besides his dome commissions, Blashfield specialized in a compromise blend of the allegorical and historical or symbolic and contemporary, most often en-acted in the form of a rectangular panel. In the commissioning of murals after 1900, market indicators were in favor of history, and Blashfield responded to the change. *Washington Laying His Commission at the Feet of Columbia* (fig. 52) in the Baltimore courthouse was an early example. Columbia was in the exact center of the composition. Other allegorical figures accompanied Washington in the center space, which were divided off from the left and right sections by trompe l'oeil columns. Revolutionary and colonial figures were placed in the left and right sections, the poses mirroring each other, and a flag was decoratively placed in each section to frame the central scene.[75]

The most common use of the rectangular panel was for purely historical scenes, however. The rectangular panels in the governor's reception room in Saint Paul (fig. 33) were all devoted to historical subjects. Gilbert, in recommending Douglas Volk for one of the commissions, said "he would not be the man to employ on decorative painting like Mr. Blashfield or Mr. La Farge, his work being more distinctly pictorial."[76] By the time of the Saint Paul commission, Millet, whose mural work changed dramatically over the course of his career, from wholly decorative and allegorical to strictly historical and documentary, preferred to place himself with the historical wing of the movement. He wrote to Gilbert that he would prefer that his panel for the governor's reception room, *Treaty of the Traverse des Sioux,* be hung as a historical picture instead of being "maroufled"; that is, he preferred that it be stretched and framed instead of glued into place.[77]

Since historical scenes were most often in the form of narratives, the artist was careful to retain the two-dimensional orientation favored by the decorative aesthetic. A typical composition in a rectangular panel by Turner, *The First Trial in the County,* at the Mahoning County Courthouse in Youngstown, showed the figures in a shallow space aligned close to the picture plane. Other artists—for example, Robert Reid, who painted the *Five Senses* at the Library of Congress—tried to adapt their decorative principles to the painting of history. The assign-ment for the Massachusetts State Capitol in Boston, "James Otis Arguing against the Writs of Assistance" (which became the title for Reid's work; fig. 47), was one that other muralists found unpromising for decoration: Thayer, Walker, and

33. Cass Gilbert, governor's reception room,
Minnesota State Capitol, Saint Paul, c. 1904.
Courtesy of Minnesota Historical Society.

Simmons had turned the assignment down.[78] Reid, too, was flummoxed by the
subject until he was given an account of the incident by John Adams. He zeroed
in on two details he found striking in Adams's account: that there was a fire in
the council chamber and that the judge was dressed in scarlet. He unified the
fire in the grate with the red robes of the judges.[79]

The move toward history went hand in hand with the move away from the
decorative aesthetic of Puvis. William Walton reported in 1908 that "the primal
theory of not making a 'hole in the wall' with your painting has somewhat lost
favor."[80] Blashfield, in his 1913 book *Mural Painting in America,* said that his con-
temporaries had made the mistake of thinking Puvis's method, "admirably
suited to certain kinds of building, was suited to every kind—that it and it only
was decoration."[81] Some of the most stylistically innovative and un-Puvis-like
artists were those who indeed pushed the eye deep into space, in tune with com-

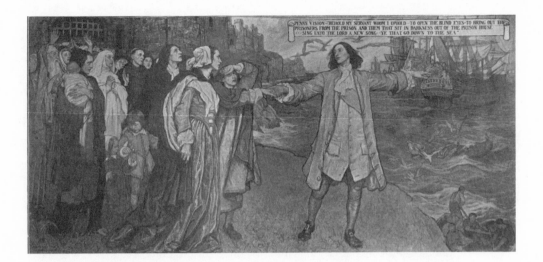

34. Violet Oakley, *Penn's Vision*
from *The Founding of the State of Liberty
Spiritual,* governor's reception room,
Pennsylvania State Capitol, Harrisburg,
1906. From Blashfield, *Mural Painting in
America,* opp. 200.

positional changes that had come from the Impressionists and ultimately from Japanese prints. Alexander's *Evolution of the Book* in the Library of Congress; William Van Ingen's and Violet Oakley's (fig. 34) paintings at Harrisburg; Howard Pyle's compositions in Essex (fig. 51) and Hudson County Courthouses; and Millet's panels for the Cleveland Trust Company showed asymmetrical designs, sharp diagonals, radical foreshortening, and oblique angles.[82] Since they still retained the modeling and chiaroscuro that marked Western art, the overall flatness did not match Japanese prints. Neither, on the other hand, were they, like Puvis's mature aesthetic, obsessed with surface. Pyle's panels for the Hudson County Courthouse, for example, moved deep into the spatial background to depict old Manhattan and New York Bay. The counterreaction against Puvis's decorative aesthetic was part of the move from allegory to history, from universal to local, and from ideal to the tangible. But while the former reigned, it reigned near supreme.

The cult of Puvis reinforced the subordinate relationship of painter to architect. As Caffin noted in his gendered division between architecture and painting, the relationship was as man to wife. In the separate spheres still very much in effect at the turn of the century, women were supposed to act out a support role in the home, not questioning the direction in which the husband led the family. They were simultaneously the managers of the household, responsible

for its smallest details, yet also its moral exemplars, responsible for holding up the ideals of individual and family.

If the aim was to be perfectly integrated into the architecture, to achieve a seamless harmony, to reinforce its stability, then not only the architecture was being sustained but the principles it embodied. If the space was in a private home or a semipublic space like a hotel or theater, then a more festive and seemingly less ideologically oriented iconography was permitted. But most of the major mural commissions were public ones: libraries, capitols, courthouses, federal buildings. Whether the subject was allegorical and ideal or historical and real, it reinforced the democratic, imperialist, or capitalist ideologies that the architecture embraced and celebrated. The concepts could be antimodernist or antiprogress; the murals held up the ideals already in place that had produced the building—the architectural symbol of order and stability, whether it was statehouse or courthouse. But at the same time, they were grand and rich, showpieces on the level of architectural display preferred by the wealthy in Newport and New York (depending on one's politics, the "robber barons" or the "merchant princes"), giving a lushness and ornateness to democratic institutions that bespoke confidence and pride. This decorative orientation was used by the artists not to dissemble but to reinforce the prevailing social and economic ideologies that supported their work.

5 | DEMOCRACY, EDUCATION, AND COMMERCE

That He Who Runs May Read

MOST BEAUX ARTS MURALS IN THE UNITED STATES WERE commissioned for public spaces like courthouses, state capitols, town halls, libraries, art museums, and banks. When an architect favored adding mural decorations, the decision to commission them was sometimes easily made by those with the funds: state legislatures, building commissions, and boards of directors. More often, however, because of the added cost and the ambivalence of many in the United States toward the arts, especially government patronage of the arts, architects, muralists, and other advocates had to sell the idea of mural decoration. Favorable arguments supporting murals included the inherently democratic nature of mural decoration, its enormous potential as an educational tool, and its function as a commercial asset. To what end the public was being educated, however, was not always easy to determine. The possibilities included everything from morality to taste to patriotism to investment. No matter what the purpose of a mural, however, its accessibility, scale, and readability were always given as a reason for support of funding. These justifications for mural decoration yield a clearer understanding of the form, function, and content of beaux arts murals in the United States.

that the "material necessity of defining our nation's civic importance" had given the artist the right to be numbered with others "long since accepted as useful members of our social fabric."[14]

It could be argued that Low's insecurities and rationalizations were part of a larger discourse about the feminization of culture in the United States. In fact, in the days before women's suffrage, *democratic* was coded as an appeal to an expanded masculine audience. In other words, the "useful members" were not the upper-class females who decorated drawing rooms (and attended art exhibitions) but the male movers and shakers who operated in the public sphere of law courts and other government buildings. The constant references to the democratic nature of mural art were directed as much to males of Low's class and society as to another "public" that included less-educated classes—whose members, male and female, already were "useful members."

Nevertheless, the constant references to accessibility suggest that the artists really did want to attract a larger audience beyond their class and the cultural elite. Furthermore, the emphasis often placed on the artists' ownership of copyright for their designs suggest that they wanted their works to be known far beyond the municipalities in which they were placed (and obviously for themselves to benefit financially).

Design legibility, content accessibility, and a desire to attract a wide audience must also be seen as factors in the widespread shift from allegorical to historical murals after 1900. National history was, after all, the history of the world's most successful democracy, establishing the foundation and rationale for everything from male suffrage to free-market capitalism. That males dominated its history and historiography also meant a break from a genteel aesthetic, an imported culture that preferred the idealized forms of allegory. The preference for history may also have given a leg up, in increase of mural commissions, to illustrators like Abbey and Pyle who had made their living from frock coats and hobnailed boots.

EDUCATION

Murals being democratic did not mean that, in any traditional sense, the wider public were patrons of the art. Public taxes paid for the mural decorations, but it was the state legislature (in Boston, for example) or the artists under the direction of the architects (in Saint Paul, Pierre, and Madison) who recommended

the subject or theme. Moreover, it was hard to convince elected representatives to appropriate funds for murals in the first place, and, aside from their democratic nature, it was their educational value that was most cited.

In the contemporary discourse, I detect an occasional note of patronizing condescension. By the late 1890s, when the majority of their patrons were public, not private, the muralists assumed that people could not be given "festive" works but needed art that was "educational" and "inspirational." (This was also a form of self-advertisement: as much as they may have believed that the goal of art was beauty, education was a better selling point.) To invest their public murals with an educational mission was to emphasize weight and stability over lightness and grace. In the United States, this was to increase their cultural status.

Blashfield, one of the movement's most fervent proselytizers, phrased his arguments touting the benefits of municipal art in ways intended to persuade government officials as much as to inspire the public. Although he truly thought he was working for the public good, his tone was often paternalistic. Yet there is no indication that he did not believe the words he was saying. In his speeches and published papers, Blashfield repeatedly mentioned the educational value of public art; it was, he said, a "public and municipal educator,"[15] and the decorated public building was "that great teacher of history, patriotism, morals, aesthetics."[16] Architect Cass Gilbert, writing to the chairman of the Board of State Capitol Commissioners in Saint Paul, voiced twin arguments in favor of mural painting that he must have used to convince many other public commissioners with whom he worked: "Nothing will give the building greater distinction or lend more to its educational value and to the advancement of civilization and intelligence of the state than its recognition of the arts as represented by the great painters and sculptors of the present day."[17]

What were the murals teaching? On one level, the public would be taught the importance for their lives of art itself. Mural painting could become a kind of advertisement for art, a way to penetrate the wall of apathy most Americans seemed to erect around much "high culture." This attitude is apparent in Crowninshield's early arguments about the value of murals and their possible locations. In the mid-1880s, he wrote that "for ages custom has sanctioned the painted wall of temple, capital and theater; but what glorious opportunities are offered by the walls of our colossal railroad stations, our public halls, our . . . hotels and costly restaurants, our vast stores! Paint them and the people would be brought face to face with art in the daily routine of life, and absorb it as children absorb a foreign language."[18]

Certain murals functioned directly as propaganda for the value of art in modern society. When artists painted a series of panels they assumed an evolutionary progression of civilization, often placing art at the culmination of the process. Cox's paintings for the Iowa State Capitol, *The Progress of Civilization,* provide an example: starting with *Hunting* (fig. 35), they evolve, through *Herding, Agriculture,* and four other stages, into *Art.* Abbey painted four gold medallions with females representing Art, Science, Religion, and Law at the Pennsylvania State Capitol. The series implies, if not a progression, an equal status.

Beyond teaching an appreciation for art, mural painting would teach an appreciation for beauty through its example. *Beauty* was a word much in evidence in the art magazines, critical reviews, and monographic articles in the late nineteenth century. In contemporary parlance, beauty elevated and spiritualized viewers and provided an alternative to the materialist cast of American society. The equation of mural decoration with beauty was a common theme in the early years of the movement, especially when "decoration," "ideal," and "symbolism" were privileged over "story," "literal," and "history." The critic Coffin argued the importance of the Library of Congress murals for "giving a strong impetus to the rapidly growing conviction that other public and private edifices should be made beautiful as well as convenient."[19]

The calls for beauty in art in the face of rampant materialism were neither consistent in their rationale nor perfectly linear in the transition from beaux arts to more modernist ideals. Contradictions abound. Blashfield's *Evolution of Civilization,* one of the murals most widely praised for its beauty, celebrated the United States' contribution as Science, symbolized by a very contemporary invention, the electrodynamo. Abbey's dome murals for the Pennsylvania State Capitol, which included ideal symbols of Science and Abundance, also depicted laborers in Pennsylvania coal mines, oil fields, and steel factories. But in those cases as in many others, the artists believed that they were offering a version of modern life that purified and elevated its grosser manifestations.

Most notably, the concept of beauty was integrated into the contemporary discourse about mural paintings as it was used by the advocates of the aptly named City Beautiful movement, which originated in the so-called White City of the World's Columbian Exposition in 1893. Murals and other manifestations of the movement—monumental classicizing architecture, sculptural decoration, straight axes, open vistas, grand, tree-lined boulevards—were supposed to provide an uplifting environment for the operation of government and business,

one that visually, literally, and concretely reclaimed the harmony, balance, and restraint associated with classicism.

35. Kenyon Cox, *Hunting* from *The Progress of Civilization*, Iowa State Capitol, Des Moines, 1906. Courtesy of the State Historical Society of Iowa, Des Moines.

Proponents thought that the harmonious architectural whole could not only signify but guarantee a harmonious body politic. The critic and artist Charles H. Caffin, reviewing the Municipal Art Conference in Baltimore in 1899, spoke of beauty's ability to "regulate individualism."[20] He believed that there had been little regulation or planning in cities and that individual buildings had arisen without regard for their surroundings. In another context, Caffin found that while individualism defined the American character, "Beauty" had the power to check the "progress" of cities. Caffin argued that U.S. cities were entering a "transition from individualism to civicism as the vital force"; he argued that public opinion must be enlightened to create the "first important step toward beautification of our cities."[21]

The moral effect of beauty that Caffin and other reformers cited was meant to rein in, regulate, and refine what were perceived as the gross excesses of American society; the crowding and ill-considered planning that rampant growth and commercial greed brought. In that way, municipal arts like mural painting were political, because they acted out a certain ideological stance: a conservative need to control and temper the untamed or foreign aspects of American life. As others

have noted, it is no coincidence that the City Beautiful movement flourished at
the same time as both the closing of the frontier and the greatest influx of im-
migration in U.S. history. In the Midwest, traces of the Native American culture
that settlers had so recently displaced would be literally erased by the built envi-
ronment of monumental classicism. In the East, the recent immigrant culture's
"Slavic" elements could be controlled by a rejuvenation of the classic spirit.
Refined taste, cool restraint, and the ordering of American cities were supposed
to create a harmonious whole from sea to shining sea.

Besides having a moral effect, the artistic beauty of murals was also touted
as spiritual inspiration. Like Caffin, Low often wrote about the spiritualizing po-
tential of art. Both men saw painting as an antidote for modern life's materialism.
Low (in another of his articles using the "he who runs may read" phrase) be-
lieved that murals in public places "will bring into your daily life a message of
spiritual aspirations which he who runs may read."[22] In another context, he said
he thought of the muralist as doing missionary work: if the painter is capable of
conveying meaning quickly through clarity of composition, then "a cursory
glance may carry away, if not its full import, enough at least to impart a leaven
of spirituality to a day of material preoccupations."[23]

Unfortunately, we do not have records of individual reactions to the murals
by the public that Caffin and Low claimed the muralists were trying to affect.
We don't know if immigrant readers at Boston's Public Library felt that Abbey's
Quest for the Holy Grail reflected their search for education or if his lunettes on
Pennsylvania's industries had any spiritual affect on a visiting coal miner; one
might easily doubt that a significant number of coal miners or oil diggers or
steel workers saw the murals, and further, that if they did see them, doubt that
his vision of their elevated task mediated their worries about safety conditions
or salaries. Such were some of the sad ironies of the movement, that although
the placement of murals was so often in locations that symbolized the power of
the democratic masses, they were rarely seen by them, and their concerns so sel-
dom matched the people they were ostensibly trying to attract.

The language of municipal reform crosses boundaries between many disci-
plines, from art and culture to housing and sanitation. An important aspect of
the City Beautiful movement was the building of public parks, which was a way
to control leisure, to direct it both literally and metaphorically along certain paths
and certain forms of sanctioned recreation. In their desire to cleanse, improve,
and elevate urban life, reformers often crossed the line between advocacy and
paternalism.

Nevertheless, the frequent call for the subjects of mural painting to be important—Law, Justice, or some historical scene, rather than music, dance, or some mythological episode—was significant. The muralists and those who commissioned them were trying to be relevant to contemporary concerns. Low, for example, said that "we painters must leave the commonplace and the trite; we must learn to distinguish in the complex and cosmopolitan civilization, where we find ourselves, the essential qualities which are at once pictorial and national."[24]

The *Craftsman,* echoing its frequent association of mural decoration and democracy, often advocated murals that were more relevant and responsive to a larger public audience than they had been in the preceding decade, when allegorical and abstract subjects were popular. The muralist and critic Charles Shean, believing history was the solution, said that wall paintings on public buildings "must have a purpose, decorative it is true but higher than mere embellishment in order to command public approval and justify the expenditure of public funds." A substantive article published in the *Craftsman* in 1906, "Mural Painting: An Art for the People and a Record of Our Nation's Development," championed the democratic nature of murals and argued for subjects that were relevant to the public: "[Mural painting] is essentially a democratic form of art, and the greater part of it must respond to the demands of the people." Easel paintings are for connoisseurs,

> but the paintings on the walls of public buildings are for the people, and to the people they appeal chiefly because of beautiful symbolism or valid recording of some historical event of which the nation or the state is justly proud. By emphasizing of this link with the bygone life of the community, the pictures acquire an historical as well as an artistic value, and have their place among the important records of a nation. It is simply another form of beauty that grows naturally out of some practical need.[25]

On an even more more practical level, mural paintings could instruct the public in national history, much as frescos had taught an illiterate medieval public the lessons of the Bible. The frequent calls around and after the turn of the century for murals to be more American often resulted simply in historical, especially colonial and federal era, subjects, rather than allegorical or symbolic themes. An article on Turner's Baltimore courthouse murals, for example, commented that his subject in his *Burning of the Peggy Stewart* (fig. 36), an episode from colonial Maryland, was not widely known, but that murals could instruct the public in such historical incidents.[26]

36. Charles Yardley Turner, detail of *The Burning of the Peggy Stewart*,
Baltimore courthouse (now the Clarence M. Mitchell, Jr.
Courthouse), Baltimore, 1905. From *The Craftsman* 9 (1905–6): 211.

Historical subjects seemed especially appropriate for high schools, perhaps because history, if compared with allegory, seemed to have a more concrete reality for students. An 1898 article in the *New England Magazine* recommended that schoolrooms carry murals celebrating "the virtues of fathers and hardships they endured," while subjects like Justice and Prudence should be reserved for courthouses and legislative halls.[27] New York's Municipal Art Society responded to that impulse. Its Committee to Decorate Public Schools, founded in 1902, was instrumental in having murals painted in two city high schools. When Charles Yardley Turner won the commission for two panels in the auditorium of DeWitt Clinton High School in Manhattan, he appropriately painted *Opening of the Erie Canal* and *The Marriage of the Waters* (fig. 37), depicting a historical scene in which Clinton poured water from Lake Erie into the Hudson River. The otherwise little-known Edward W. Deming received the commission for murals at Morris High School in the Bronx, where he painted *Treaty Between the Indians and the Dutch at the House of Jonas Bronck in 1642* and *Gouveneur Morris Addressing the Constitutional Convention* (1905). There was also a move to put historical murals in schools in Chicago. The Chicago Public School Art Society, founded by philanthropist Kate Buckingham in 1894, chose three students from the Art Institute of Chicago to decorate the North Side's Lane Technical High School with murals of a steel mill, a construction site, and a dock scene (1909–10).[28]

Murals in public schools could satisfy both the need to educate students about American society and help to socialize the immigrant populace. For those not fluent in English, the picture could teach more easily than words. The same *New England Magazine* article that recommended murals for schoolrooms noted that "with our immense area and enormous population, with a constant influx of ignorant immigration, we have a task in assimilating and educating the various elements of our people that is enormous."[29] An article on municipal art three years later in the *American Journal of Sociology* spoke of the function of art as education. Although the article assumed that art was analogous to beauty, the author seemed to think of municipal art mainly in terms of history lessons for a foreign populace: "Here in America, particularly needed because of our vast foreign population, how great may be the effect of this symbolic, impressive way of teaching some of the great facts of our land, its institutions, and its men!"[30]

The painter George Bissell, chair of the Committee to Decorate Public Schools, voiced the Municipal Art Society's belief that art was a municipal educator. He hoped that "in our schools as in the churches in Europe children can be given a chance to grow up under the influence of art and the sentiments

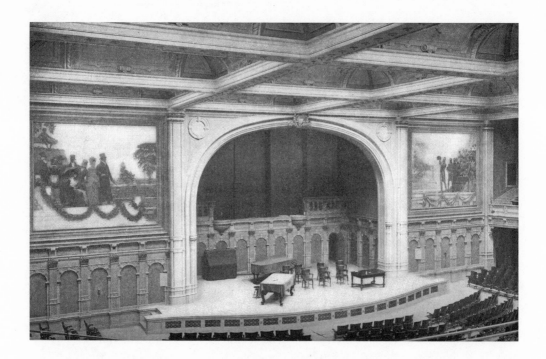

37. Charles Yardley Turner, *Opening of the Erie Canal* and *The Marriage of the Waters,* DeWitt Clinton High School, New York City, 1906 (moved to school's Bronx location). From *Review of Reviews* 34 (December 1906): 690.

expressed by it." At a time when a majority of New York schoolchildren were foreign born (in 1909 the figure was 70%),[31] Bissell echoed other City Beautiful reformers like Caffin when he pictured a "vast army of children" who would eventually go out into the world with tastes formed on correct lines and high ideals. Civic pride, "such an important factor in the success of a city, will then be the controlling spirit, and the era of ugliness, confusion and disorder with which the city has been cursed to date will give way to an era of good taste, convenience and personal comfort."[32]

The great deeds of past public figures could be an inspiration, could create the "high ideals" of art that reformers like Bissell sought. The critic Royal Cortissoz, speaking of Abbey's *Apotheosis of Pennsylvania* (1911), which depicts thirty-five of the great (male) historical figures from Pennsylvania on steps leading up to an allegorical figure of the state, said that "if there is any moral force in art, then *The Apotheosis of Pennsylvania* should help weightily in the making of a better state."[33] Low, too, spoke of the "moral effect" of murals: he believed that if art were present in law courts as well as museums, then it would become the prop-

erty of the people and they would eventually care for it as "a precious possession of their own."[34]

Others believed the importance of mural paintings in public spaces lay in their cultivation of civic spirit among the public. One critic spoke of Turner's Baltimore courthouse murals as a "constant incentive to patriotism." Historical murals such as Turner's were most often cited in this regard. An article titled "American History and Mural Painting" specifically said that "one of the ways to stimulate patriotism and a love of the national annals is to appeal to the eye through painting or sculpture having historic themes," which was especially true of mural painting. It cited the murals by Turner and Deming then in place in the two high schools in New York and ended by saying that historical subjects "may thus exert upon generations to come an influence for good citizenship and enlightened patriotism."[35] Even the vast number of murals depicting Justice or Law were meant to embody the virtues of a democratic society and to assert their value, which might be spelled out as "the Rule of Law" and "Justice for All." Thus murals were associated with democracy on two self-supporting levels: they are available to all and they teach the virtues and lessons of a democratic society.

However, some works portraying Justice and similar abstracted symbols were more ferocious than others, offering a veiled warning to those who would oppose them. Blashfield's *Law* at Cleveland and *Justice* at Wilkes-Barre were noticeably more vigorous and threatening than his previous allegories. At Cleveland, *Law* is seated impassively in the center of the composition as activity swirls around her, a woman begging for mercy and evildoers fleeing. In the background, among the great men who have paved the way for civilizing influences, are Moses and Justinian. At Wilkes-Barre, the personification of Law, who has "set up her judgment seat in the Coal Regions," hoists out a sword against evildoers; again, a woman throws herself at her mercy. In this composition, however, rather than great men of the past Blashfield paints working people of his day, some on the side of righteousness, some siding with evil.

Some thought that a vigorous municipal art could inspire municipal reform. One writer suggested that that by painting virtues like prudence and vigilance, art could be enlisted in the cause of overthrowing "the corrupt governments of our great cities."[36] Everett Shinn said that his mural in the city hall in Trenton, which depicted workmen in the city's two major industries, pottery and steel (fig. 38), showed the "grand and glorious work that makes the city and City Hall possible. Keep that before the men that sit in the Council Chamber and you keep the interests of the city ever before them."[37]

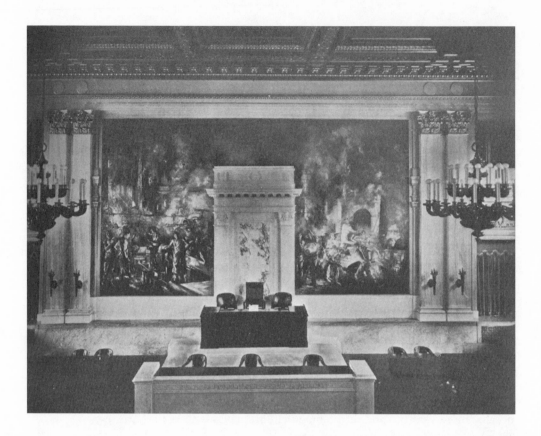

38. Everett Shinn, *Steel and Ceramic Industries,* Trenton City Hall, Trenton, N.J., 1911. From *The Craftsman* 21 (January 1912): 379.

It is perhaps not coincidental that other arguments for murals in public buildings favored the choices of American artists. Indeed, given that in the late nineteenth century, collecting habits were oriented toward European art, including the works of the academic teachers of American students, it is somewhat surprising how quickly American artists were able to gain a foothold in the mural movement. But the very public nature of that movement seemed to demand American artists: the explication of American civic values and historical subjects encouraged it. Europe had many muralists, but Puvis de Chavannes was one of the few from there to get a commission in the United States— recognition of his incomparable place within the European movement and the enormous respect American artists and architects had for him. Even then, everyone did not agree with the choice. A critic complained about Puvis's mural in the Boston Public Library that "as the requirements of mural painting in America are more deeply understood, it will be felt, we are convinced that great decora-

tion can only be painted by Americans, if not living in America, at least in touch with the country."[38] In fact, the only non-American to receive any substantial commission in the beaux arts movement after the turn of the century was British artist Frank Brangwyn, who decorated the Cuyahoga County Courthouse in Cleveland (1913) and the Missouri State Capitol (1917–22).

COMMERCE

Despite the high-flown language and sentiments, a good part of the muralists' task was to guarantee themselves continued work, and to do so they had to prove to public committees, city councils, building commissions, and the like that murals were worthwhile. They were in essence subcontractors on a government job, and they had to convince building commissioners and elected officials of the educational and inspirational mission of mural paintings. They also had to advocate the ideals and the ideologies that their bosses demanded—which invariably were socially, politically, and artistically conservative. The artists and architects, even without government oversight, supported the status quo. They were inclined by training and tradition to use appropriate subjects: Music for concert halls, Law for courts, local history for municipal and state locations. Perhaps reacting to the tenuousness of their position in American society, muralists were not going to embarrass their patrons, as Diego Rivera infamously did twenty years later when he painted Lenin into his Rockefeller Center murals. They advocated establishment values. For law courts, it was Justice; for the halls of the congressional library, Good Government; for county courthouses, peace and prosperity; for banks, prosperity and thrift.

Low acknowledged the dichotomy between the high rhetoric of mural painting and the language of salesmanship, and while being conscientious about adhering to the wishes of his private or civic patrons, he was always lobbying for his own art. In ringing terms, he argued that muralists must prove they had something to say, especially as the audience grew in sophistication:

> He has or will have to paint for the great public. He must meet with the man whose hand is at the outlet of the public purse, and must prove to him and to the tax paying masses behind him, that his art is a force which the wise legislator can employ. He must convince bank presidents that public confidence in the security of deposits will be stimulated by the presentation of fundamental truths upon their walls. He must show hardheaded

businessmen that their various enterprises can be so pictured that the public
of whom they seek support will understand at a glance the advantage which
they offer.[39]

Caffin, the critic, went even further. As a sympathetic reporter on the Balti-
more Municipal Art Conference in 1899, he voiced an argument often heard in
connection with the City Beautiful movement—that beauty has a market value
and that making cities more desirable would encourage commerce.[40] He articu-
lated this sentiment again in 1908, when he wrote that the World's Columbian
Exposition had taught "the desirableness and the commercial value of beauty.
The shrewd, large-minded citizens of a city that is essentially the product and
assertion of commerce, discovered that they could give expression to their own
local pride and attract business from outside, not only by following the old crude
idea of attempting 'the biggest show on earth' but by trying to make it the most
beautiful."[41]

Blashfield, one of the most articulate advocates of mural decoration, in 1899
wrote "A Word for Municipal Art," arguing for its educational value but also that
"down from this high mission of art to a level plane, we find that municipal art
has swelled the revenues of cities." He cited Renaissance towns like Assisi, whose
main tourist industry was its art. In places like Paris, art has permeated the fabric
of the city, "set to work in the interest of the trades and corporations of the city's
daily service, even of her places of amusement."[42] Blashfield wrote more bluntly
in *Mural Painting in America:* it was a shame, he said, that the first thought is "that
it shall not cost too much" since "beauty is a tremendous commercial asset."[43]
Such claims were common at the time, which is not surprising given that the
artists believed that they were participating in an American Renaissance.

As Low and Caffin implied, one of the most striking examples of the mu-
ralists' support of the economic and political status quo were their paintings for
banks. Not suprisingly, then, the idea that commerce and art were intertwined
was a frequent theme. Early on, Crowninshield recognized that the commercial
spirit, while it might sometimes offend, is the driving force behind art. He cited
the example of Venice and Florence,[44] and he mentioned banks as a fertile
ground for mural commissions.

The first major bank commission was the Bank of Pittsburg (Pittsburgh),
which commissioned murals from Frank Millet and Blashfield in 1897. Caffin
said that the Pittsburgh bank shared with the National Bank of Commerce in

New York the "honor of being the first to recognize that art and commerce may be combined to the advantage of both." He found that "in some respects it is a more notable testimony to the spread of culture even than a noble library, for it shows that the leaven of beauty is working in the very heart of our social organization, and that even where money making is necessarily the main motive, there is recognition that it is not mere money but what money can add to the dignity of life, that we are learning to desire."[45]

At the Bank of Pittsburg, Blashfield and Millet were commissioned to fill two lunettes in the large public banking room. Millet's *Thesmophoria* (fig. 13), a hymn to Agriculture in the form of a procession of white-robed, Athenian women, was somewhat anemic, but Blashfield's celebration of manufacturing, *Pittsburg Offering Her Iron and Steel to the World* (fig. 59), was a shameless advertisement for Pittsburgh's industrial might. Blashfield himself had said that banks, along with libraries and courthouses, were opportunities to celebrate the spirit of progress in this country.[46]

In Detroit, Thomas Dewing painted *Commerce and Agriculture Bringing Wealth to Detroit* (fig. 44) for the State Savings Bank building designed by Stanford White. In Cleveland, murals by Blashfield and Cox were commissioned for the Citizens' Savings and Trust Company (1902–3), whose new building had been designed by Hubbell & Benes. An enthroned figure of Prudence presided over Cox's *Sources of Wealth*. Prudence greeted the genius of Commerce, who in turn introduced Industries to her. Also in attendance were Manufactures, Agriculture, and Fisheries. The critic William Walton, writing about Blashfield's companion piece *The Uses of Wealth* (fig. 39) (its full title is *Capital, Supported by Labor Offering the Gold Key of Opportunity to Science, Literature, and Art*) was mouth-wateringly ecstatic with the result: "Capital—the sordid and unlovely 'Capital' of the demagogues and the statisticians—here appearing as a beautiful feminine vision, gleaming like a new sunshine in the yellows of her own gold coin and hair and robe, key and sword hilt and chased helmet, hundreds of yellow, varying, delicate, complementary colors, setting off, reflecting, and burnishing up each other in a very blaze of affluence."[47] Janet Marstine, who has exhaustively studied the murals, has written that businesses that commissioned murals "exploited the propagandistic potential of art to ennoble their institutions during a time of hostility toward high finance, while shaping the behavior of customers and employees just as unions were gaining strength."[48] Comments such as Caffin's in the popular press only reinforced the murals' message.

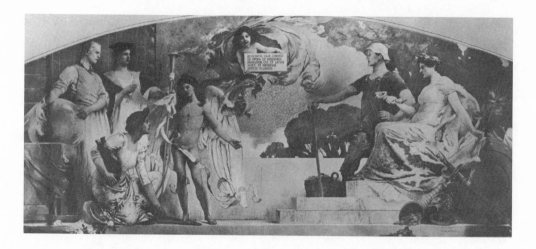

39. Edwin H. Blashfield, *The Uses of Wealth*, Citizens' Savings and Trust Company (destroyed), 1903. From Cortissoz, *Edwin Howland Blashfield*, n.p.

Commissioning murals was also a way to make commercial institutions seem the equal of government institutions in terms of their benevolence, stability, and inspirational purpose. They could tie their own agendas in with that of the City Beautiful movement, making their own success seem a public good.

In Cleveland, the close proximity of the banks to the grand public buildings designed for the city plan,, as well as architectural similarity, erased the borders between public and private in a way that could only help the public image of the financial institutions.

Although there were other commissions for commercial locations,[49] with few exceptions, leading beaux arts muralists did not receive as many such commissions as the rhetoric surrounding them might lead us to expect. Charles Shean believed that "absence [of art] is not felt nor its advantages recognized."[50] Mural decoration added visibly to the perceived cost of the building, and by *not* commissioning murals, companies were showing themselves to be good money managers—more so than by having paintings titled something like *Prudence Binding Fortune* on the walls.

It was a sad irony that the beaux arts murals in banks were among the first to be destroyed. Given the vagaries of business, banks merged or went bankrupt or were absorbed into other financial institutions. New buildings were planned to symbolize the new order and the old ones were torn down; unlike murals in nearby government buildings, they had rapidly outgrown their purpose. Like outworn advertising logos, they were superseded.

When the arguments for democracy, education, and commercial value succeeded, murals were commissioned. They were painted in the aesthetic then in vogue—a harmony of architectural and decorative details. This approach meant that the murals' values, promotion of democracy in statehouses or justice in courts or learning in libraries or patriotism in schools or capitalism in banks, were literally upheld by the building and integrated into the architecture's symbolism and signification. Those values seemed to grow naturally from the site. Architecture was a concrete symbol of status, power, and financial muscle, whether for a city or a business, and the murals that decorated them reinforced that message.

It is no coincidence that peace and prosperity abide in Low's mural in Wilkes-Barre or that *Passing Commerce Pays Tribute to the Port of Cleveland* is in the federal building there or that the *Beneficence of the Law* is in Newark: the building of grand county courthouses in Wilkes-Barre or Youngstown or Cleveland or Newark or Jersey City signaled the relative wealth of those northern, industrial locations. The construction of new state capitols in Saint Paul, Madison, or Pierre similarly symbolized the new status of those states, as not just recently emerging from territorial status but as large, powerful locations with wealth, taste, and aspirations. The buildings were symbolic of their material and cultural progress. Architecture, Art, Commerce, and Government, all in one building, sent powerful signals to the body politic. Wealth and culture were joined in an ideal marriage. Take any element away—size, magnificence, symbol, or power—and the equation collapsed.

6 | FROM ALLEGORY TO HISTORY

BEAUX ARTS MURAL PAINTING CONTAINED A GREAT VARIETY OF subjects. They ranged from single figures to complex, multifigured compositions and from symbolism and allegory to historical illustration, with many permutations in between. There were single symbolic figures, light and delicate, like Frank Benson's *Spring* and massive and weighty ones, like Edwin Blashfield's *The Law in Modern Times*—usually part of a larger grouping of, for example, seasons or virtues. More common were complex, multifigured compositions in which each figure was given a definite identity, such as in Elihu Vedder's lunettes on government in the Library of Congress and Edward Simmons's panels *The Civilization of the Northwest* in the Minnesota State Capitol in Saint Paul. Less common were compositions in which figures did not really symbolize the subject but acted it out, as in John La Farge's *Music* and *Drama* for the Whitelaw Reid mansion in New York and Kenyon Cox's *The Progress of Civilization* panels in the Iowa State Capitol, which progressed from *Hunting* to *Art*.

By the early twentieth century, there frequently were compositions in which one or more figures were given symbolic identities but the others were not. The other figures might be historical figures, as in Blashfield's *Washington Laying His Commission at the Feet of Columbia*, or they might represent generic groups, as did the miners in Edwin Austin Abbey's *Science Revealing the Treasures of the Earth*

and the pioneers in Blashfield's *Westward*. There were also scenes in which historical figures acted out eternal verities—a rare genre, represented particularly by La Farge's lunettes in the Minnesota State Capitol, where *Moral and Divine Law* (aka *Moses Receiving the Law on Mount Sinai*) records the institution of law in Western society and in *The Recording of the Precedents,* Confucius and his followers collate and transcribe documents. A variation was to have generic historical figures, like William Van Ingen's representatives of the religious groups that founded Pennsylvania in the capitol there or Simmons's trader and Indian in *Advent of Commerce* in the South Dakota State Capitol. Another example was H. Siddons Mowbray's nobles and commoners in *Common Law*. At the far end of the spectrum were historical scenes with identifiable figures, sometimes represented in a decorative mode as in Turner's *Marriage of the Waters* and sometimes in a manner much more akin to illustration, as in *The Landing of Carteret (or Captain Peter Carteret Appointed Governor of the Colony of New Jersey Landing in Newark Bay in 1665)* by Pyle and *The Revolt of the Grand Jury* (or *The Foreman of the Grand Jury Rebuking the Chief Justice of New Jersey, 1774*) by Millet, both in the Essex County Courthouse in Newark.

Discernable within this spectrum of subjects are three major changes that took place during the relatively short period that the beaux arts mural movement was active. This chapter discusses the first two shifts. The first concerned the change from the type of imagery favored for private commissions to an iconography more suitable for public sites. The second was the shift from allegory and symbol to history. Chapter 7 will explore the third transition, from history to modernity.

Despite the vast differences among artists' styles, the painters did not make any clear distinction between *allegory* and *symbol,* although some, like Blashfield, preferred use of the latter, probably because it did not imply the storytelling that this generation, with its Whistlerian and aesthetic orientation, so despised. Certainly the difference between the two terms and what they conveyed was rarely discussed in the art press or in published material by the muralists. Theoretical discussion on the level of Samuel Coleridge's *The Statesman's Manual* (1816) seems not to have occurred among artists and critics or their patrons, public and private. It is clear, however, that the opposite of *allegory* (and to some extent *decoration*) was not *symbol,* but *history* and *modernity.* For consistency's sake, the term *symbol* here refers to a one-to-one correspondence between sign and signifier, as in Walter Shirlaw's series of sciences in the Library of Congress, and *allegory* to the more complex compositions that are in essence symbolic narratives, such as Cox's *Sciences,* in the same building.

As I indicated in chapter 1, early commissions were mostly for private homes, usually drawing rooms and ballrooms, or for public areas in hotels and for theaters. The murals commissioned in the years after the World's Columbian Exposition reflected the confluence of the American Renaissance in the arts since the 1876 centennial with the more civic directions of the City Beautiful movement. With wholly different kinds of sites being decorated with murals—libraries, courthouses, state capitols—and as the critics responded to a change in the zeitgeist, arguing for an iconography more specific to national context, the center of gravity shifted from allegory to history.

Private commissions and semipublic ones for hotels, clubs, and music halls seemed to demand a consistently light and festive style and iconography. Decorations like La Farge's *Drama* and *Music* (for Whitelaw Reid, 1887–88) and Robert Blum's *Moods of Music* and *Vintage Festival* for the Mendelssohn Glee Club[1] were all of a kind—large-scale, buoyant, joyous, and, if the few extant can be trusted, brightly colored. The common focus on music and the dance befit their presence in ballrooms and music rooms.[2] Other popular subjects were temporal symbols (also common in decorative easel paintings of the period), such as Dewing's *Dawn* (or *Night, Day, and Dawn*) (fig. 41) for the Hotel Imperial and, in another New York hotel, Simmons's months and seasons for the Waldorf-Astoria. These subjects were sometimes dictated by the number of spaces to be decorated—three graces, four seasons, five senses, nine muses, twelve months, any number of musicians.

There was a rococo flavor to many of these decorations. In subject and even at times in style, they recalled the eighteenth-century era of aristocratic patronage of the decorative arts. Temporal symbols made architectural and decorative extravagances seem the logical order of things, as though the wealth that commissioned the paintings was as natural as the times and seasons depicted. There were no profound issues on these walls and ceilings to disturb the reverie of their owners and viewers or to question their social or moral position. Great wealth was celebrated with verve and spirit: music is played, the figures dance with joy, and all is right with the world.

With the growth of public commissions after the World's Columbian Exposition came discussion of how to make the mural "appropriate" to the site. The matter of appropriateness was, as I suggested in chapter 4, partly a matter of design and color, of harmonizing the mural with the architecture, so that it became integral to the structure. But appropriateness was also a matter of subject and

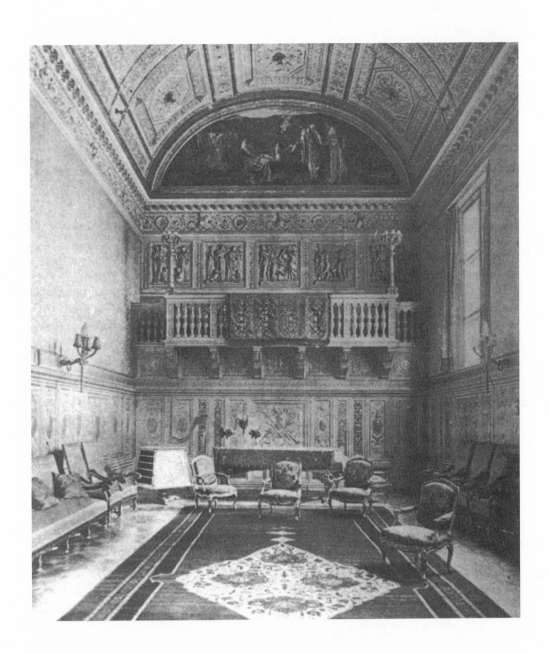

40. John La Farge, *Drama*, Whitelaw Reid House
(now Helmsley Palace), New York City, 1887–88.
From *House Beautiful* 15 (May 1904).

41. Thomas W. Dewing, *Dawn* (or *Night, Day, and Dawn*), Hotel Imperial,
New York City, 1892. Smithsonian American Art Museum, gift of John Gellatly.

mood. Most artists and critics thought festive themes unsuitable for the portrayal of the more public and high-minded ideals demanded by government commissions. Festivity was too lighthearted for the high seriousness of their mission; it was not inspirational or educational. The critic Charles Caffin, seeking to differentiate between types of mural commissions, stated that "the character of its [the mural's] subject will partake of that of the building, solemn, serious, elegant, and sportive according to the spirit in which the architecture, attuned to the purpose of the building, has been planned."[3] A writer in the *Brush and Pencil* in 1900 believed that public murals "should have some relation of significance, or at least of appropriateness to the uses of the buildings which they embellish" and called for "reserve and reposeful dignity" and not "garishness or triviality."[4] In 1906 the sometime muralist Elliot Daingerfield was quoted as saying that public murals should be "of the loftiest significance."[5]

The Library of Congress stood at a juncture between those representations found in private commissions and the new iconography of public structures.[6] The architect Ned Casey asked the artists to address the evolution of Western civilization and the United States' contribution to it, but beyond that prescription most of them were free to choose their subject.[7] Some artists merely transferred the types they had developed in Chicago but gave them new identities. For his *Virtues* in the corridors of the Library of Congress, George Maynard, for example, treated the viewer to the same female types and the same Pompeian red background that he had used in the *Four Seasons* under the portico of the Exposition's administration building; Shirlaw's voluptuous beauties now figured in *Sciences;* and George Barse, at the Exposition a newcomer to mural decoration, used similar figure types to represent subjects from literature. Simmons abandoned the male figures he had painted at Chicago and represented the nine Muses.[8] Robert Reid and Benson created genteel, impressionist representations of the *Three Graces,* the *Four Seasons* (fig. 42), the *Four Virtues,* and the *Five Senses* that would have been appropriate in any drawing room or hotel.

Other painters created more complicated allegories and more complex compositions and seemed to try conscientiously to celebrate the purpose of the building; for example, Cox's *The Arts* and *The Sciences* (fig. 55). Downstairs was Henry Oliver Walker's *Lyric Poetry* (surrounded by personifications of Mirth, Beauty, Passion, Devotion, Truth, and Pathos); also downstairs were Vedder's *Government, Good Administration, Peace and Prosperity, Corrupt Government,* and *Anarchy* (fig. 43), each with a centralized female figure with symmetrically placed adjuncts that represented specific allegories. The compositions by Cox, Walker, and Vedder

42. Robert Reid, *Autumn* from *Four Seasons,*
Library of Congress, Washington, D.C., 1896.
Courtesy Architect of the Capitol.

presumed a precise reading that depended on a correct interpretation of the figures' identities. They were usually understandable on some level without any accompanying written explanation, although this may not always have been exactly as the artist had interpreted them.

Blashfield was given the most prominent location, the dome collar over the main reading room, and his mural *The Evolution of Civilization* depicted the great civilizations and epochs from the past and the contributions they had made. The idea was similar in conception to the great cities that the artists had chosen at the Walker Art Building, but here each culture was represented by a single figure in a larger design, and as the title indicated, a temporal and evolutionary progress was followed. Blashfield's choices, like those for the Walker, were weighted toward Western civilization. In the world of 1896, no Far Eastern or sub-Saharan

African cultures were represented.[9] Otherwise, historical narratives were not depicted in the Library of Congress. The closest were John White Alexander's six lunettes *The Evolution of the Book,* which showed developments in the evolution of the written word: *The Cairn, Oral Tradition, Egyptian Hieroglyphics, Picture Writing, The Manuscript Book,* and *The Printing Press.* The only actual historical figure represented was Gutenberg, in the *Printing Press.*

43. Elihu Vedder, *Anarchy,* Library of Congress, Washington, D.C., 1896. Courtesy Architect of the Capitol.

In the Gilded Age and the Progressive Era, public murals were often sites for the production of meaning about the role of government institutions. The types of allegory used were mostly personifications of solid virtues, like Justice, Law, or Religious Liberty, or the acting out of symbolic narratives that stressed democratic values. (Occasionally, however, one suspects the artist of a tongue-in-cheek attitude: why else Abbey's *Quest for the Holy Grail* in the book delivery room of the Boston Public Library?) The values were those of the institutions they adorned; for courts, Law, Justice, the Judicial Virtues, and so on; for libraries, Arts and Sciences; for state capitols, the themes of exploration and settlement or

local cultural and commercial products. In banks, some representation of commerce was common, or at least a celebration of the city that had provided the wealth that enabled the banks to be built and flourish, such as Blashfield's *Pittsburg Offering Her Iron and Steel to the World* and Dewing's *Commerce and Agriculture Bringing Wealth to Detroit* (fig. 44). The ancient practice of symbolic personification of geographical places was used elsewhere, too: for the cities that appeared in the Walker murals—Rome, Venice, Florence, and Athens; and for Blashfield's different civilizations on the dome collar of the Library of Congress; and later, when there was a demand for more American subjects, for Abbey's Pennsylvania, Alexander's Pittsburgh, Cox's and Will H. Low's Clevelands, and Blashfield's Detroit.[10]

The allegory and symbolism found in early murals at the World's Columbian Exposition and the Library of Congress do not bear much icongraphic scrutiny. Again, inexperience, the pressure to come up with something quickly, the lack of time for research, and the muralists' underdeveloped skills accounted for much that was found at the White City and the nation's capital. What other explanation is there for the reliance on the same formula at the Manufactures and Liberal Arts Building (other than an admittedly strong desire to create a consistency and decorative harmony)? They placed four figures in each dome, one in each corner, occasionally an additional figure in the center, with costumes, attributes, and labels signaling their individual identity—all those having something to do with the building's displays. There was a pedestrian sameness in the domes, even allowing for Beckwith's inventive iconography: female figures decoratively holding new inventions such as the telephone, arc light, and dynamo. Scholars such as Janet Marstine and Sally Webster have offered provocative and convincing interpretations of why certain artists chose particular iconographic solutions, but my purpose is broader—to map out the breadth of the artists' choices, rather than probe individual psyches. The choices were not arbitrary. There was always a didactic and controlling purpose, but manifold choices could match that agenda.

So why all the allegory and symbolism? First, it was a matter of inexperience —it was easier to stick to the tried and true. Second, there was the conditioning of the painters' academic training. This generation of American artists, most of whom trained in Paris early in their career, considered themselves realists. They had been taught to follow the model closely and to replicate it precisely. But they were also imbued with a strong feeling for the ideal. Most academic realists such as Jean Léon Gérôme taught that it was not enough to copy nature; artists had to invest their subject with something else, some idea that, since their training

was so similar, is what actually conveyed the indi-
viduality of its creator. When these artists were
hired to do large-scale public commissions, the bal-
ance tipped in favor of the conceptual and ideal. A
revival of interest in the Renaissance marked this
generation, especially those who had studied at
venerable institutions like the Ecole des Beaux

44. Thomas Dewing, *Commerce and
Agriculture Bringing Wealth to Detroit,*
State Savings Bank, Detroit, 1900.
Private Collection, courtesy of
Spanierman Gallery, LLC, New York.

Arts. The art of Rome and Florence was the ideal, the model for all that came
after. The artists they looked to all spoke the language of allegory. This included
Puvis, who was both credited and blamed for this generation's use of allegory.[11]

And finally, to them allegory was constructed as universal: to speak in alle-
gory was to speak of all times and to all times. These muralists were ambitious
for art in the United States and for themselves; allegory was elevated above the
contemporary; it was a way to associate themselves with the great masters of
the past. They had a long history of allegorical personifications to look back on
to learn how to place seminude women in decorative compositions. There was
little precedent in public art for railroads, cars, office buildings, skyscrapers, steel
factories, or men in suits and women in shirtwaists; moreover, that kind of sub-
ject would date them and diminish their art.

As we saw in chapter 2, the Library of Congress and the appellate courthouse
in New York came under criticism for a "department store" approach to mural
painting. It may have also been the case that, given that the federal government

was the patron and the nation's capital the location, the architects pulled out all the stops. In both cases, the sites were allotted to many artists, whose works appeared in close proximity, and the result was a profusion of effects, sometimes competing with each other. That is probably the reason that subsequent public buildings did not have the overwhelming number of murals that were commissioned for the Library of Congress, where every available space seemed to be decorated. Tall, rectangular panels such as those that Maynard painted for his eight *Virtues* were in future often handed over to decorative firms, who painted garlands or the like, instead of large-scale figures in a distinctive style.

When single figures were depicted in subsequent mural decoration, they were restricted to major focal points, such as pendentives that grew more logically out of the building's design. Abbey painted *Art, Science, Religion,* and *Law* as female figures in gold medallions in the pendentives under the dome in the Pennsylvania State Capitol. Cox designed glass mosaics depicting single representative figures for *Legislation, Justice, Government,* and *Liberty* in the Wisconsin State Capitol. Blashfield was a near specialist in both that kind of allegory and that kind of space. In Newark, he painted *Wisdom, Mercy, Power,* and *Knowledge;* in Youngstown, *The Law in Remote Antiquity/Classical Antiquity/the Middle Ages/Modern Times;* and in Jersey City, four figures of Fame holding shields with the faces of four famous New Jerseyites. The decorative aesthetic that demanded harmony of parts in subservience to the architecture made each entity/figure seem equal, implying no hierarchical arrangement, so in Harrisburg, *Art* was given the same weight as *Law,* as were *Wisdom* and *Power* in Newark.

In Blashfield's dome collar *The Evolution of Civilization* and his four pendentives depicting law throughout history, there was of course an implied temporal sequence. It would not do to switch the figures—for example, placing America between Greece and Rome or Law in Modern Times between Law in Remote Antiquity and Classical Antiquity. Likewise, Cox, in eight panels that included *Hunting, Agriculture, Manufacturing, Commerce,* and *Art,* painted the flowering of civilization in Iowa in an implied progression.

In 1904, Simmons painted an allegorical narrative, *The Civilization of the Northwest* (or *Settling the West*) (fig. 45), in four successive panels below the dome of the Minnesota State Capitol. Simmons departed from the usual female symbols and depicted the main figure, America, as a young man (as Blashfield had also done in the Library of Congress). In the first, a young, male figure, tall, muscular, and Nordic, "The American Genius," follows Hope and is guided by "Wisdom," a female figure of Minerva, suspended in the air in front of him. In

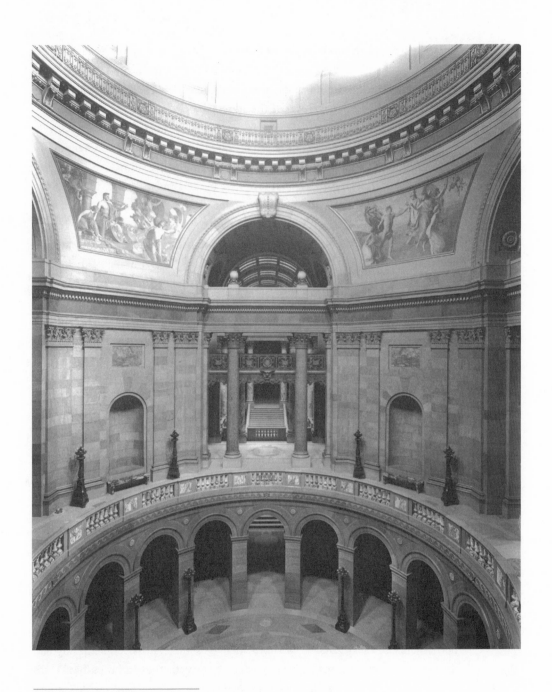

45. Edward Simmons, *The Civilization of the Northwest*
(or *Settling the West*), Minnesota State Capitol, Saint Paul, 1904.
Courtesy of Minnesota Historical Society.

the second panel, the young man and Minerva "banish savagery," represented as animals. In the third, they clear the ground of boulders. In the last panel, the young man, now Minnesota, and clothed in the cloak of wisdom, directs the four winds to distribute the products of the state.

The allegories in Simmons's panels were also noteworthy for their relatively active aspect, which may be a function of the male gender of the main figure. In most allegorical compositions, there is a static, impassive, immobile, and symmetrical quality that was thought appropriate for decorative compositions. As the mural movement developed, this active quality became more pronounced, with the exception of murals by the most conservative artists (e.g., Cox and Mowbray).

In highly academic murals, there was a symbiosis between style and subject. The contemporary mural aesthetic encouraged clarity: the outlines of the figures and the design elements of the composition were supposed to reinforce the lines of the architecture. The distance at which many of the murals were viewed also necessitated clarity of pose and gesture. In addition, the educational purpose of public murals required easy readability. If the artist's design was clear, then the spirit if not the letter of the allegory could be ascertained through gesture or pose or position within the composition. In Simmons's *Justice of the Law* (fig. 11) in the appellate courthouse, New York City, Justice was flanked by such beneficent figures as Peace, Plenty, Labor, and Mercy. Only Brute Force was a negative character, and his malevolence was clear as he is restrained by the arms of Fear.

Have these symbols and symbolic narratives always been exactly understood? Probably not, because they depended on a precise reading—a reading determined by the artist and conveyed only through written explanations.[12] When the murals were allegorical, ideal, or decorative, the artist often was requested to provide a key that helped the casual visitor "read" it. La Farge, for example, received a letter from the chair of the Board of State Capitol Commissioners in Saint Paul asking him to write out "a description of each one of the our pictures which you are making for our building, embodying in same, in as concise language as you can make it, your theme behind each picture, calling attention, in your own language, to what you intend each one to portray." This would be printed on cardboard "for permanent use of visitors."[13] Without such assistance, most people hardly had the esoteric knowledge necessary to recognize correctly the attributes that identified the figures. The paragraphs neatly typed on the walls of the Luzerne County Courthouse run to about two hundred and fifty words per mural. Blashfield's explanation of *Westward* (fig. 46) in the Iowa State Capitol extends to seven dense paragraphs.

But then again, there is the question of wheth-
er precise interpretation really mattered. For any of
them, did it have to be Law, not Legislation? Jus-
tice, not Mercy? And which symbols, anyway? In
fact, the sign and the signified were rarely aligned
precisely. There was an interchangeability of fig-
ures and identities, and even arbitrariness to the interpretation of many murals,
even those that had the episodic qualities of Simmons's Saint Paul murals. An
early handbook at the Library of Congress admitted that in Maynard's panels "the
number of virtues to be represented was determined beforehand of course, by
the number of spaces at the disposal of the painter. The selection, therefore, was
necessarily somewhat arbitrary."[14]

46. Edwin H. Blashfield, *Westward,*
Iowa State Capitol, Des Moines, 1905.
From Cortissoz, *Edwin Howland Blashfield,*
n.p.

This arbitrariness and interchangeability was often acknowledged, if only
implicitly. Vedder easily changed the title of his mural in the Walker Art Build-
ing from the *Art Idea* to *Rome* when the other painters decided to celebrate the
great cities of Western civilization. Cass Gilbert, writing to Channing Seabury,
the chairman of the Board of State Capitol Commissioners, included a thumb-
nail sketch of Cox's lunette and was at pains not to be tied down too much: "His
subject is quite formal and allegorical and is about as follows: A seated figure of
Justice or perhaps Contemplation in the center. On either side two supporting
figures representing, as I understand it, Philosophy and Control. (He will prob-
ably give a different description of it but this will serve for the moment.)"[15] Henry
Oliver Walker, writing to Gilbert about his Essex County Courthouse mural, said
that he did not know Cox was doing a Justice, too, but that it did not matter.[16]
(Eventually, Walker's mural was called *The Power and Beneficence of the Law* and
Cox's *Beneficence of the Law*). Simmons's, Walker's, and Blashfield's murals in the

courtroom of the appellate courthouse were full of figures, each given a precise identity that could easily be substituted for another. Simmons's *Justice of the Law,* for example, contained figures of Justice, Peace, Plenty, Brute Force, Fear, Labor, and Mercy; but why (we may ask) not Law, Benevolence, Abundance, Violence, Apprehension, Work, and Solicitude?[17]

THE SHIFT TO HISTORY

The belief that allegory was the native language of murals was not universal among artists or their audience in the United States. As an alternative, history was usually chosen as subject. In 1892, in New York City's Hotel Imperial, Abbey painted one of the first historical murals of the beaux arts movement—a representation of the colonial game of bowls on Bowling Green in Dutch Manhattan. Two years later, the Municipal Art Society competition for a decoration slated for a courtroom in the new criminal courts building in lower Manhattan was interesting evidence of the relative popularity of allegory and history at an early juncture in the movement. There were already indications that some artists believed history to be a more appropriate vehicle than allegory for communicating the type of civic message that the visibility of public murals demanded. The society received forty-seven entries, and though a complete list of them has not been found, the various newspaper accounts give a fair idea of the range of subjects. At least eleven artists submitted representations of Justice, among them Shirlaw, Low, and Louise Howland Cox, in addition to Simmons, the winner. At least four artists portrayed Moses, and one, chose King Arthur. Historical narrative was not much in evidence, although Turner, who would be the foremost specialist in historical murals in the next decade, submitted a sketch of an eighteenth-century scene, the first trial in New York City after the Revolution.

Dissatisfactions about the prevalence of allegory emerged sporadically in the late 1890s. In 1897, the artist and critic William Coffin, reviewing the decorations in the Library of Congress for *Century Magazine,* said that

> there were, if not too many abstract themes, at least too many similar ones. The arts and sciences, for example, have been used pretty frequently in the decoration. The point has no bearing whatever on the merit or effectiveness of the decorations in the artistic sense, but concerns only the whole of the work from the literary point of view. Historical subjects of a certain

class would seem to be well fitted for use in the decoration of a library if the abstract themes do not suffice to give variety to an extensive scheme of decoration.[18]

Just a few years after the unveiling of the Library of Congress murals, the tide had turned so far that the public and critics openly expressed their boredom with allegory. The architect Russell Sturgis laid the blame for an excessive use of allegory at the feet of Puvis de Chavannes, saying that when one studies his mural at the Sorbonne, one "may feel there is enough symbolism for a while."[19] He spoke of the "wearying sequence of metaphorical, symbolic, non natural subjects in our mural painting" and cited landscape as a refreshing alternative that should more often be considered.[20]

Another problem was that in the age of photography and the dawning of cinema, the artificiality of allegorical personifications was everyday more apparent. Van Ingen, for example, himself a muralist, found that the training of contemporary artists led them to paint from the live model, but "this is far from a free rendition of life. Instead of painting Abundance Rewarding Labor, he may easily, too unintentionally, paint a picture of one model giving another model a cornucopia filled with wheat and apples."[21] The muralists were highly aware of how thin the line was between allegory and parody in the modern age. Blashfield admitted that

> today a nymph is further from our daily custom (and costume) than she was from that of Renaissance Florence. If we paint her in bathing-dress she will seem rather an advertisement for Atlantic City than something which has stepped out of contemporaneous poetry but Botticelli's Virtues or Beatitudes or Bacchantes might illustrate Poliziano's verses, and yet wear gowns very little removed from those which the Florentine girls shopped upon the Ponte Vecchio.[22]

Sometimes murals were made fun of. Marstine has cited the description of murals in Henry Blake Fuller's novel *Under the Skylights* (1901) as lampooning works such as Kenyon Cox's *Sources of Wealth* and Blashfield's *Uses of Wealth* (fig. 39). Fuller's fictional Grindstone National Bank was decorated with *Genius of the West Lighting the Way to Further Progress* and *Science and Democracy Opening the Way for the Car of Progress*. He had "the Goddess of Finance, in robes of saffron and purple, 'Declaring a Quarterly Dividend.' Gold background. Stockholders summoned by the Genius of Thrift blowing fit to kill on a silver trumpet. Scene takes place in an autumnal grove of oranges and pomegranates—trees loaded

down with golden eagles and half eagles. Marble pavement strewn with fallen coupons."[23]

Allegory's lack of relevance to the American experience was most often cited, despite many artists' belief that the universality of allegory made it appropriate for all locations. Many people in the United States in the late nineteenth century constructed allegory as foreign and wanted something more American. Blashfield was acutely aware of this attitude. In 1899, he wrote: "There are people who say when we decorate American buildings we want the celebration of American history, we do not want foreign decoration of symbolical figures; we want realistic painting, not idealistic. There I beg to contradict flatly. We want both kinds, and we want them very much." Blashfield believed art should be at the same time realistic, "that is to say like nature," and idealistic, "that is to say informed with a sense of beauty, a sense of individual selection from nature, by the creator." He insisted that symbolic figures were not foreign: "The Attributes and the Graces have not settled by the Seine or the Rhine; the Muse is just as willing to take up the Lyre at Concord or Cambridge as at Florence or by the Fountain of Vaucluse. We surely want historical decorations, but we also want there symbolical figures because they are beautiful and graceful, and because decorative art needs them peculiarly."[24]

Many disagreed. In 1906, an article appeared that criticized Cox's murals for the Iowa State Capitol (the eight lunettes that presented the progress of civilization as single figures represented stages from Hunting to Art). The writer praised their decorative quality, but found the series "has no more relation to the State Capitol of Iowa than it has to ancient Rome. There is not even the feeling of the West, for the atmosphere and landscape are those of New England, the architectural accessories of classic Italy, and the figures, the outcome of a necessity for just that mass of color and those lines in that particular place."[25]

Some muralists—for example, Low—made an attempt to localize their subjects by including a landscape setting that was demonstrably local. For his mural *Prosperity under the Law* in the county courthouse at Wilkes-Barre, Low included the nearby Wyoming Valley of Pennsylvania. In a series of lunettes in the law library of the New York State capitol in Albany, he painted the figure of Civilization with the personified attributes of Literature, Art, and Science against the backdrop of the Hudson River. Another attempt to localize was to mine the ancient tradition of personifying cities. In 1897 Blashfield painted Pittsburgh for a bank (fig. 59), and in 1900 Dewing did likewise for a Detroit location (fig. 44). Personifications of Cleveland by Low (fig. 20) and Cox, Pittsburgh by Alexander (fig. 57), and Pennsylvania by Abbey (fig. 17) followed. All were more or less "ideal"

compositions, with no historical narratives, although Abbey's Pennsylvania joined thirty-five historical figures.

It is ironic that one of the most cogent and yet passionate calls for a more relevant iconography came in 1901 from Low, an academic muralist who consistently employed allegorical personification. In his article "National Expression in American Art," he noted that most contemporary artists like himself had had foreign training; "art," he said, "is a foreign language which we speak with fluency and expression; but we still lack a method of expression which is unmistakably our own." In mural painting, "the complacent acceptance of threadbare allegory or conveyance of ready-made solutions of problems, which we should solve for ourselves, should no longer prevail." Instead, the "tiresome commonplaces" of "Science, Art, Justice, Philosophy, the Muses and the Graces,—the whole heathen pack of Jupiter, Mercury, and Mars, should be debarred."[26]

Soon after Low's article appeared, the muralist Charles M. Shean published a near-manifesto, "A Plea for Americanism in Subject and Ornamental Detail," in *Municipal Affairs,* a journal whose editors and writers articulated City Beautiful ideals. Shean called for the American painter to "look for his inspiration in his own country and among his own people." In ringing, rhetorical terms, he sounded a clarion call:

> If the mural art of this Republic, this government 'by the people, of the people, and for the people,' is ever to become vital and living, is ever to become a dignified, honorable and worthy calling for men and women, it must cease to bedizen and bedeck. It must become more than an academic echo, a Renaissance reminiscence. The artists must learn to make the walls of our public buildings splendid with pictured records of American exploit and achievement, of American industry and commerce, of American life and culture.[27]

Gustav Stickley's publication, the *Craftsman,* became a vehicle for some of the strongest arguments against the use of allegory in contemporary mural decoration. Three years after his original plea for Americanism, in an article entitled "Mural Painting from the American Point of View," Shean stated that

> American historical painting, after a period of neglect, is struggling to its feet and again many of our artists are seeking their inspiration in the history and tradition of their own land, leaving to the old in spirit and the feeble in invention the long array of well worn and over used allegories and personifications, characterless figures of no particular age of clime, and bending their energies to depict American endeavor and achievement.[28]

Shean cited two important commissions, the Massachusetts State Capitol and the Baltimore courthouse, as important milestones in the shift from allegory to history.

By 1908, the zeitgeist was so against allegory that even Royal Cortissoz, usually a champion of the academic and traditional, jumped on the bandwagon. In an article on Abbey, he set up a straw man (who seems pointedly like Kenyon Cox):

> Everyone knows the banality of the modern figure of The Arts, say, en-throned in the middle of a lunette like some matronly acrobat, embarrassed by unaccustomed garments but bent upon keeping herself at the precise center of the canvas. The gesture of the figure on her right is repeated in the reverse direction by the figure on her left. Thus the artist holds the scales even to the extreme limits of his canvas, and the decoration remains absolutely lifeless.[29]

That same year, an article appeared in the *Chautaquan* that identified two schools of mural painting, with a clear preference for the one that had developed more recently. The first was the academic group, Cox, Mowbray, Pearce, and Blashfield, who painted "comely" women as personifications of virtues and abstract qualities. The second school was a group of history painters, Turner, Pyle, Violet Oakley, Van Ingen, and Alexander, who rejected "unrealities, alle-gories and symbolism borrowed from Greece and Rome, and Florence, and like the painters of old, are interpreting on the walls of many public buildings in a large and imaginative way, the history and traditions of their own country and the civilization of their own time."[30] This division into two schools would con-tinue, and although allegorical murals would persist for the life of the beaux arts movement, history, as subject, was clearly in the ascendancy.

The murals commissioned for the Massachusetts State Capitol addition men-tioned by Shean formed the first important step in the move from allegory to history. In 1900, the state legislature mandated incidents from Massachusetts his-tory; state allegiance also went so far as to hire Massachusetts natives. For the area above the main staircase hall, the commissioners for the state house assigned *James Otis Arguing against the Writs of Assistance* (fig. 47) to Robert Reid (Abbott Thayer, Walker, and Simmons had turned the commission down as offering an unpromising subject).[31] The event they wished to have illustrated occurred in 1761, when the British Parliament told the collector of customs in Boston to apply to civil authorities for "writs of assistance" so that customs officers could search

for illegal or untaxed goods.[32] Two years later, Reid painted two additional panels, one on either side of the first, depicting the ride of Paul Revere and the Boston Tea Party.

47. Robert Reid, *James Otis Arguing against the Writs of Assistance,* Massachusetts State Capitol, Boston, 1901. From Blashfield, *Mural Painting in America,* opp. 216.

Massachusetts history was also designated for the area over the Memorial Hall, even though the spaces were tall lunettes, usually reserved for allegorical subjects (the shape was perceived as awkward for historical incidents; see chapter 4). Walker painted two murals, *The Pilgrims on the Mayflower, November 9, 1620* (fig. 14) and *John Eliot Preaching to the Indians.* Describing the former, a critic wrote that "the spirit of the scene is well suggested but the picture is, of course, ideal and none of the figures is a portrait. Over the heads of the group the two angels are seen bearing an open Bible, and across the painting is the inscription 'For the Lord is our defence [*sic*] and the Holy One of Israel is our King.'"[33] Sturgis called Walker's murals "semi-historical," noting that they were "not quite as purely historical as the public had been told to expect" and he called attention to the "group of superhuman beings."[34] Alternating between the two lunettes by Walker were two by Simmons. He supplied a battle scene, *The Battle at Concord Bridge, April 19, 1775,* and, marking the end of the Civil War, *The Return of the Battle Flags.* In his autobiography *From Seven to Seventy* (1922), Simmons mentioned that the subject assigned to him was "war," but he implies that beyond

that prescription he was able to choose the subjects. From this it seems possible that Walker was given the broad theme of "religion" and went from there to chose his own subjects.

Muralists seem to have been given more leeway when allegorical programs were in vogue than when the fashion was for historical narrative. The shift from allegory to history was in part a shift in power from the artist and architect to the state or municipality, usually in the form of a committee made up of elected or appointed officials in charge of state building projects. The state legislature decided on the historical murals in the Massachusetts State Capitol, for example, and the state building commissioners carried out their wishes. A little more than a decade later, Blashfield acknowledged this shift, as well as what it implied for the changing goals of American mural painting, from pure decoration to historical celebration. In typically rhetorical fashion, Blashfield ventured that "if the commissioners of a State capitol came to one of our mural painters to-day [1913] it would be preposterous for him to say to them: 'Beauty is all that you require in your rooms, beauty of pattern and line, color and figures.' They would reply: 'We have suffered and fought in the cause of progress and civilization; remind us of it upon our walls. We have bred heroes; celebrate them.'"[35]

In 1914, a critic writing on Hugo Ballin's murals in the governor's reception room of the Wisconsin State Capitol assumed that the split between what the artist wanted and the commissioners desired was the split between history and the ideal: "We have the blending of the realistic, necessary for the portrayal of the historic side and to please the commissioners who must be considered, with the allegory where the artist has given free rein to his invention."[36]

Gilbert, the architect, was both a staunch supporter of allegorical, ideal subjects and a believer in the artist's right to choose his subjects. To Seabury, the chairman of the Minnesota State Capitol commissioners, about muralist Simmons, he wrote:

> I have stated to him that he shall have a free hand to develop his conception to the fullest extent, without interference on the part of the Board as to the nature of the subject, considering that in point of subject he will have to meet my views as the Architect. . . . I find that the artists are occasionally seriously embarrassed by change of views and by subjects that are insisted upon by various members of committees after a start has already been made, and I have promised him "the opportunity to do an ideal thing in an ideal way."[37]

When Gilbert was increasingly pressed by special interests, especially the survivors of Minnesota's Civil War regiments and the Roman Catholic Church, he set aside the governor's reception room to commemorate their history (fig. 33). He wrote ominously to Seabury that

> if the Board does not cover the vacant spaces then somebody will get in their deadly political work later on and make that room a chamber of horrors in the name of patriotism. I personally believe in historic pictures for such a room and think they should be treated from the pictorial standpoint rather than from the decorative standpoint, that is to say, that they should really be pictures of the events as nearly as they can be transcribed.[38]

Gilbert was effectively segregating history into a relatively modest space, however, not the grand public entrance spaces or the halls of the legislative and judicial bodies but the room where the people's representative, the governor, would greet them. In contrast to the grand public spaces, the painters there were assigned subjects. To satisfy the Roman Catholic Church,[39] Douglas Volk was commissioned to paint *Father Louis Hennipin Discovering the Falls of St. Anthony in 1680* (fig. 48). In addition, there were Civil War battle scenes of the glory days of each of Minnesota's three Union regiments. Although the historical paintings in the room were called murals, their relatively small size (10 feet in length) as well as their enclosure in heavy frames made them less mural-like and more like traditional easel paintings. It is noteworthy that battle paintings had not been common in American art, and with few exceptions, such as some of Brumidi's murals for the Capitol, the most notable examples dated from the early nineteenth century. Gilbert's commission was itself a minirevival of the genre.

La Farge's murals in the supreme court in the Minnesota State Capitol were also exceptions to the overall allegorical treatment of the major architectural spaces in Saint Paul, but in a quite different way. La Farge himself wrote to Gilbert that he had chosen "more novel or less used themes so that your building would have an additional mark of special choice and care by the avoidance of the commonplace."[40] Strictly speaking, they were historical narratives detailing episodes in the development of law, representing Confucius (fig. 16), Moses, Socrates, and Raymond of Toulouse. Their scope was obviously more specific and documentary than allegory, and at the same time more international and universal than the depictions of American history that graced other locations. Elizabeth Cary, contrasting them to Puvis's Boston Public Library murals, found

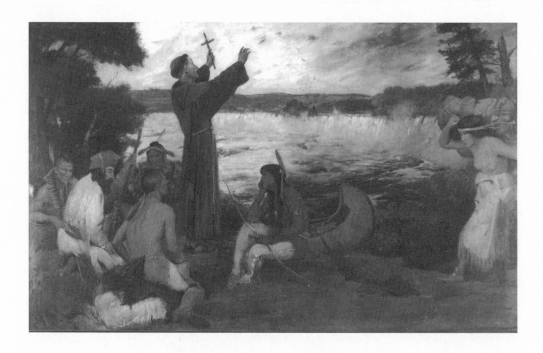

that they were not a "summary representation of impersonal types, but a kind of portrait of the scene which may never have occurred as he painted it, but which might have occurred . . . no definite story is told, but a general truth about the temper of the time and the people is worked subtly into all the elements of the painting."[41] La Farge's murals received the highest critical praise of all those in the capitol. A writer in the *Craftsman* called them "magnificent examples of the historically symbolic idea" and praised their "decorative value," finding that La Farge had satisfied both schools of mural painting.[42] The artist's architect friend, Sturgis, was more blunt, saying that La Farge showed them "how history could still be used in mural painting and not be a desolation and a bore."[43] La Farge's intensely colored Venetian style and naturalistic approach were unique, however, to both the Minnesota capitol and to the mural movement as a whole; he would, however, inspire emulation, most notably in Van Ingen's designs for the Federal Building in Chicago (1909, destroyed).[44]

As we have seen, Gilbert and La Farge were constantly at odds during the work on the Minnesota State Capitol, mostly over La Farge's inability to meet deadlines and his rather arrogant attitude toward the architect and the state com-

missioners; thus, it was no surprise that he was not invited to decorate Gilbert's next major commission, the Essex County Courthouse in Newark. The success of the Saint Paul decorations, however, led to another commission for La Farge, the second phase of murals for the Baltimore courthouse. In a conception similar to the Saint Paul murals, but without their compositional complexity, he painted six lunettes in the entrance corridor, representing the lawgivers Numa, Lycurgus, Confucius, Mahomet, Justinian, and Moses. Barbara Weinberg has cited the influence of Delacroix's murals in the Palais Bourbon,[45] and it was no surprise that at the time there was some doubt expressed of their appropriateness to their location in Baltimore. One writer spoke of the

> question [that] has been raised as to the fitness of the subject chosen, as the other paintings in the Courthouse [by Blashfield and Turner] are distinctly commemorative of epochal events in the history of Maryland, but the final decision has been that the world wide scope of a series of panels representing the great lawgivers of all history lends a dignity and breadth to the whole scheme of decoration that might have been lacking had the paintings been confined in subject to the presentation, whether direct or allegorical, of scenes from local history alone.[46]

Meanwhile, in Newark, Gilbert reacted to the increasing demand for historical scenes: in prominent locations at that site there were as many historical scenes as allegories. Pyle and Turner painted colonial history, Millet revolutionary history. Low's painting *Diogenes in Search of an Honest Man* was close in spirit to La Farge's paintings in Saint Paul. Cox, Maynard, and Walker supplied allegories.

By the time of the Essex County commission, Turner had emerged as one of the foremost painters of historical murals in the country. In fact, in what was an indication of the passing of the torch, in 1904 Turner took over as president of the National Society of Mural Painters (he served until 1909). Early on, Turner had painted *The Triumph of Manhattan,* which combined allegory and realism, for the Hotel Manhattan. He also won a number of other commissions for historical scenes for several other hotels. His submission for the Municipal Art Society competition was a mural of the first trial in New York City after the Revolution. But the panels for the Baltimore courthouse (fig. 36) marked him as a leading muralist painting history. He next painted *The Landing of the New Englanders at Newark, May 17, 1666* for the Essex County Courthouse in Newark. A critic wrote of it, "It is Mr. Turner's aim to create through this class of painting an art typically American"[47] and that this direction should be encouraged.

Turner subsequently won the 1906 competition sponsored by the Municipal

Art Society for murals at the DeWitt Clinton High School, for which he painted *The Opening of the Erie Canal* and *The Marriage of the Waters* (fig. 37)—the latter, despite its title, a historical, not allegorical, scene.[48] That year, William Walton, summing up the state of mural painting since 1898, cited Turner as believing "that the figurative and allegorical can scarcely be considered the language of our day, that something more direct and practical, more nearly adapted to the limitations and requirements of the people is required."[49] His later commissions included the *First Trial in the County* for the county courthouse in Youngstown and *General Washington at Fort Lee, November 16, 1776* (fig. 49) and *First Passage of the Steamer "Clermont" to Albany* for the Hudson County Courthouse. He followed this with *The Trial of Captain John Smith, 1607* and *The Conclave of Pontiac and Rogers Rangers at the Mouth of the Cuyahoga River, November, 1760,* for the Cuyahoga County Court-house. Later he painted a series of panels on the history of transportation in Wisconsin for the state capitol in Madison.

Despite his choice of historical subjects, Turner's compositions were not at all dramatic. A standard device of his was to paint figures standing on shore, looking at an event in the distance. For the trial scenes, the figures were usually strung out across the foreground, with a definite absence of dramatic focal point. It is noteworthy, therefore, that although history was often posited as the opposition of "decoration," Turner remained true to the current mural aesthetic, creating a frieze-like effect that spread over, not into, the space. Sturgis, however, did call the *Burning of the Peggy Stewart* (fig. 36) "exciting" and a "great composition full of narrative." It was "a relief, indeed, from the personification of the State, the City, the Fatherland, or patriotism, with two or three Sciences, two or three Arts, or half a dozen national Virtues."[50] Women figured in his paintings in ways that other artists had not used them. Whereas most historical episodes were chosen for theatrical effect, Turner's subjects and method of presentation, often showing an audience an historical event, allowed him to give equal visual weight to females in the historical episode.

Frank Millet, a powerful figure in the mural movement, also became over the course of his career an advocate of historical murals. In 1893, he had supervised the decoration at the World's Columbian Exposition, and as late as 1910 he did the same at the Hudson County Courthouse in Jersey City. His first mural decorations embraced an allegorical, ideal, and abstract style, as when he painted *The Triumph of Juno* for the New York State Building at the World's Columbian Exposition—an Allegory of the Empire State, represented as Juno, encouraging the Arts and Sciences. Another early mural decoration, *Thesmophoria* (fig. 13),

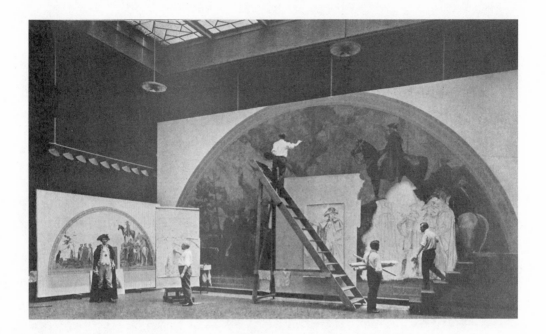

showed a harvest procession of white-clad Athenian maidens, who represented the general theme of Agriculture.

In his easel painting, however, Millet had been a specialist in costume genre of the classical, Elizabethan, Regency, and colonial periods. Millet soon disavowed allegorical fancy in favor of a nononsense, documentary style of mural painting.

49. Charles Yardley Turner at work on *General Washington at Fort Lee*, Hudson County Courthouse, Jersey City, N.J., 1910. From Blashfield, *Mural Painting in America*, opp. 274 (location misidentified in caption).

This was most evident in the commission he completed for the Baltimore customhouse, for which he created eighty-seven panels illustrating the *History of Shipping from the Earliest Recorded Use of Boats until the Present Time* (fig. 50). In an oft-cited remark, Millet famously said they were something different from "the customary representations, such as a group of young women in their nighties presenting a pianola to the city of New York,"[51] which might describe his own early murals.

In the Essex County Courthouse, Millet painted *The Revolt of the Grand Jury*, a historical episode from 1774. In Jersey City, where a combination of allegorical and historical scenes was used, he supervised the decoration of the entire building. The project showed him to be a believer in the appropriateness, in different parts of the building, of either allegory or history. One critic noted that Millet

50. Francis Davis Millet, *History of Shipping from the Earliest Recorded Use of Boats until the Present Time,* Baltimore customhouse, Baltimore, 1908. From *The Architectural Record* 24, pt. 1 (August 1908): 101.

had told him "that when the commission was first given to him he mapped out a general scheme dividing the work among his associates so that each man who did a part of it should have assigned to him the kind of work he was specially interested in."[52] The courthouse included the allegorical pendentive figures of Fame, by Blashfield, and the grisaille tympana over the doorways representing judicial virtues, by Kenyon Cox. Millet himself supplied twelve historical panels documenting the history of Jersey City and two major lunettes under the rotunda, *The Repulse of the Dutch (1609)* and *Paying for the Land (1658)*. In addition, he supervised Turner's and Pyle's contributions from colonial history.

In his later work, Millet mostly painted panels documenting a historical process step by step. In a similar vein to the Baltimore murals, he painted a frieze on panels for the banking room of the Cleveland Trust Company (each panel sixteen feet by five feet), *The History of the Settlement of Ohio*. The series began with the Puritans and ended with the settlers in Ohio. In 1909–10 he painted another frieze, *The History of Mail Delivery,* for the post office in the Cleveland federal building.

After Millet's death on the *Titanic* in 1912, a critic said of him that "his in-
tention . . . was to leave for posterity a series of strictly accurate historic docu-
ments rather than a collection of vague symbols."[53] Leila Mechlin, a critic who
consistently praised his work, wrote of the murals in the federal customhouse
in Baltimore that

> too much the mural painters of our day have feared an idea, and too often
> they have become entangled in symbolism. Paintings which signify without
> being inherently literary are rare—commerce represented other than by an
> heroic female figure bearing some familiar token is scarcely recognizable.
> And yet why must we keep repeating the same old story—why not occasion-
> ally have a new thought? Mr. Millet has ventured it, and successfully. In every
> little factor of his decorations there is suggestion, appropriate significance.[54]

Pyle, whom Millet supervised at Jersey City, was a latecomer to mural paint-
ing. Given his experience as an illustrator, he naturally gravitated toward histori-
cal scenes. He had three major commissions for public sites in his short career as
a muralist: a panel for the governor's reception room in the Minnesota State
Capitol and larger works for the Essex (fig. 51) and Hudson County Courthouses.
They were done in a style reminiscent of his book illustrations, but enlarged.
Their strong, linear design, despite their illustrative quality, were in tune with
the current mural aesthetic only in their readability from a long distance.[55] It is
noteworthy that Pyle came to mural decoration after the success of his student
Oakley in Pennsylvania. She painted the frieze in the governor's reception room,
The Founding of the State of Liberty Spiritual, consisting of eighteen panels done in
the linear style her teacher favored, with dramatic foreshortening and asymmetri-
cal compositions. Oakley traced the origins of religious freedom in Pennsylvania
from William Tyndale's publication of the Bible in Cologne in the sixteenth cen-
tury to William Penn's arrival in the seventeenth century.[56]

The overwhelming majority of historical scenes in murals come from the
colonial and revolutionary period, and those are inevitably set in the thirteen
original colonies, especially those in the north or mid-Atlantic: Massachusetts,
Maryland, Pennsylvania, and New Jersey. The "Colonial Revival" has long been
recognized as a phenomena distinctly associated with the late nineteenth and
early twentieth centuries. Richard Guy Wilson has cited the "burgeoning na-
tionalism, the genteel concern that a lack of history meant decadence," and the
enthusiasm sparked by the centennial.[57] It is important to note, however, that
the colonial revival took place during a period of increased immigration—that the

51. Howard Pyle, *Landing of Carteret,* Essex County Courthouse, Newark, N.J., 1907. From *The Essex County Courthouse,* 1908, n.p.

reaching back into the distant past may have been a desire to establish precedence and status and to socialize newcomers.[58]

Whether it was because of patrician snobbery, geographical proximity, temporal distance, or local boosterism, colonial subjects appealed to building committees. In fact, with few exceptions, historical episodes chosen for murals were local, not national, unless the national event had occurred locally.[59] Washington resigned his commission and the *Peggy Stewart* burned in Annapolis —events appropriate for the federal courthouse in Baltimore. The historical incidents portrayed in Newark, Jersey City, and Boston happened in or near those locations. Those were safely distant psychically as well as temporally and did not evoke the more recent tensions of the Civil War or the Indian Wars. When Native Americans were depicted, they were in a peaceful context, with the exception of *The Repulse of the Dutch* in Jersey City. But even that episode had a "happy" ending, portrayed in Millet's companion piece *Paying for the Land*.

It was all right and good for locations in Pennsylvania, Massachusetts, Maryland, and New Jersey to choose historical narratives: those states had a relatively long history to choose from. Obviously, however, colonial and revolutionary

scenes were not as relevant for western states, and Minnesota, Iowa, South Dakota, and Wisconsin all built or refurbished their capitols between 1903 and 1913. A 1906 article on recent decorations in state capitols spoke of the "improbability of young states having events to record";[60] other solutions had to be found.

An intriguing compromise emerged, a midpoint between decoration and narrative, allegory and history, idealism and realism, tradition and modernity—one that could satisfy many constituencies, artistic and provincial. Turner, in the Hotel Manhattan murals, and Walker, at the Massachusetts State Capitol, were among the first to effect this compromise:[61] Turner combined a symbolic personification of Manhattan with historical figures; Walker painted Pilgrims with floating spirits who guided them. But it was Blashfield's Baltimore courthouse murals that positioned him clearly at the midpoint between the allegory-versus-history dialectic. His *Washington Laying His Commission at the Feet of Columbia* (fig. 52), with its historical figures and monumental icon, Columbia, in a shallow, stage-like space, set the standard for many later compositions. Caffin called Blashfield's Baltimore panel of Washington "a thoroughly successful example of how an event of history may be treated so as amply to fulfill the purposes of a decoration."[62] An article on civic art in Baltimore in the *Craftsman* found his "subjects admirably chosen for the place, on the principle that a decoration should be the outgrowth of the conditions which brought it forth, and related to the surroundings amid which it is placed."[63] Walton contrasted the approach of pure allegory with "the much more difficult one in which realistic or historical personages mingle with these abstractions and personifications without apparent incongruity."[64]

This approach seemed particularly appropriate for western states with limited history since it could invest meager historical detail with lofty significance, and indeed, several midwestern state capitols opted for Blashfield, the most successful purveyor of this compromise, as their artist. In *Minnesota, Granary of the World* at Saint Paul, his central figure of Minnesota, astride an oxen, was surrounded by figures of Civil War soldiers and nurses, against a background that included the state capitol. In the companion lunette, the Indian spirit great Manitou, father of the waters, is greeted by "discoverers and civilizers" abstracted from their chronological sequence to appear symbolically on the same stage together.

In other Blashfield murals the figures were not specific historical personages but stood for types such as pioneer, soldier, and so forth. In such symbolic reenactments of westward expansion as his *Westward* (fig. 46), in Des Moines, the prairie schooner was led by ideal women flying overhead, representing the

52. Edwin H. Blashfield, *Washington Laying His Commission at the Feet of Columbia,* Baltimore courthouse (now the Clarence M. Mitchell, Jr. Courthouse), 1902. From *The Craftsman* 9 (1905–6): 208.

Spirits of Civilization and Enlightenment; two others followed, carrying the potential for Steam and Electricity. In the iconographically complex lunette *Wisconsin, Past, Present, and Future,* the female symbol of the state was surrounded by figures representing Lake Superior, Lake Michigan, and the Mississippi River. The historical figures included Father Claude Allouez, Nicolet, Radisson, and the color guard of a Wisconsin Civil War regiment. "Today" pointed to the capitol through the woods. The space allotted to the present included lumbermen, miners, and farmers and their families. At the extreme right, Indians shaded their eyes from the light. At the extreme left, "Future" shelters the "Lamp of Progress" with her hand and listens to the figures of "Conservation of Force" telling her to take care of the trees.[65]

With the exception of the South Dakota State Capitol, Blashfield's solution was not adopted for the far western capitols. He was under consideration for the

state capitols in Utah and Montana but did not receive the commissions: their later date assured that more purely historical murals were commissioned. In Utah, Vincent Aderente, Blashfield's assistant, painted Brigham Young examining a block of granite destined to be part of the Mormon temple in Salt Lake City. In Montana, straightforward narrative compositions by Charles Russell—a western artist from a western location who was known for his western themes —won the commission In Austin, Texas, little-known Henry A. McArdle painted the *Battle of San Jacinto* (1898) and *Dawn at the Alamo* (1905) for the state capitol.[66]

In some quarters, however, there was a backlash. A certain dissatisfaction, even boredom, regarding the kind of historical subject that had been chosen was evident in the popular press. Criticism of this type was leveled in Boston, Baltimore, Newark, and Jersey City. In 1906, muralist Low was quoted as saying that he was "almost as tired of the 'early settlers' as I am of 'Justice,' 'Science,' and 'Art.'[67] Sturgis struck a similar note the following year. Admitting that some people had complained about an excess of allegory, he said, "The answer is that other people are as tired of the cocked hat and the broad-skirted coat as anyone can be of pictured Faith, Hope, and Charity."[68]

Blashfield's blend of allegory and history, idealism and realism, female and male, was widely emulated, but some artists substituted locality or modernity for history. This was notable in Abbey's murals in Harrisburg and Alexander's in Pittsburgh. Alexander depicted the Arts and Graces of Life as female; the symbol of Pittsburgh, amid scores of muscled young men, was male. His solution to the choice-of-subject issue was a blend not just of allegory and history, however, but of allegory and modernism. After the two previous shifts in the iconography of mural painting, from private to public imagery and from allegory to history, this third shift would complete the development of beaux arts mural painting.

7 | MODERNITY AND GENDER

The Virgin and the Dynamo

BY 1910, IT WAS NOT SO MUCH HISTORY THAT WAS CONSTRUCTED as the opposite of allegory, but modernity, and the more "modern" it was (and not coincidentally, the more masculine it was) the more it was "American." Female personifications may have been appropriate in the early years of the movement when the goal of mural painting was perceived as pure "decoration" or "ideal" art. Women's role as "other" enabled them to function well as abstractions and symbols outside and above the reality of everyday life.[1] But as the twentieth century advanced, an antigenteel attitude began to argue for the representation of more "virile" aspects of the national culture. The dynamo, or a least the masculine face of modern industry, dynamic in its force, replaced the virgin.

The trend toward historical subjects had already reoriented murals in the United States toward masculine figures: men were far more often represented than women when the murals celebrated historical events. Historical subjects, whether they marked exploration, war, the negotiation of treaties, or the enactment of laws registered spheres in which men had historically taken a major role or historiographically had been perceived as having done so. The infatuation with modernity would complete the gender transformation of American

53. J. Carroll Beckwith, dome decoration, Manufactures and Liberal Arts Building,
World's Columbian Exposition, Chicago, 1893 (destroyed).
From *The Century Magazine* 24 (July 1893): 328.

murals from feminine to masculine and from European to American, often with
a binary opposition: allegory/foreign/idealism/female versus modernity/Ameri-
can/realism/male. The images of science, technology, and industry functioned as
the sieve through which issues of modernity and gender were sifted and called
forth the most emphatic recognitions of modernity in mural painting, especially
from critics writing for a popular audience. The language of such criticism was
often gendered. Not only were industrial subjects extolled as particularly modern,
but they were associated with traits perceived as masculine: energy, power, and
virility.

As Janet Marstine has demonstrated, much of the mural imagery at the World's Columbian Exposition "articulated an image of an artisanal past in which work is artful and saintly."[2] The figures painted in the domes of the Manufactures and Liberal Arts Building were most often gendered according to what they represented. While, in *Industries,* Kenyon Cox painted industries such as Ceramics, Textiles, and even Metalwork as female, Edwin Blashfield painted his Ironworker as male, and Simmons did the same for the resource of Iron. However, J. Carroll Beckwith, one of the first beaux arts muralists to create recognizably modern subjects, focused on scientific inventions of the nineteenth century while retaining the traditional female personifications. He painted four allegorical females in one of the domes in the Manufactures and Liberal Arts Building, in *The Morse Telegraph, The Arc Light, The Dynamo,* and *The Telephone and the Ticker* (fig. 53). In the center of the dome, a young boy personified the Spirit of Electricity. Beckwith varied his physical types more than his contemporaries had in the adjacent domes. A provocative nude held the light in *The Arc Light,* as a symbol of Truth traditionally holds a mirror. In *The Telephone and the Ticker,* a curvy woman in nearly transparent drapery was swathed in ticker-tape ribbons and the cords of the telephone. In *The Telegraph,* a serious young woman refers to a large book in her lap as she taps out Morse code. But *The Dynamo* departed most from artistic convention. As described by Pauline King, the Dynamo is "a stalwart young factory girl in working apron and blouse with sleeves rolled up, and smooth hair, seated on a magnet with revolving wheel at her feet."[3]

Beckwith's *The Dynamo* was a transitional type in the shift toward modernity. Her femaleness and the inclusion of an identifying attribute were grounded in the traditions of allegory, as was her abstracted gesture. Her working-class status, as well as her association with a symbol of modern industry—the dynamo—presaged the murals of the coming years that would further embrace modernity by transforming allegories of science and industry to industrial activity, and from the female to the male.[4]

Blashfield notably parted from the ancient tradition of personification that gendered most symbols of place as female. He painted America on the ceiling of the Library of Congress as a muscled young man, the man being identified in the contemporary literature as an engineer holding a dynamo (fig. 54). The mural, read in conjunction with its title, *The Evolution of Civilization,* meant that America's contribution to civilization was science and its attribute was the dynamo. The decorative arrangement gave equal weight to each figure so that the offering of the dynamo was matched to what other cultures had contributed: law, literature,

54. Edwin H. Blashfield, detail from *The Evolution of Civilization,* Library of Congress, Washington, D.C., 1896. From Cortissoz, *The Works of Edwin H. Blashfield,* n.p.

art, and so forth.[5] Marstine has noted that while Blashfield called his figure Science, the man is more convincingly identified as Technology, which normally called for a male figure (it is noteworthy that Blashfield had studied at MIT for two years).[6] Blashfield showed science put to a practical task, the invention of the dynamo and, by implication, the harnessing of electricity. Similarly, William DeLeftwich Dodge depicted male inventors in *Science* in the Library of Congress's Northwest Pavilion. A winged female figure crowned Edison, the inventor of the phonograph and the electric light.

As a counterpoint, a mural in the same building, Cox's *The Sciences* (fig. 55), depicted five nude or semiclothed females representing branches of the sciences. Astronomy is in the center, with Physics and Mathematics on the left, Botany and Zoology on the right. *Sciences* is a pendant to a painting, *Arts,* in the same room. Both are articulated in the "timeless" language of abstract personifications and are thus female. Furthermore, Cox ignored the more recent developments of modern science, perhaps to point instead to subject categories in the library.[7] Likewise, elsewhere in the library, Walter Shirlaw painted eight panels with single female figures representing the sciences: Zoology, Physics, Mathematics,

55. Kenyon Cox, *The Sciences,*
Library of Congress, Washington, D.C.,
1896. From King, *American Mural
Painting,* 209.

Geology, Archaeology, Botany, Astronomy, and
Chemistry. Each was distinguished by an attribute
identifying its particular science; for example, Geol-
ogy holds a fossil and a globe.

While Dodge had included various inventions
associated with electrical science, Blashfield included
the dynamo itself, one of the most powerful symbols of that generation. The
electrodynamo, or generator, had transformed New York in the 1880s and was
fast illuminating the cities and towns of the artists' boyhoods.[8] The light that it
brought—intense, blinding, pervasive—was analogous to modernity itself. Henry
Adams most famously used the dynamo to symbolize the modern age. Adams
implicitly acknowledged the gendered division between past and present when
he described the Virgin as "force" in the medieval period, symbolizing the unity
of the past, whereas the Dynamo stood for the multiplicity of the future (and
could function as a symbol of male sexual energy).

Blashfield's image of America is noteworthy in another way. The contempo-
rary literature identified him as an engineer, but in the ceiling painting, America
was depicted as a working-class laborer in the clothes of a machinist. It was such
a working-class laborer who, more than anything else, came to symbolize Ameri-
can modernity and, simultaneously, to embody principles of industry, in both
senses of *industry,* as hard work and as the institutionalization of manufacturing.

Charles Caffin's *The Story of American Painting* (1907) is evidence of the con-
temporary boredom with allegorical and historical subjects and the embrace of
a more modern iconography such as Blashfield had painted at the Library of
Congress. Caffin praised Blashfield, Charles Yardley Turner, and Elihu Vedder,
among others, but his overall evaluation of contemporary mural painting was

negative. He found that artists were "for the most part, out of touch with the vital forces at work in the community, not possessed of that vigor and originality which characterizes the leaders in other departments of life." Caffin, a British transplant, bemoaned the excessive propriety of American art, so out of tune with the country's "crudity of contrasts" and "its virility, not without its flavor of brutality."

Caffin singled out Cox's Library of Congress decorations *The Arts* and *The Sciences* (the artist was a scapegoat often cited by progressive critics because his mural style was recognized as one of the most academic, traditional, and conservative). Caffin complained that the conception in the two works displayed no imagination and offered little to interest the visitor: "In this threadbare affectation of classicalism [*sic*] there is evidence neither of American inspiration nor of the painter himself having any participation in the fullness of our modern life. His aim has been solely decorative."[9]

Caffin's comments exemplify the antigenteel attitude that marked much criticism in the first decade of the twentieth century. His choice of words, with its opposition of *propriety* and *virility*, anticipates George Santayana's famous essay "The Genteel Tradition in American Philosophy" (1911). Santayana coined the term *genteel tradition* to characterize the attitude against which Caffin and many others were already voicing their dissatisfaction. Santayana cast it in gendered terms:

> The truth is that one-half of the American mind, that not occupied intensely in practical affairs, has remained, I will not say, high-and-dry, but slightly becalmed; it has floated gently in the backwater, while, alongside, in invention and industry and social organization the other half of the mind was leaping down a sort of Niagara Rapids. This division may be found symbolized in American architecture; a neat reproduction of the colonial mansion—with some modern comforts introduced surreptitiously—stands beside the skyscraper. The American will inhabits the skyscraper; the American intellect inhabits the colonial mansion. The one is the sphere of the American man; the other, at least predominately of the American woman. The one is all aggressive enterprise; the other is all genteel tradition.[10]

The emergence of an antigenteel attitude accompanied the rise of realism in literature, exemplified by the novels of Stephen Crane, Jack London, and Theodore Dreiser. Painting and sculpture, however, were usually behind literature in the development of new critical orientations. Antigenteel literary criticism

provided the scaffolding and furnished an audience for the move in art toward a similar sensibility (although the subjects remained somewhat tamer than those in contemporary literature). The year after Caffin's survey was published, the artists known as "The Eight" staged their first exhibition. Now remembered as part of the so-called Ashcan school, the major players depicted American life as more urban, masculine, and energized than had their predecessors. John Sloan, Everett Shinn, George Luks, and George Bellows did not paint aristocratic women in well-appointed interiors, cradling the precious objets d'art that were so ubiquitous in late-nineteenth- and early-twentieth-century painting, but instead painted the working woman in working-class locations. There were also far more male figures than had been painted by the American impressionists contemporary to the mural movement, and those male figures acted with an easy familiarity toward women. The Ashcan artists gravitated toward the city streets, brimming with immigrant life, with a range of male and female, young and old —subjects not seen in paintings for half a century. Instead of "art for art's sake," there was, according to Robert Henri. art for life's sake.[11] In the Ashcan paintings, that life was contemporary and energized, not genteel and aestheticized.

The Ashcan school was part of a changing sensibility in American society and culture. During this period, when the beaux arts mural movement came into being, flourished, and then seemed anachronistic, the United States made giant steps in the transition from rural to urban, agricultural to industrial, provincial to cosmopolitan. But the tremendous changes in American life, attitudes, and place in the world can scarcely be inferred from mural paintings. Two years after Edison produced the first lightbulb in 1879, the first electric power plant was built in New York City, and John La Farge and his assistants were decorating the Cornelius Vanderbilt II home. At the World's Columbian Exposition, Frederick Jackson Turner proclaimed the end of the frontier, but this was not registered in the decorations at the Fair. The year after the Walker Art Building murals were installed, celebrating the great cities of Western civilization, the first wireless was invented, and six years later the first transatlantic message was sent. The Library of Congress opened in 1896 with electric lighting—and many timeless allegories.[12] The first foreign war in fifty years erupted the same year that the allegoric murals *Wisdom, Justice,* and *Power of the Law* (fig. 11), were painted in the appellate courthouse. The Wright Brothers first flew in 1903, the same year Henry Ford founded the Ford Motor Company . . . and Blashfield was painting *Washington Laying His Commission at the Feet of Columbia.* In 1914, World War I began in Europe, changing forever the meanings of words like *culture, beauty,* and *civilization*

—words that meant so much to that generation of artists. When the war cata-
pulted the Western world into the modern age, the idealistic impetus behind
their movement became one of its casualties. As Ernest Hemingway said, most
of the big words were lost for the generation that came of age during the war.

Most of these artists were middle-aged when the mural movement acceler-
ated in the mid-1890s. La Farge, the old man of the movement, was born in 1835,
Vedder, also senior to most, in 1836. Abbey, Alexander, Beckwith, Blashfield, Blum,
Cox, Dewing, Low, Millet, Mowbray, Pearce, Sargent, Simmons, and Thayer were
born between 1846 and 1858, and Reid and Benson in 1862. Oakley, born in 1874,
was one of the youngest to receive a major commission during this period. The
male artists were too young to fight in the Civil War (except for Millet, who was
a drummer boy) and too old to go to the Spanish-American War. Many were
studying in Europe when Reconstruction ended and during the railroad strikes
and other economic battles of the late 1870s and the 1880s. Although few got
rich from their art, their world was privileged. They distanced themselves from
the labor unrest that marked the period and from the great waves of immigration
that transformed New York, where most of them lived. For many successful
painters, social connections were with the artistic elite of the period, with fellow
members of the Players or Metropolitan Clubs.

This generation of artists had been rebels of a sort, however, when they
broke away from the provincialism of the Hudson River school and the American
genre. Some briefly flirted with a European-derived academic realism, but then
many set themselves up as aesthetes, claiming that the aim of their art was
beauty. After their European training, they considered themselves cosmopolites
and dismissed nationalist themes in favor of a genteel "art for art's sake" stance.
They came to mural painting late, as middle-aged artists whose artistic tastes,
life styles, friendships, and contacts were largely formed. But the public nature
of their mural commissions forced them to do an about-face and embrace con-
tent over style. In their mural painting, they had a tremendous opportunity to
register the forces transforming American society, but their background and train-
ing largely prevented them from realizing that opportunity. It was not just that
they did not have the imagination. The whole orientation of their art pointed in
a different direction, toward timeless truths and elevated sentiment and away
from the contemporary, progressive, or modern. It could be argued that this is
nothing new. In whatever era, whether sixteenth-century Venice or nineteenth-
century France, public art rarely registered contemporary events. Such art thus
came to be seen as timeless and universal and beyond the petty events of a given

period. For the Americans, to create timeless art in the early-twentieth-century United States was to elevate both their role as artists and their work in contemporary culture.

Although or perhaps because they came from an older generation, it was a struggle for the beaux arts muralists to be part of the sea change in art and attitude in the early twentieth century. When their audience, chiefly the dual powers of critics and building commissioners, grew tired of the allegory that most artists believed was appropriate for public sites because it was inherently more decorative and ideal, muralists shifted to history. William Van Ingen's murals representing the history of electricity for the Edison building in New York (c. 1900) exemplified this change from allegory to history. His subjects included Faraday, Franklin, and Sir Humphrey Davy. But history, especially because it was more often of the tricorned variety, in turn became tiresome. Its pedestrian references to the past were seen as not relevant to the restless, surging energy that Americans imagined all around them. Some muralists complied and redirected their art stylistically and thematically. The ones who were perceived as the most modern were those who shifted their subject to industry and technology.

As early as 1895, in his article "Outlook for Decorative Art in America," the painter Frank Fowler had said that the "the multifarious occupations of a young and growing country will be used as suggestive themes reducible to lofty treatment by means of mural art . . . business enterprise may be turned to aesthetic account, and transportation, freight, traffic and agricultural pursuits become fit subjects for noble illustration."[13] In the works of the more traditionally inclined muralists, where "lofty treatment" was a watchword, the treatment of industries seemed a token addition. The working man did, however, become particularized. Merging the wish to be modern with the desire of building commissions for local subjects, there was an understandable focus on the industries (e.g., mining, steel, shipbuilding) that had benefitted the localities where murals were being painted. William T. Smedley and Will Low, for example, both incorporated coal miners into their otherwise allegorical and genteel compositions. In Low's *Prosperity under the Law,* a Native American woman, personifying the Wyoming Valley of Pennsylvania and accompanied by allegories of Justice, Civilization, and Prosperity, appears with male figures dressed as farmer and coal miner. In Smedley's *Awakening of the Commonwealth,* a coal miner and a steelworker, representative of the state's two major industries, sit at the base of a throne on which the female Commonwealth reigns, raising her veil to greet the morning sun. On either side of the throne stand colonial figures from Pennsylvania's history.[14]

But more than any other examples, murals by Edwin Abbey and John White Alexander seemed to meet this challenge to be modern. Again the location was Pennsylvania, one of the most industrial states, and the emphasis in both was weighted toward the steel industry. Abbey decorated the state capitol in Harrisburg and Alexander the Carnegie Institute in Pittsburgh. Abbey painted four lunettes in the rotunda under the dome of the capitol. While *The Spirit of Religious Liberty* represented the impetus that sent settlers to the state, the other three paintings represented the "treasures" they found there: *Science Revealing the Treasures of the Earth* (coal) (fig. 56), *The Spirit of Light* (oil), and *The Spirit of Vulcan* (iron). The compositions, anticipated in earlier combinations of allegory and history by Blashfield and others, juxtapose the allegorical and ideal (female) with the literal and modern (male). *Science* included floating female figures representing Science, Fame, and Abundance, and in *The Spirit of Light* there was also a virtual crescendo of flying nymphs holding torches. But earthbound, below, are male figures, not dressed in the prosaic clothes of their occupations but draped in a kind of loincloth, revealing muscled torsos and heroic gestures. In Abbey's *Apotheosis of Pennsylvania,* also in the Pennsylvania State Capitol, excavating miners were depicted at the base of a set of steps; on the steps stand the notable males of Pennsylvania history, markedly different from the gracefully draped women in the *Hours* on the ceiling above.

One writer, calling Abbey's paintings "on a large scale modern life and modern science," contrasted them favorably with his Boston Public Library murals —"the present generation being much more immediately concerned with oil and iron than with the Holy Grail."[15] The critic Royal Cortissoz located Abbey in the forefront of iconographic innovation: "The church, and then coal, oil, and steel—these things have made Penn's commonwealth, and in going to them for his ideas Mr. Abbey has ranked himself with those mural decorators of his time who are in the van."[16] Blashfield went to Harrisburg and rhapsodized, "The whole impressed me, but the men going down into the earth with the floating goddesses at their side were *superb* as decoration."[17]

Alexander's murals for the Carnegie Institute, *The Crowning of Labor* (fig. 57, 58), spanned three floors. On the first and second floors were painted numerous muscled young men, emerging out of the smoke of undefined industries, presumably the steel and coke factories of Pittsburgh. In *The Apotheosis of Pittsburgh,* which occupied five panels in a prominent position on the second-floor landing, the city was represented by a male knight, variously identified as either the artist or Carnegie, who was surrounded by the "arts and graces of life"—women

56. Edwin Austin Abbey, *Science Revealing the Treasures of the Earth,*
Pennsylvania State Capitol, Harrisburg, 1908. Pennsylvania Capitol
Preservation & Hunt Commercial Photography.

bringing him the cultural rewards that industry brought.[18] The critic William
Walton's interpretation was typical:

> It appeared to be demonstrable that in this case the usual personification in
> a female form was not the most appropriate, that something more virile,
> less graceful, might be fitter, and thus appeared, in the great wall panels of
> the second story, the apotheosis of the steel City, as the mail-clad warrior,
> sword in hand, to whom the elements, the nations, the influence of Nature
> herself, brings gifts and tribute—the arts, the graces of life, that come to
> crown and complete the conquest of matter.[19]

Alexander's solution met with widespread praise. Caffin wrote that Alexan-
der "has realized a quantity of impressions locally characteristic and powerfully
suggestive. For it is Labor, as the foundation of the city's material greatness and
as the base on which she build her efforts toward the ideal that he set out to
commemorate."[20] An article on contemporary mural painting in 1908 found
Alexander's mural "a new and original way of interpreting modern life and offers
a suggestion for future development of our mural art, in the treatment of Ameri-

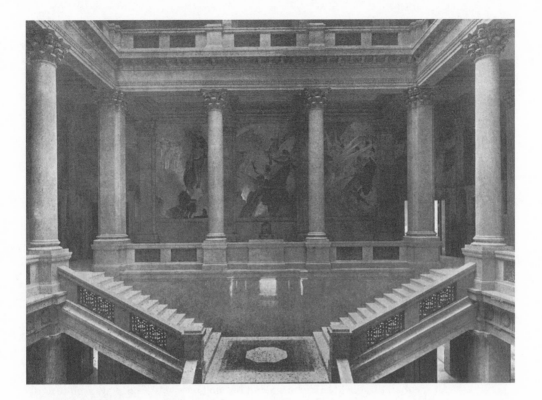

can subjects for a large and imaginative manner."[21] It was as though Alexander had transcended both straight allegory and history in much the same way that Blashfield had done, but with greater flavor of modernity. Walton related that Alexander had evolved a "resolve not to content himself with a mere record upon the walls of some of the most notable events in the local history but to create a great triumphal pictorial epitome, a monument of light and color and form, which should present in tangible and admirable shape all that the great manufacturing and commercial metropolis stands for in the annals of mankind."[22] Another critic praised Alexander's Carnegie decoration for its innovation and modernity: it is "a new and original way of interpreting modern life and offers a suggestion for future development of our mural art, in the treatment of American subjects for a large and imaginative manner."[23]

57. John White Alexander, *Apotheosis of Pittsburgh,* Carnegie Institute, Pittsburgh, 1905–8. From *The Craftsman* 16 (April 1909): 9.

The contrast of Abbey's murals with Cox's *The Sciences* or of Alexander's panels with Blashfield's lunette depicting *Pittsburg Offering Her Iron and Steel to the World* (fig. 59), painted only ten years earlier, is striking. The difference is not just

58. John White Alexander,
detail of first-floor Carnegie decoration,
The Crowning of Labor, c. 1905. From
Harper's Monthly 114 (May 1907): 847.

one of artistic styles but in the sensibility of different centuries. In Cox's *Sciences,* the Sciences are stiffly organized around a central figure of Astronomy—an anemic ensemble compared with those by Alexander and Abbey. Blashfield's dark and brooding Pittsburgh —iconic, frontal, impassive, centralized—is a monumental abstraction, which despite celebrating a contemporary city is ancient in its iconographic references. Alexander's knight was no more relevant to the modern age than Blashfield's Pittsburgh, but his maleness was. And so was the clear division between male workers who created civilization and the females with their gifts of the arts and graces of life that are their reward. In addition, Alexander and Abbey have eschewed the precise symmetry of Blashfield's and Cox's compositions; instead, their compositions were asymmetrical, full of movement, energy, and dramatic contrasts of light and dark. More importantly, they included with the details of modern industry the male figures that drive it. The paintings, Abbey's *Science* and Alexander's *Pittsburgh,* floated serenely above the ground, but below workers sweated to dig coal out of Pennsylvania's mines and to forge its steel. The male workers guided these murals into the twentieth century.

Again, writers for the *Craftsman* were responsible for some of the strongest arguments in favor of a more relevant iconography and more modern subjects. In 1909, an article provocatively entitled "Is American Art Captive to the Dead Past?" addressed itself in highly gendered language to "you painters and sculptors who think to get closer to architecture by decorating the stolen and effeminate glories of our modern Renaissance, who in the end only emphasize the emptiness of the temple by accenting or igniting its banalities." It called for them to "come out from among the tombs, join your fellow craftsman, the quarryman and

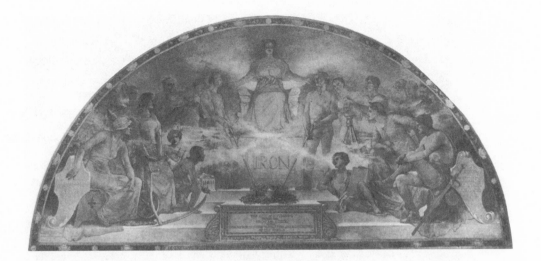

the woodsman, and realize that the cornerstone comes before the capstone. Realize that until the work of our hands in fashioning the necessities of life has been glorified, there can be no art that shall move men's souls."[24]

59. Edwin H. Blashfield, *The City of Pittsburg Offering Her Iron and Steel to the World* (a.k.a. *Triumph of the City of Pittsburg*), Bank of Pittsburg, Pittsburgh, 1898 (perhaps destroyed with structure). From King, *American Mural Painting*, 253.

Three years later, another article in the *Craftsman* extravagantly praised Shinn's decoration for the city hall in Trenton, New Jersey (figs. 38 and 60). Shinn's mural was not then nor did it ever become quite as famous or celebrated as Alexander's or Abbey's works. Shinn was younger and had not yet achieved the reputations of the beaux arts muralists, and a municipal building in Trenton was not prominent. Although a painter of urban subjects in his easel paintings, associated with the Ashcan school, Shinn, in his previous murals, had curiously presented a rococo flavor, probably because the paintings were all done for domestic or theater interiors.[25] In Trenton, however, his solution was akin to that of Alexander and Abbey, yet Shinn finally purged allegory from his murals.

Shinn depicted scenes from two industries native to Trenton, steel mills and pottery works—specifically, the Roebling Steel Works and the Mattock Kilns.[26] When the murals were painted in 1911, the current reaction against and boredom with historical subjects probably played a part in Shinn's choice of subject. According to the *Craftsman,* some observers had said that the obvious subject would be "Washington Crossing the Delaware." After all, murals celebrating

60. Everett Shinn, *Ceramics Industry,* detail of *Steel and Ceramics Industries,*
Trenton City Hall, Trenton, N.J., 1911. From *The Craftsman* 21 (January 1912): 381.

New Jersey's history had been recently painted in Newark and Jersey City. Shinn, however, believed mural painting ought to commemorate "not past glories but present ones."

The mural, which is in the form of a panel in two sections on either side of the city council bench, depicts male figures at work in the dark, smoky interiors of the steel mill and pottery works. Instead of including allegorical figures, as Alexander and Abbey had done, Shinn relied wholly on the heroic gestures of the laboring men to convey uplifting and energized sentiment. The anonymous author in the *Craftsman* found "not a single suggestion of insincerity, artificiality, of the painting for pure decoration's sake." Instead, "because these studies are realistic, because blood courses through the bodies of the workers, because the dignity of the workmen is the dignity of men and not of supermen, critics say that they are wholly modern, and admire them as a *new* phase of art. But as a matter of fact, they really represent an art of decoration that is as old as the ages, the art based on truth, and inherent in it."[27] The article also emphasized that Shinn used actual working men as models and noted how much they appreciated his work. In contrast to the murals by Alexander and Abbey, the absence of allegory and symbol also meant an absence of women (although the ceramics industry in Trenton employed both men and women).[28] As the subjects of science, technology, and industry gradually eliminated allegory, and with it women, they drew forth ever more exuberant recognitions of modernity.[29]

The young men in the murals by Abbey, Alexander, and Shinn were muscled but lean, their husky bodies stripped to the waist, working in a fiery realm of smoke and light. It is labor working heroically, but shorn of unrest. Modernity was synonymous with the strength of labor, but not with its dissatisfactions. Walton, who was an artist as well as critic, noted the celebratory aspects of Alexander's murals approvingly, finding that the laborers "work unrebellious and without discontent noble or otherwise, rather with a fine, impersonal, dispassionate ardor, much as we may image Vulcan's immortal smiths to have hammered out the Olympian thunderbolts." To Walton, this was the true theory of decoration: "Art, decorative art at least, should be neither bitter, cynical nor despairing, neither statistical, pathological, minatory nor too purely intellectual." His attitude was in tune with fellow critic Charles Caffin and the muralist Will Low, who also believed mural painting should be an antidote for the materialism of society in the United States. Apparently it was also best if it sheltered viewers from the labor problems of a newly industrialized society.[30] There is no hint of the intense labor organizing that took place during the period, nor of the strikes and work stoppages that plagued many industries.

The smoke that obscured the details of industry can be read as a metaphor (albeit an unintentional one) for the obfuscation of the labor struggles, the dangers of the work, and even the mundane details of salaries, pensions, and the length of the work week. The decorative aesthetic then in place reinforced the idealized message of labor's nobility. Alexander's murals, for example, advertised Carnegie's essay *Gospel of Wealth*, with its message that commerce and industry brought (and bought) art and culture. Art and Industry seem wedded as a seamless whole; there were no details to detract from the message; nothing seemed at odds or out of place. If we (men) work hard, then we will have the "arts and graces" of life (women). Everything worked together to produce the message and create the ideology. On the top floor, which Alexander did not live long enough to complete, he apparently intended to make this message even more explicit. According to his wife, Elizabeth, the panels on the third floor "were to be allegorical figures of the allied arts and showing that labor had enabled Pittsburgh to patronize the arts."[31]

The building commissioners who supervised the construction of edifices like state capitols or city halls were usually city fathers—the elites, if you will: male businessmen, lawyers, legislators. If one considers the building commissioners to have been the murals' patrons, the argument about the modernity of these images can be turned on its head. The embrace of modernism in this form of heroic, muscular, intensely physical workmen was a form of antimodernism. As George Beard complained in his book *American Nervousness* in 1881, many men and women were suffering from that particularly modern malaise—alienation from their bodies. T. Jackson Lears and Bruce Robertson have further investigated how many Americans, especially male elites, were in crisis in the late nineteenth century, cut off from the energetic forces of physical labor and having to compensate, either through an embrace of mysticism and aestheticism or other manifestation of antimodernism or, alternatively, through a glorification of male virility and power. Examples of the latter include novels like Charles Majors's *When Knighthood Was in Flower* (published in the 1890s) and the music of Louise Imogen Guiney. Melissa Dabakis has shown in her analysis of Douglas Tilden's *The Mechanics Fountain* (1901) that the stripped-to-the-waist body defined masculinity as heroic strength, a romantic tradition of labor that was no longer relevant to middle-class males.[32]

Gustave Stickley, the editor of the *Craftsman*, was associated with this antimodernist lament and desire for a return to the virtues and values of a previous age.[33] Another member of the elite was Henry Adams, and his famous pairing

of the Virgin and the Dynamo in the *Education of Henry Adams* (1918) articulated those dissatisfactions. Adams lamented the loss of the Virgin, as symbol of beauty and unity, while he marveled at and worried about the force of the dynamo, symbol of the multiplicity and fragmentation of modern society.

WHETHER they were taken as exemplars of modern energy or as a celebration of the brute physicality of a previous age, these murals were further indication of the debunking of the genteel tradition. Women were removed from their pedestals, as virgins, goddesses, and allegories in the inviolate realm of art, as those manifestations were increasingly seen as too genteel, elitist, foreign, and, eventually, academic or stylistically retrograde. A new hero was put in their place. When Americans worshipped the god of modernity, his symbol was the male American worker. He fulfilled yearnings for an American iconography while positioning the country as a leader to the rest of the world. In that way, he functioned like elements in other murals that positioned the United States (as America) as the culmination of the Western world.

8 | IDEOLOGY

Inventing Modern America

IT HAS BECOME A TRUISM THAT THE LATE NINETEENTH CENTURY was a time of tremendous change in the United States. The first mural movement developed at a time when the Civil War was a recent memory. At the end of the movement's heyday, the United States entered World War I. In between, the heaviest influx of immigrants in the nation's history arrived. The country moved from being an agricultural society to an industrial one; from a rural orientation to one that was urban; from being a provincial nation to assuming world power. Moreover, in this new commercial environment, as investors and speculators took advantage of the growing industrial economy, wealth became even more concentrated. A consumer culture was created out of the growing economy, providing the working and middle classes with an array of manufactured goods. New temples of commerce, in the form of department stores, and new avenues of salesmanship, in the form of mass advertising, were created to distribute these goods. New occupations, ranging from department-store clerks, stenographers, and typists to middle managers, arose. There were increased educational opportunities for women in undergraduate institutions and in universities for both professional and graduate training. Increasingly, professional specialization became the norm.

Both as individuals and as a group, the muralists positioned themselves in this new United States. Participating in the building boom in beaux arts structures in the late nineteenth and early twentieth centuries—the so-called City Beautiful movement—they embraced its rhetoric of progress in the idealist clothing of classicism. They celebrated the role of art in the creation of a new ideal—that of a harmonious architecture graced by beautiful murals that would educate, inspire and ultimately control the wayward elements of the body politic. Often exuberant in their iconography, in works like Edwin Blashfield's *Westward* they nonetheless put their optimism at the service of a controlled and controlling vision. A harmonious building promised an harmonious body politic.

The very nature of mural painting was to cover a wall, to embellish, to decorate. Or to cover up, to cover over, to wall up, to paint over. The job of beaux arts muralists was to prettify, as Will Low put it when he accepted the commission for Wilkes-Barre, or to dignify. It is perhaps no coincidence that many examples of beaux arts murals were in the gritty industrial locations of the northeast and Midwest. In the early twentieth century, those locations possessed the wealth to advertise themselves and their progress through the erection of impressive buildings and splendid murals. Like the raw materials the workers in Alexander or Abbey's paintings transformed, the rawness of a city or state metaphorized into a vision of beaux arts splendor that was the courthouse or capitol. Art and prosperity were literally wedded in the building that tax dollars had produced.

Given this role, and also given their rather precarious position as artists in the cultural life of the United States, it was not surprising that most of these muralists exhibited an establishment sensibility. They were unsubversive; there was little in their professional behavior or their products to which their clients could object. They promoted stability, harmony, balance, control, restraint and moderation. The mural aesthetic of decoration, which emphasized the harmony of the mural with the building, its essentially unobtrusive behavior, reinforced this establishment sensibility. It also made art seem a natural partner of the government; at its best, mural painting could expand the notion of democracy beyond what it had been, to incorporate art and culture.

To position themselves in the best possible way, muralists functioned as team players. In her recent study of the different identities artists assumed in America during this period, Sarah Burns identified the "corporate type," which in most cases described the contemporary muralist, at least insofar as he dealt with his clients.[1] The muralist was essentially a subcontractor to the architect. He signed a contract, articulated in the language of salary, square footage, scaffolds,

percentages, and deadlines. He was expected to be a professional like an architect or building contractor, or for that matter the businessmen-commissioners who often supervised the construction of public buildings. The architect Cass Gilbert, for one, went out of his way to convince the State Board of Capitol Commissioners in Minnesota that the artists he had chosen were professionals who could accomplish the job in the given time and produce quality work under the terms stipulated in the contracts.[2]

These ideologies and professional constructs were behind the formation in 1857 of the American Institute of Architects, in 1893 the National Sculpture Society, and in 1895 the Mural Painters, a National Society, later the National Society of Mural Painters. Echoing the increased departmentalization of American business, these groups were among many professional organizations that formed during this period. The National Society of Mural Painters soon published a list of professional guidelines that the muralists, architect, prospective client, whether it was business or government patron, should follow. The guidelines governed their relationship in competitions, contracts, deadlines, etc., and aimed to assure quality control. The client knew that behind any individual painter was an organization that guaranteed his work, figuratively if not literally. The assumption was that the artists could be trusted, and would provide quality work for a reasonable price. The value of the building would be vastly increased by murals— and depending on the building's function—decorate, elevate, instruct, and, most of all, beautify. Murals would enhance the architecture and the location's reputation and draw people to it and to the surrounding areas, and even create a tourist attraction, a sentiment still voiced today. Blashfield asserted that public art was one of the most important financial assets a place could have, citing Perugia and Paris. In this country, he called attention to the numbers of people who made pilgrimages to the Boston Public Library, the Library of Congress, and the state capitol at Saint Paul.[3] Muralists like Blashfield believed they were in the midst of an American Renaissance. The building was a tangible symbol of that Renaissance. It exemplified the alliance of the three arts, architecture, painting, and sculpture, and also the wealth, status, and prestige of the locality that had produced it.

Celebration not criticism was the metier of American murals. Instead of conflict, beaux arts murals imaged resolution. Art and commerce were wedded; the rule of law was upheld; justice prevailed, peace and prosperity abided throughout the land. The decorative aesthetic of mural painting, with its emphasis on harmony and integration reinforced this message. Beaux arts muralists were yea-

sayers, to the rule of law, the spread of commerce, the value of art, to the role of government. They may have warned about the necessity of Moderation and Restraint or the threat of anarchy but those were moralizing asides, expected of artists in their role as educators, imbued with a serious mission in the halls and domes of legislatures, courtrooms, libraries and even financial institutions.

Muralists asserted the viability of democratic values. Early on, the symbol Justice is everywhere in the courts: Simmons painted her both in his mural at the criminal court (fig. 61), and in *Justice of the Law* at the appellate courts, where Robert Reid, Metcalf, and Maynard also depicted her. Blashfield and Cox painted Justice in the county courthouses in Wilkes-Barre and Newark. The Law was another popular subject. In the appellate courthouse, in addition to Simmons's *Justice of the Law* were *The Power of the Law* and *The Wisdom of the Law,* by Blashfield and Henry Oliver Walker. In Wilkes-Barre was Low's *Prosperity under the Law,* in the Essex County Courthouse in Newark, Cox's *Beneficence of the Law*—or, to give Cox's full title, *Under the Rule of Law, Inspired by Justice, Peace and Prosperity Abide.* The fuller version is typical and indicative of the complex signification but essentially simplistic message of these murals.

Prosperity was indeed often the message, despite the economic crises of the period and labor unrest resulting from insufficient wages, dangerous conditions, and long hours. For railroad magnate Collis Huntington's home, Elihu Vedder painted *Goddess Fortune Stay with Us* and *Abundance All the Days of the Year.*[4] Dewing depicted *Commerce and Agriculture Bringing Wealth to Detroit* for the State Savings Bank in Detroit. For a bank in Cleveland, Cox depicted *The Sources of Wealth* and Blashfield *The Uses of Wealth* (fig. 39). In the first Prudence outstretches her hand toward a child holding the bridle of self-control. She sends her forward to receive the industries: Manufactures, Fisheries, and Agriculture below the protecting genius of Commerce. Blashfield's painting was described more fully as *Capital, supported by Labor Offering the Gold Key of Opportunity to Science, Literature and Art.* As Janet Marstine has shown, the message was part of a "public relations campaign to promote the bank as an institution working for the public" especially in an era when trust-busting was an issue.[5]

The buildings that beaux arts murals decorated were often marble, or limestone made to look like marble. Marble was associated with empire and wealth. These buildings were massive and immense symbols not only of culture or law or statehood but of the wealth of the municipality that had created them. They spoke in a loud voice, proclaiming their civic or cultural or commercial dominance of the city that surrounded them.

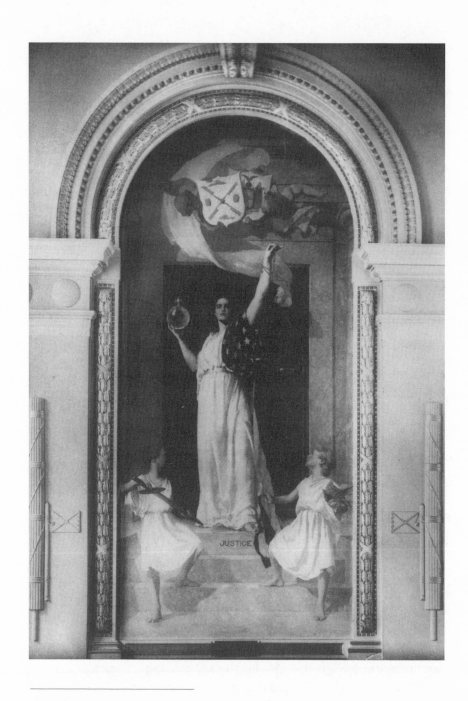

61. Edward Simmons, *Justice,* criminal courts building,
New York City, 1895 (now reinstalled in the newer courts building).
Courtesy of the Art Commission of the City of New York.

Controversy surrounding beaux arts murals was minimal and usually took the form of a kind of turf warfare, for example when artists in Minnesota objected to the employment of so many New York men; when people in the town of Saint Charles, Missouri, complained that their town, the first capital of the state, was not represented in the capitol's murals; or when special interests, the Catholics or the members of Civil War regiments in Minnesota, lobbied for something to commemorate their history. More serious controversies, as when the Catholics in Pennsylvania objected to Violet Oakley's glorification of Quaker William Penn, were wildfires quickly put out. Only the issues surrounding Sargent's *Triumph of Religion,* which offended Boston's Jewish community, could be considered a major crisis.

Given their affirming role it is not surprising that figures constructed as negative were not common. Most opposing forces are only implied, as moderation implies excess or corruption implies rectitude. There were some exceptions and they were framed in terms of polarity and binary opposition. Edward Simmons's *Justice of the Law* (fig. 11) in the appellate courthouse in New York, for example, showed Peace being protected from Brute Force by Fear. In Willard Metcalf's *Banishment of Discord* in the same location, figures of Retribution, Discord, Destruction, and Punishment appeared. Elihu Vedder clearly differentiated between the calm demeanor and stable position of *Good Administration* and the wild features and instability of *Anarchy* (fig. 43). *Corrupt Legislation* was the other negative in Vedder's program. She receives the revenue of the state while Labor was without work. Simmons's Mercer County Courthouse pendentive figures included a rare *Guilt,* pendant to *Innocence* as *Power* was to *Justice.*

As the content of American murals moved from allegory to history, law or justice is acted out instead of symbolized. Sometimes it was an event which showed the resolution of conflict: John La Farge's *The Adjustment of Conflicting Interest* in Saint Paul where Raymond of Toulouse swore allegiance to the pope, after being in conflict with his military forces over his association with a group of heretics. H. Siddons Mowbray's *Common Law* in the Cleveland federal building (1910), Frank Brangwyn's mural in the Cuyahoga County Courthouse in Cleveland (1913), and Albert Herter's *English Law* in Madison (1913) all commemorated the Magna Carta, when King John ceded some of his royal power to the nobles, making it a relatively popular subject in beaux arts murals.

Protests against the government or the rule of law were most often cast safely back in colonial history. Charles Yardley Turner's *The Burning of the Peggy Stewart* in Baltimore and Reid's *Boston Tea Party* depicted commonly known incidents of

colonists' protests against their British masters. Reid's *James Otis Arguing against the Writs of Assistance* (fig. 47) also in the Massachusetts State Capitol depicted another famous episode from colonial history: Otis argued against the writs that would have allowed British custom officials to enter premises at any time to search for smuggled goods. Frank Millet's panel in Newark, *Revolt of the Grand Jury,* showed the foreman castigating the chief justice for his comments that the imaginary tyranny in England was less to be feared that the real tyranny here.

The threat of marginalized groups such as Native Americans was neutralized by their subservience to the rule of law in the United States. Their land was bought in Jersey City; they bartered in Pierre and Baltimore or they signed treaties in Baltimore, Saint Paul, and Harrisburg; and they submitted to the rule of Anglo-Saxon law in Madison and Youngstown.[6] All those murals seems to say that we have treated the Indians well: we got their land fair and square.

When the settlement of the west took the form of a series of panels, the artists implied that the progression was the natural order of things. Millet's series of thirteen panels for the Cleveland Trust Company on the history of the settlement of Ohio traced that development all the way back to the Norse explorers, pilgrims, trappers, and frontiersmen. In *Enterprise,* the eighth panel, Indians sign a treaty with the white men. The following panels show white settlers surveying, clearing, building, tiling, and finally harvesting the land. It was as though making Indians disappear from visual iconography could make them by implication vanish from the life of the country or state.

This was also the implication behind Edward Simmons's series of four panels for the Minnesota State Capitol, *The Civilization of the Northwest* (or *Settling the West*). In Simmons's decorations (figs. 45 and 62), the allegorical narrative unfolded over four panels in the spirit of a moral fable: the male was American genius, is guided by a female Wisdom. In the second panel Wisdom banished Savagery, represented obliquely by animals. Although no Indians are represented, the implication of savage animals was clearly directed toward them.

Blashfield's panel for the governor's reception room in the South Dakota State Capitol, entitled *Dakotah* (fig. 63) was more explicit. A homesteader and a soldier accompanying a female Dakotah were led forward by a Spirit of Hope, literally crushing Indians beneath their feet. The allegorical figures were of course female, the historical figures male. In *Discoverers and Civilizers Led to the Source of the Mississippi* in Saint Paul, Blashfield appropriated the spiritual qualities of Native Americans, showing settlers and explorers in respectful homage at the feet of Manitou, an Indian who symbolized the Father of the Waters.

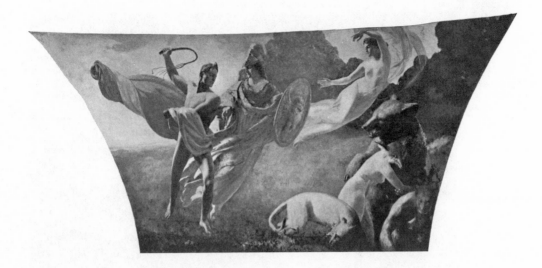

62. Edward Simmons, detail of *Civilization of the Northwest*, 1904. From Blashfield, *Mural Painting in America*, opp. 252.

But there was no doubt that the Indians' time was past. An article on the Saint Paul murals in 1905 rhapsodized that "however short a time the commonwealth of Minnesota has been in the making, it is none too soon to bid good-bye to the tomahawk, to see the pow-wow give place to the caucus, the wigwam to the capitol."[7] Blashfield himself, in his explication of his mural *Wisconsin: Past, Present, and Future* in the state capitol in Madison, stated that "at the extreme right of the picture are two Indians who shade their eyes from the light, suggesting the order of things entirely passed away."[8]

There is some sense even that Native American history was irrelevant to that of white America. Soon after La Farge's murals were installed in Saint Paul, Low wrote an article ("The Mural Painter and his Public") in which, although he did not mention La Farge by name, he seemed to sanction La Farge's approach to history when he depicted scenes from classical, biblical, Chinese, and medieval times. Low stated that in art "ethnographic considerations have little weight, and the oriental shepherd who watched their flocks by night are infinitely nearer to us, to our hearts, to every pulsating fibre of our natures than the savages that we despoiled and have nearly exterminated"; since we still wear "the yoke of the Roman empire," Caesar, he claimed, is more potent in our lives than the American Indian chief.[9]

If we set aside the fact that Indians were shown in a role fashioned for them by white society, we may note that, in contrast to the number of Native

63. Edwin H. Blashfield, *Dakotah, or The Spirit of the People*
(now known as *Only by Contemplating Our Mistakes Do We Learn*),
South Dakota State Capitol, Pierre, 1910. Photo courtesy of the
South Dakota State Historical Society–State Archives.

Americans depicted, African Americans were almost absent from beaux arts murals. Even though most murals are in northern and midwestern locations, where one might anticipate a celebration of the Union victory in the Civil War, the war's legacy can be seen in the absence of blacks. Lincoln was rarely painted. In Blashfield's *Evolution of Civilization*, however, America was an Abraham Lincoln look-alike, clad in the clothes of a machinist, perhaps evoking the myth of the self-made man. Oakley unsurprisingly painted Lincoln in her mural *The Creation and Preservation of the Union* in the senate chamber at Harrisburg. Tellingly, the other major exception was at the Chicago Federal Courthouse, where William

Van Ingen painted the Emancipation Proclamation. The location, of course, was Illinois, Lincoln's home state.[10]

It is no coincidence that Liberty and Freedom were also conspicuously infrequent. Liberty was intimated in colonial terms, with its white males arguing for judicial or tax rights. The only freedom that was highly visible was Religious Liberty, depicted by both Abbey and Oakley in Harrisburg and by Blashfield in Baltimore. Vivian Fryd's argument about the similar absence of both blacks and the abstract concepts of Liberty and Freedom in the antebellum U.S. Capitol holds here. She has theorized that, while Native Americans could be safely banished to the reservation, African Americans were more visible and were seen as a continuing problem as they operated outside mainstream society.[11] The issue of African Americans had obviously deeply divided America, whereas over the treatment of Native Americans, most were in agreement. For artists seeking consensus and harmony, images of African Americans were still too divisive.

In both their private and public remarks, beaux arts muralists occasionally articulated a casual yet ingrained racism. When Low painted sixteen nations and the musical instruments they were known for (for the Waldorf-Astoria Hotel)—Italy with a cello, Spain with castanets, and so on—he stumbled when he came to the United States: "Our own country, for instance, can hardly be said to have a national musical instrument, unless it be the banjo, and that in some way would have seemed to necessitate the portrayal of a colored woman. This difficulty I overcame by making America typical of vocal music."[12] And the offhand nature of everyday racism was evident in a letter Blashfield wrote to Mowbray in 1921, warning him against night travel on trains to Washington, D.C., where the Pullman porters—or, as he says, "the darkies"—will "boil you till two or three a.m. and then turn off the steam suddenly."[13]

In an era of increased immigration, especially from eastern Europe, we naively might expect a glorious celebration of the United States as a melting pot. Indeed, that was the subject of a mural by Vesper Lincoln George for a high school in Ohio, but it was an obscure example.[14] Instead, in the main immigration was reflected obliquely. Alexander's murals at the Carnegie Institute project a desire for a population sanitized of all foreign elements. His *March of Progress* on the third floor contained more than three hundred figures, all white and appearing to be northern European.

But most often scenes of immigration were safely distant in the colonial past. This not only established a pedigree for the longer-established white inhabitants

but, by implication, contrasted them with the current arrivistes. Walker's *The Pilgrims on the Mayflower, November, 9, 1620,* at the Massachusetts State Capitol, Turner's *Landing of the New Englanders at Newark, May 17, 1666,* Howard Pyle's *Landing of Carteret* in the Essex County Courthouse, Newark, Pyle's *The Coming of the Dutch* and *The Coming of the English* in the Hudson County Courthouse were examples of local pride in early settlement. It was no coincidence that the Magna Carta was depicted so often (by British artist Brangwyn, in Cleveland, and by Herter and Mowbray): the Magna Carta established the Anglo-Saxon heritage as the legal and democratic forerunner of the United States, positioning the Anglo-Saxon race as the nation's rightful ancestors.

Anti-Semitism was also casual and ingrained. Critic William Coffin wrote to Mowbray from New York in 1920: "We are pretty well swamped by the foreign element from the most undesirable parts of Europe—all that Russian, Balkan, cheks-Slavak realm wherever it is. And the chosen peoples crowd the sidewalks and every other place."[15] Michelle Bogart has discussed Blashfield's murals for the City College of New York that depicted the great universities of the West in this context. Blashfield's original idea, akin to what he had done for the Library of Congress, was to depict the countries that had been centers of education. At a time when City College was 75 percent Jewish, it would have been logical to include ancient Israel, but Blashfield demurred, believing that he would appear to be selling out to special interests. Instead, his solution, the depiction of great universities, was to his mind a way to claim universal and long-lasting values.[16]

Women's marginalized presence in society was of course not signified by their absence but by the plethora of female presences as allegorical figures—figures of everything from Religious Liberty and Cleveland to the Telegraph. The physical type of women depicted in the Library of Congress murals and others of the period was to a certain extent a function of the artist's style and whatever psychological motive and aesthetic preference led him to depict them in his way: Walker's were tall and elegant, Shirlaw's chesty and curvy, Blashfield's massive and iconic, and Cox's monumental and pale in color. As many feminist art historians have argued, although women were depicted endlessly, Woman was absent. The women in the murals were the tabula rasa of desires and ambitions of their male creators, whether they were the artists, architects, or members of building committees. Their identities acted out the ideologies of male-dominated society.[17]

There was, however, a change in the physical type favored by easel painters who received private mural commissions in the 1880s and early 1890s. If we com-

pare the figures in Dewing's *Morning* (1879; Delaware Art Museum), for example, with those in *Night, Day, and Dawn* (fig. 41) in the Hotel Imperial, there is little difference. There was, however, a great deal of change between, on the one hand, the types favored by Mowbray in his easel paintings and those chosen for his mural decorations in the appellate courthouse and the Cleveland federal building and, on the other hand, Dewing's later *Commerce and Agriculture Bringing Wealth to Detroit* (fig. 44). The change is partly a result of the public nature of their new roles, but it also can be associated with the reorientation of society in the 1890s—a change first argued by John Higham and, more recently, Alan Trachtenberg and T. Jackson Lears. Instead of the elegant gentility of the women in the easel paintings, there was either an active energy or an iconic presence that bespoke a concern with reinvigorating American society. Both the nervousness of males in the United States, noted by George Beard in his 1881 *American Nervousness,* and the fragility of American females were rejected. This phenomena was related to fears about the future of the Anglo-Saxon race in the face of widespread immigration. The monumental women of these murals, whether iconic or active, were impressively formed Anglo-Saxons, capable of bearing a race of the same. As I argued in *Angels of Art,* these more physically monumental types can be related to other phenomena of the era, such as the New Woman and the increased physical culture of women's lives, which encouraged them to ride bicycles and play tennis.[18]

But the fact remains that women were rarely shown as direct participants in history or as the movers and shakers of American progress. Blashfield was one of the few to show them as pioneers and to show a female academic as an indication of women's role in education. Mary Cassatt intended a section of her mural *Modern Woman* to be interpreted as woman's search for knowledge, but the mural's transitory nature and difficult readability made that interpretation problematic. When Edwin Abbey depicted the *Apotheosis of Pennsylvania* (fig. 17), that female icon was massive and elevated above the rest. Nonetheless, she appears embalmed, while flesh-and-blood men, historical personages, were arrayed on the steps beneath her. Hers was the universality and power of symbol, theirs, the specificity and power of active lives on the stage of human history.

The concept "American exceptionalism" (that the United States was special in every way, defying all previous definitions of nationhood) described the norm in beaux arts mural painting. But some artists went further, positioning the United States as the culmination of human evolution. The best-known example was Blashfield's *The Evolution of Civilization.* As an early handbook of the Library

of Congress noted, it was "the function of a great library to gather and preserve" the records of that evolution,[19] and Blashfield symbolized the evolution by having twelve figures represent either countries or epochs, which in turn were identified by their major contribution.[20] His iconography reinforced contemporary ideologies, which usually ignored East Asian, sub-Saharan, and Pacific cultures: the orientation was, with the exception of Judea and Islam, decidedly Eurocentric. The use of the decorative aesthetic then in vogue—the creation of a mural in perfect harmony with the architecture—made his choices seem the natural order of things, not based on the beliefs and prejudices of the late-nineteenth-century United States. The pale, cool colors made his figures seem otherworldly. They inhabited an ethereal ideal realm of chaste spirituality, giving his very selective choices divine sanction. The contemporary chauvinism of his choices was, and still is, most apparent in the final figure in the dome, the male engineer who represented the United States and its contribution, Science. The eleven cultures that had come before were seemingly united in an effortless, harmonious, and seamless evolution throughout history, all leading toward America. Blashfield not only selected the history that produced the engineer but also presented him as the culmination of the history of Western civilization.

There was also a constant attempt to place the nation's laws within the context of an older legal tradition and to make it seem by implication that the United States was at the end of the legal evolutionary chain. For the supreme court in the capitol at Saint Paul, La Farge painted four lunettes representing Moses, Confucius, Socrates, and Raymond of Toulouse, and in the Baltimore courthouse he placed six of the great lawgivers of the past, including Mohammed, Moses, and Confucius—implying that the capitol and courthouse were the culmination of the contributions of past lawmakers. Similarly, in the Cuyahoga County Courthouse, the two major murals facing each other across the rotunda are Brangwyn's representation of the signing of the Magna Carta and Oakley's scene from the Constitutional Convention. In Herter's series on law, his *American Law* (represented by the Constitutional Convention) follows *Roman Law*, and *English Law*, and is followed by *Local Law*, a scene from Wisconsin.[21]

In the first decade of the twentieth century, Manifest Destiny was still being celebrated. In Simmons's *The Civilization of the Northwest* in Minnesota and Blashfield's *Dakotah* in South Dakota, the move westward was interpreted as a cleansing process. In Blashfield's murals in Minnesota and Iowa, the celebratory spirit of its rhetoric sanctioned the white man's move. In the Essex County Courthouse, Pyle painted *The Landing of Carteret* (fig. 51), a scene from 1665, when Philip

Carteret, the new governor, landed in Newark and was greeted by settlers. In the typescript explaining the mural, written presumably by Pyle, the scene is glorified as a paean to Manifest Destiny:

64. Kenyon Cox, *The Marriage of the Atlantic and Pacific,* Wisconsin State Capitol, Madison, 1915. Courtesy of the Wisconsin Historical Society.

> The faint fragment of a rainbow against the passing clouds, the symbol of promise of the divine enlightenment of the future of the new nation about to be established upon the margin of that strange new world . . . a new world in which the coming peoples should upbuild a mighty nation, which, dwelling in peace and tranquility, should stand before the entire world, the example of a world ruled, not by the strong hand of arbitrary power, but by firm and rigorous laws of self government, framed by themselves for their own self control.[22]

Putting the United States at the end of the evolutionary chain and sanctioning the nation's right to conquer all lands could be seen as legitimizing her behavior in a range of spheres. As Frederick Jackson Turner so famously articulated, the frontier was no more by 1890. But the imagery derived from Manifest Destiny could be a code for the imperialism that replaced it. American exceptionalism not only gave a sanction of sorts to her move westward but also formed a part of the ideology of world expansion. Murals embodied the expansionist values in U.S. government, and this exceptionalism sought to sanitize the nation's imperialist ambitions. Works like Reid's *America Unveiling Her Natural Strength* at the 1900 Universal Exposition in Paris were more obvious renderings of this

ambition, made explicit by the Spanish-American War and U.S. annexation of the Philippines.

When Cox lobbied for and received an additional commission for the Wisconsin State Capitol in 1915 (Alexander had accepted it but then pulled out), he choose a topical subject, the recent opening of the Panama Canal. He called his work *The Marriage of the Atlantic and the Pacific* (fig. 64). Madison, Wisconsin, was far from either ocean, not to mention Panama, but it was a momentous event for the whole country. Cox painted it as a male Atlantic putting a ring on a finger of a female Pacific; he also included symbolic personifications of Japan and Polynesia. Located in Madison, in the heart of the country, the mural carried the implication that the the United States, not Panama, was at the center, the product of that marriage.

9 | ECLIPSE

AFTER 1917 THERE WERE SOME NOTABLE COMMISSIONS, BUT most did not fit the beaux arts mold. The Missouri State Capitol in Jefferson City, for example, was a study in exceptions. It was not until after the 1917 completion of the capitol building (designed by Tracy & Swarthwout, a New York firm) that a board of commissioners was appointed to oversee the decoration of the building. The board, instead of being led by the usual business or civic leader, was headed by John Pickard, an art historian from the University of Missouri at Columbia. Pickard was instrumental in the selection of artists. For the most prominent location under the dome, he chose the British artist Frank Brangwyn, who seems to have appealed to him for his lack of connections to the U.S. beaux arts movement (his only major commission in the United States to date had been the Cuyahoga County Courthouse). Brangwyn contributed both allegorical and historical paintings: as well as allegorical figures of Agriculture, Commerce, Science, and Education, he depicted four episodes from the history of the state, one scene from the colonial stage, two from pioneer times, and one from the modern era—a unique choice for pendentives. Brangwyn's style was also unusual for mural decoration in the United States: it was closer to postimpressionism than to

Puvis de Chavannes in its light yet intense coloration (blues and oranges predominating) and relatively radical foreshortening. Although Brangwyn depicted the heroic labors of modern workmen, in this case building the Eads Bridge in Saint Louis, his style was less romantic than Alexander's and Abbey's, without the smoke and mist that heroically framed their workmen.

In addition to Brangwyn's paintings, there were, among others, works by Gari Melchers—anemic depictions of four great Missourians (one of them a woman) in tall lunettes in the governor's reception room. The style was akin to grand-manner portraiture, a rare exception in beaux arts mural decoration. Missouri native Richard E. Miller represented four historical scenes for other tall lunettes in the senate. A French artist, Charles Hoffbauer, painted a scene from World War I for the house of representatives.

All of the remaining spaces were lunettes in the corridors on the second floor, leading off from the central area under the dome. For two of these lunettes, illustrator N. C. Wyeth furnished Civil War battle scenes, and the majority of those remaining were painted by members of the so-called Taos school of landscape painters, who were chosen by Pickard in a kind of package deal (Pickard had been vacationing in Taos, New Mexico, for many years). Their scenes, reminiscent of Charles Russell in their coloring, gave a decidedly western cast to the Missouri landscape. The lunettes were at eye level, and smaller in scale than those usually found in beaux arts structures. They function more as easel paintings than as murals.

The Missouri State Capitol was noteworthy for more than its important list of exceptions. Far more than for the murals by Brangwyn, Melchers, or the Taos school, its artistic fame lies in the 1936 decoration of the senate lounge by Thomas Hart Benton (fig. 65). Benton's paintings, associated with American regionalism and its offshoot, the murals of the government-sponsored Works Progress Administration, have for years served as a stylistic and thematic foil to the beaux arts murals in the rest of the building. They did not glorify explorers or settlers but bluntly depicted a low-life aspect of politics, complete with moonshine jug and the hardships of farm life, and included Missouri subjects such as "The Ballad of Frankie and Johnny," Jesse James, and Huck Finn and Jim. Despite their determinedly national iconography, Benton's decorations were done in a style indebted to European modernism, with expressionist distortion and radical shifts of scale.

As Benton's mural attests, there were vast differences between the beaux arts mural movement and what emerged in the 1930s. Benton seemed determined to

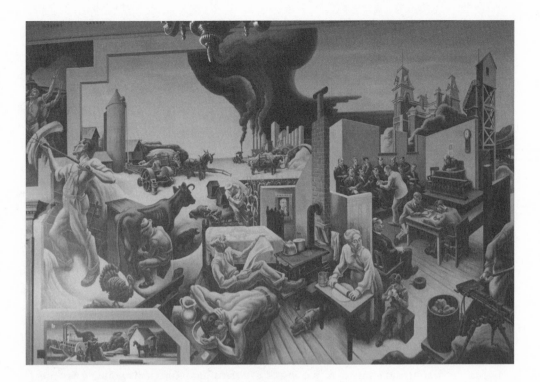

65. Thomas Hart Benton,
from *Social History of Missouri,*
Missouri State Capitol, Jefferson City,
1936. © T. H. Benton and R. P. Benton
Testamentary Trusts/Licensed by VAGA,
New York, N.Y. Photo © Zeal S. Wright,
Jefferson City, Missouri.

find a particular American idiom and was not willing to sacrifice to the niceties of genteel taste. His treatment of Missouri life was frankly accepting of all aspects of life, however sordid. His style was boldly designed and graphically colored. The idea that a mural was supposed to make nice and act subservient to the architecture was apparently an old-fashioned idea. Benton's murals take over the room, grabbing viewers and making them take notice.

The Missouri murals, 1918–21 and 1936, indicate the hiatus in mural painting between the early 1920s and the beginning of the Great Depression. By that time, most of the beaux arts muralists were either past their artistic primes or dead. Exceptions like Violet Oakley were working in what now seemed an out-of-date style. Despite attempts to keep the tradition alive at the American Academy in Rome, and artists like Barry Faulkner and Allyn Cox (Kenyon Cox's son), producing murals related to their recent forebears, the tide changed from the beaux arts tradition. It was seen as increasingly anachronistic. The new generation did not

seem interested in taking the place of the older beaux arts muralists. Architects and building commissions were not willing to advance vast sums for grandiose figure subjects. As early as 1912, Cass Gilbert wistfully recalled to Blashfield the glory days at the Minnesota State Capitol: "Will we ever again have just such a group of artists and such a client as in the old Minnesota Capitol enterprise. . . . What a group! Is our American Renaissance passing? All too short lived? Or are we going on to yet greater things? Let us hope, and work on." But it was not to be. The next year, Blashfield complained in a letter to Mowbray that the people "accepting the idea that mural painting can be done by <u>any</u>body at any time without special education almost without preliminary education of any sort . . . today a small group of men think that learning how to do ornament well, will suffice (without knowledge of the figure)."[1]

In 1921, artist Ernest Peixtoto published "The Future of Mural Painting in America," an article in *Scribner's Magazine.* Noting that what he defined as the "passing generation" had been chiefly concerned with the decoration of public and semipublic buildings, he complained that too much mural painting was "spoken of in hushed whispers and raised to a dignity that has placed it above the reach and the comprehension of most people." Peixtoto claimed that mural painting has come to a "parting of the ways" and that many younger architects were tired of it. They "have ceased to count it among the necessities of the decoration of their buildings." He mentioned that other forms of mural decoration were springing up—for living rooms, business buildings, shops, and other sites. The new style was "more amusing, more stimulating, more imaginative and romantic in character." As examples, he cited artists recently returned from Rome —Arthur Crisp and Barry Faulkner.[2]

Several discourses led to these shifting perceptions that labeled beaux arts mural painting as anachronistic: the antigenteel movement (the rejection of the ideal and beautiful and the concurrent desire to see works that reflected energies, dynamism, and even crudeness of modern life, perceived as American and inevitably masculine); the cultural-nationalist point of view (the call to emphasize the people and places of the United States, and not eternal or universal verities); the economic bias (the perception that allegorical and symbolic subjects were somehow elite and antidemocratic); and the modernist movement (the reaction against the beaux arts style in the face of artistic modernism).[3]

All the attitudes involved in these trends were fully in place by the beginning of World War I. By the time the war ended, the zeitgeist had shifted so much that in the jaded, modernist decade of the 1920s, the beaux arts muralists and

their contemporary soulmates were perceived as distinctly old-fashioned, staid, and boringly bombastic. By 1930, the critic Lloyd Goodrich (later to be a much-esteemed curator and art historian) could excoriate Oakley for her "wearisome, prayerful academic art." With all the brashness of his youth, Goodrich used Oakley to denigrate the whole generation of his elders, the beaux arts muralists:

> She is one of those artists who, by dint of much formal decoration, divine and profane, has lifted herself to a position where her friends look upon her art as something too dignified and serious to be referred to critically. Essentially the seriousness of her art is due to the fact that its author has come to be known as one of America's dignified mural painters. Like the others of her group, she has managed to impose upon the public an uncritical attitude. Her work is thought to be important because it occupies high sounding places. The truth is that most of the official decorators in America are decorators, not because they have any particular talent for such work but because their original impulse was too lifeless to bring them any success in the larger competitive field of the easel picture.[4]

A 1932 exhibition in New York at the Museum of Modern Art, *Murals by American Painters and Photographers,* was accompanied by a catalog in which Lincoln Kirstein wrote of the beaux arts murals as "filled with pompous echoes of Venice and Rome" or genteel costume illustrations. He lambasted the American Academy in Rome as an "academy of a particularly strangulated, debased and flat archaisticism—the dilution of models already diluted."[5] Neil Harris has written that the turnabout was so radical that Lewis Mumford's *The Brown Decades* (1931) was revisionist in its attempt to treat the period at all. That same year, the Empire State Building was completed. With its soaring phallic profile, metal details, and rigidly geometric design, it was in high contrast to the building it replaced, Henry Hardenburgh's Waldorf-Astoria Hotel, with its murals by Low and Blashfield, completed only thirty-five years before. Many other beaux arts buildings and their murals were destroyed in those years.

In the 1920s, new ideals replaced the old. But while the beaux arts style was not geared to take on the new energies, neither was a new American style yet formed to tackle them. The gradual importation of European modernism, ironically coupled with the isolationist tendencies of the 1920s and the democratic impulses of the depression, coalesced in the 1930s to produce a new mural style by painters like Benton and the WPA artists. A similar blend of nationalism, modernism, and socialism produced the great Mexican muralists, Diego Rivera,

David Siqueiros, and José Clemente Orozco.[6] Generally, there has been more interest, both popular and scholarly, directed toward them than to their beaux arts predecessors, perhaps because the murals have an easier readability and narrative thread and seem to celebrate the "common man" and an ideology more easily associated with more popular historiographic trends.

Nevertheless, beaux arts murals have found a renewed appreciation, partly as a result of the "landmarks" movement of the last thirty years, with recognition of the appalling loss that the modernist thrust of most urban renewal projects wrought in the 1960s. Recent publications such as Mary Lackritz Gray's *A Guide to Chicago's Murals* document the extant decorations as well as those gone "but not forgotten."[7] Except for the Essex County Courthouse in Newark, which is undergoing renovation, all of the major extant sites discussed in this book have already been restored in the last fifteen years, with the result that the newly gilded, painted, touched up, restored buildings and their murals shine with a renewed life.

It is poignant, however, to see that the locations of many beaux arts murals that were thriving, proud, ambitious places in 1900 have since slid into decay. The source of their wealth was often in industry, and that industry has often shrunk or moved away, leaving them—Youngstown, Newark, Detroit, Wilkes-Barre—symbols of rust-belt decay. In some instances, Cleveland and Newark especially, the current municipal rhetoric is all upbeat, although one doubts that they will again achieve the prominence and wealth they had in the first decade of the century.

Preservation and conservation have had some curious repercussions. In South Dakota in the 1970s, the decade of Wounded Knee and the formation of the American Indian Movement, the state commissioned a Native American artist, Paul Warcloud Grant, to paint a mural for the governor's reception room. Entitled *Unity through the Great Spirit,* it was divided into Indian and non-Indian scenes. It celebrated the history of the state, site of not only some of the bloodiest events in the Indian wars but the also the Black Hills, sacred to the Sioux. But in the spirit of historical verisimilitude during the capitol's 1975–89 renovations, that mural was removed to the state library and the beaux arts murals by Blashfield, Simmons, and Charles Holloway were restored.

The problem came up of how to handle Blashfield's *Dakotah* (or *Spirit of the People*) (fig. 63), since it showed a symbolic figure of the state spurred on by a Spirit of Hope, accompanied by a homesteader and soldier who are literally crushing Indians beneath their feet. An ingenious solution was found—simply change the title: it is now *Only by Remembering Our Mistakes Can We Learn.* A

plaque notes that the new title was fashioned "to appropriately reflect the changes in the times and the attitudes of the people."

The irony is that the old-fashioned iconography is postmodern in its fluidity and ability to accommodate the change plausibly: the vacant-staring (shell-shocked?) woman can still symbolically be the state of South Dakota. But instead of being spurred on by Hope, she can be seen as drawn back by Memory. The once physical, tangible, realistic forms accompanying her—the homesteader and soldier crushing Indians—are now figments of that memory. She stares ahead: they are in the past, and she is intently learning from her mistakes. Blashfield took his art so seriously that he probably would not be amused at how his carefully worked out iconography has been manipulated into a new interpretation. Yet he was a showman, an advertiser, a public-relations man who carefully calibrated the effects that he wanted. It is a measure of his success that his imagery survived to become an issue so important that its meaning must be altered to remain viable and visible.

NOTES

ABBREVIATIONS

AAA Archives of American Art
MHS Minnesota Historical Society
NYHS New-York Historical Society

INTRODUCTION

1. Will H. Low, *A Painter's Progress* (New York, 1910), 7.

2. Irving Sandler, *The Triumph of American Painting: A History of Abstract Expressionism* (New York: Harper & Row, 1970), 10.

3. This was simultaneous to the creation of murals internationally in places of political unrest—Belfast and Nicaragua, for example. See Bill Rolston, *Politics and Painting: Murals and Conflict in Northern Ireland* (Rutherford, N.J.: Fairleigh Dickinson University Press, 1991), and David Kunzle, *The Murals of Revolutionary Nicaragua, 1979–1992* (Berkeley: University of California Press, 1995).

4. The library was financed partly through fund-raising among special-interest groups in the city. The reading room received donations from gay and lesbian groups.

CHAPTER 1

1. For this opinion, see Selwyn Brinton, "Modern Mural Decoration in America," *International Studio* 42 (January 1911): 176. This was overwhelmingly the contemporary opinion, but Kathleen Curran has recently challenged it. She argues that there was a tradition of mural painting in New England and New York churches prior to Trinity—notably, in Richard Upjohn's Bowdoin College Chapel in Brunswick, Maine (1844–55), and in Saint George's Episcopal Church, New York, designed by Leopold Eidlitz and Charles Otto Blesch (1846–48). Curran cites the influence of German murals. She acknowledges, however, that Trinity was distinguished from its sources by its use of encaustic (a medium that later muralists in the United States would not continue) and by the collaborative spirit of artists and architects:

Kathleen Curran, "The Romanesque Revival, Mural Painting, and Protestant Patronage in America," *The Art Bulletin* 81 (December 1999): 693–722. Curran does not, in my opinion, enough emphasize the influence of French aesthetic theory on Trinity Church. The French posited that the whole decoration, figural and ornamental, should be unified and should reinforce the architectural elements. See my chapter 4 for more discussion of this aesthetic.

2. The most complete study to date of this phenomenon is *The American Renaissance, 1876–1917* (Brooklyn, N.Y.: Brooklyn Museum, 1978).

3. I am grateful to Barbara Wolanin for clarifying the chronology.

4. H. Barbara Weinberg, "John La Farge: Pioneer of the American Mural Movement," in *John La Farge* (exhibition catalog) (Pittsburgh: Carnegie Museum of Art; Washington, D.C.: National Museum of American Art, 1987), 164.

5. Ibid., 164–65.

6. Pauline King, *American Mural Painting* (Boston, 1902), 29.

7. Sally Webster, *William Morris Hunt* (New York: Cambridge University Press, 1991), 140–42.

8. Ibid., 148.

9. Ibid., 151.

10. Ibid., 156.

11. For the fullest treatment of this subject to date, see *American Renaissance.*

12. Webster, *William Morris Hunt,* 187.

13. Weinberg, "John La Farge," 177.

14. Henry Adams, "The Mind of John La Farge," ibid., 64; Henry James, *The American Scene* (1907; Bloomington: Indiana University Press, 1968), 93.

15. Weinberg, "John La Farge," 185.

16. Susan Hobbs, *The Art of Thomas Wilmer Dewing: Beauty Reconfigured* (Washington, D.C.: Smithsonian Institution Press, 1996), 9–10. The Osborn and Garrett houses were Stanford White commissions.

17. Leonard N. Amico, *The Mural Decorations of Edwin Howland Blashfield, 1848–1936* (Williamstown, Mass.: Sterling and Francine Clark Art Institute, 1978), 66.

18. King, *American Mural Painting,* 58.

19. Mowbray autobiography, H. Siddons Mowbray papers, AAA, reel 1899, frame 132.

20. See King, *American Mural Painting,* chapter 3, for a discussion of these and other early examples. For the most recent study of Post, see Sarah Bradford Landau, *George B. Post, Architect: Picturesque Designer and Determined Realist* (New York: Monacelli Press, 1998).

21. *Puvis de Chavannes* (Ottawa: National Gallery of Canada, 1977), 25.

22. Frederic Crowninshield, "Mural Painting XII," *American Architect and Building News* (May 29, 1886): 259.

23. Frederic Crowninshield, *Figure Painting as Applied to Architecture* (New York, 1888): n.p.

24. Crowninshield, "Mural Painting XII," 259.

25. Edwin H. Blashfield makes the distinction, tellingly calling them two classes: the trained artists and the decorative firms: Blashfield: *Mural Painting in America* (New York, 1913),

155. Crowninshield himself, although he did get some commissions (for example, the law library in the federal building in Cleveland in 1910) often was hired for that type of filler.

26. Barbara Wolanin suggested this copying of another's designs to me.

27. Charles de Kay, "The Ceiling of a Café," *Harper's Weekly* 36 (March 12, 1892): 258.

28. I am indebted to Janet Marstine for this observation.

29. Royal Cortissoz, *The Works of Edwin Howland Blashfield* (New York: Charles Scribner's Sons, 1937), n.p.

30. Sarah Burns, *Inventing the Modern Artist: Art and Culture in Gilded Age America* (New Haven, Conn.: Yale University Press, 1996), 32–33.

31. Sally M. Promey's *Painting Religion in Public: John Singer Sargent's Triumph of Religion in the Boston Public Library* (Princeton, N.J.: Princeton University Press, 1999) is the most complete discussion of Sargent's uncompleted work. For Vedder, see Regina Soria, *Elihu Vedder* (Fairfield, Conn.: Fairleigh Dickinson University Press 1970), 218. See Promey, 103, for a contemporary engraving of what the hall would look like with a Whistler mural. According to Promey, Whistler never got beyond the first sketch.

32. De Kay's article on the mural, "The Ceiling of a Cafe," lists other decorations by Dewing (257–58): "female figures and dogwood blossoms," done for a reception room at Mamaroneck, New York, the home of Charles Osborn; and a frieze of Cupids and garlands, in the Baltimore ballroom of the Robert Garrett home.

33. Erica E. Hirshler gives the location as the Hotel Amsterdam: Hirshler, "A Quest for the Holy Grail: Edwin Austin Abbey's Murals for the Boston Public Library," *Studies in Medievalism* 6 (1994): 36; but both King (*American Mural Painting*, 59) and the list of murals in "Mural Painting in the United States" (*American Art Annual* 9 [1911]: 25) give it as the Hotel Imperial.

34. Brinton, "Modern Mural Decoration in America," 184.

35. Amico, *Mural Decorations of Blashfield*, 4.

36. Regina Soria's biography of Vedder paints a figure that was terrified of the competition in Chicago and afraid he was not up to the high visibility of his position among younger artists: Soria, *Elihu Vedder*, 209–12.

37. Ibid., 209–11.

38. Pepi Marchetti Franchi and Bruce Weber, *Intimate Revelations: The Art of Carroll Beckwith, 1852–1917* (New York: Berry Hill Galleries, 1999), 18.

39. F. D. Millet, "The Decoration of the Exposition," *Scribner's Monthly* 12 (December 1892): 692–709, treats the murals at length. See also Daniel Burnham, *Final Report of the Director of Works . . . World's Columbian Exposition* (1893; rpt. New York: Garland, 1989).

40. Samuel Isham, *The History of American Painting* (1905; enl. ed., New York, 1927), 544.

41. Royal Cortissoz, "Mural Painting at a Parting of the Ways," *New York Herald,* February 10, 1935, 10.

42. Will H. Low, "The Art of the White City," *Scribner's Magazine* 14 (October 1893): 511.

43. Louise Hall Tharp, *Saint-Gaudens and the Gilded Era* (Boston, Mass.: Little, Brown, 1969), 250.

44. King, *American Mural Painting, 67.*

45. Candace Wheeler, "A Dream City," *Harper's New Monthly Magazine* 86 (May 1893): 840–41.

46. See Bailey Van Hook, *Angels of Art: Women and Art in American Society, 1876–1914* (University Park: Pennsylvania State University Press, 1996), for a much more complete discussion of this issue.

47. I am grateful to Barbara Wolanin for bringing the issue of clothing to my attention.

48. Roszita Parker and Griselda Pollock, *Old Mistresses: Women, Art, and Ideology* (New York: HarperCollins, 1981).

CHAPTER 2

1. Henry Van Brunt, "The Columbian Exposition and American Civilization," *Atlantic Monthly* 71 (May 1893): 584.

2. "Public Art in American Cities," *Municipal Art* 2 (March 1898): 8. See Bailey Van Hook, "Clear-eyed Justice: Edward Simmons's Mural in the Criminal Courts Building, Manhattan," *New York History* 73 (October 1992): 443–58. For an excellent discussion of the parallel movement in public sculpture, see Michelle Bogart, *Public Sculpture and the Civic Ideal in New York City, 1890–1930* (Chicago, Ill.: University of Chicago Press, 1989).

3. Webster, *William Morris Hunt,* 162.

4. On the method of murals, see Newton A. Wells, "Some of the Aesthetic Requirements and the Technical Difficulties Peculiar to Mural Painting," *Brush and Pencil* 6 (August 1900): 228–36; Will H. Low, "Mural Painting—Modern Possibilities of an Ancient Art," *Brush and Pencil* 11 (December 1902): 174–75; E. V. Lucas, *Edwin Austin Abbey* (London, 1921), 2:441. La Farge wrote an extended description in a letter to Channing Seabury, July 16, 1904, MHS.

5. Homer Saint-Gaudens, "Edwin Howland Blashfield," *International Studio* 35 (September 1908): lxx–lxxiii.

6. Frank Fowler, "The Outlook for Decorative Art in America," *Forum* 18 (February 1895): 687.

7. Royal Cortissoz, "Mural Decoration in America—First Paper," *Century* 51 (n.s. 29) (November 1895): 121. See also his "Decorative Painting in America," *Scribner's Magazine* 19 (February 1896): 259–60.

8. Unless otherwise noted, all information about the Walker murals is from Richard V. West, *The Walker Art Building Murals* (Brunswick, Maine: Bowdoin College, 1972).

9. Vedder, quoted in West, *Walker Art Building Murals,* 5.

10. Richard Murray, in *American Renaissance,* 185. For the most recent discussion of the murals, see Richard Murray, "Painted Words: Murals in the Library of Congress," in John Y. Cole and Henry Hope Reed, eds., *The Library of Congress: The Art and Architecture of the Thomas Jefferson Building* (New York: Norton, 1997), 193–225.

11. Elizabeth Alexander, John White Alexander's wife, later recalled that General Casey had sent letters to each of the artists. Kenyon Cox, however, received a letter from Bernard Green: Elizabeth Alexander, interview with DeWitt Lockman, 1928, John White Alexander

papers, AAA, reel 1727, frame 190; Cox to Green, December 2, 1894, in H. Wayne Morgan, ed., *An Artist of the American Renaissance: The Letters of Kenyon Cox, 1883–1919* (Kent: Kent State University Press, 1995), 125.

12. For more information on Evolution, see Bailey Van Hook, "Edwin Blashfield," in *American Dreams: American Art to 1950 in the Williams College Museum of Art* (Williamstown, Mass.: Williams College Museum of Art, 2001).

13. Janet Marstine has pointed out that Vedder's content was harshly critical of capital, warning that a corrupt alliance between capital and government creates unemployment. For her extensive exegesis on the murals, see Janet Cecilia Marstine, "Working History: Images of Labor and Industry in American Mural Painting, 1893–1903," Ph.D. dissertation, University of Pittsburgh, 1993, and her upcoming book on the Library of Congress.

14. William A. Coffin, "The Decorations in the Congressional Library" [hereafter, "Decorations, Congressional Library"], *Century* 53 (March 1897): 695.

15. See, for example, "The Decorations for the Library of Congress," *Scribner's Magazine* 20 (August 1896): 257–60.

16. This was also a criticism leveled at the Hotel de Ville in Paris.

17. Mural Painters, *Constitution and By-Laws: The Mural Painters, a National Society* (New York, 1895), n.p.

18. King, *American Mural Painting*, 152–53, 224; *Temple of Justice: The Appellate Division Courthouse* (New York: House of the Association [NYC Bar Association], 1977), 24.

19. *Appellate Division of the Supreme Court of the State of New York, First Judicial Department* (pamphlet, n.d.): 6.

20. There was some scuffle over Mowbray's decorations. The part allotted to him was a frieze, forty-four-inches high. His colleagues wanted the figures to be life-size, but Mowbray argued for small-scale. When La Farge, who had been appointed arbiter, was consulted, he sided with Mowbray. Mowbray's comments on La Farge are, nevertheless, rather acerbic: he noted that the artists took a deduction of 10 percent on their contracts to compensate him, but that as soon as he got his advance, La Farge sailed for Europe. The artists subsequently had to wait several months to get his approval for their designs: H. Siddons Mowbray autobiography, Mowbray papers, AAA, reel 1899, frames 357–58.

21. Kenyon Cox, "Some Phases of Nineteenth Century Painting: Part III: Mural Painting in France and America," *Art World* 2 (April 1917): 15.

22. Albin Pasteur Dearing, *The Elegant Inn: The Waldorf-Astoria Hotel, 1883–1929* (Secaucus, N.J.: Lyle Short, 1986), 21.

23. Ernest Knaufft, "An American Decorator: Edwin H. Blashfield," *International Studio* 13 (March 1901): 30.

24. Low, "Mural Painting," 171.

25. The murals are now owned by the Brooklyn Museum of Art.

26. King, *American Mural Painting*, 165.

27. Royal Cortissoz, "The Making of a Mural Decoration: Mr. Robert Blum's Paintings for the Mendelssohn Glee Club," *Century* 59 (n.s. 37) (November 1899): 58, 60.

28. Charles H. Caffin, "Frank D. Millet's Mural Painting for Pittsburg," *Harper's Weekly*

41 (December 25, 1897): 1294. Millet included portraits of Mrs. Millet, Mary Anderson, Mrs. Alma Tadema, and the artist's two sons: Francis Millet Rogers papers, AAA, reel 1096, frame 211.

29. H. Barbara Weinberg, "The Career of Francis David Millet," *American Art Journal* 17 (1977): 17.

30. See Bailey Van Hook, *A Mural by Thomas W. Dewing: "Commerce and Agriculture Bringing Wealth to Detroit"* (New York: Spanierman Gallery, 1998) for a fuller account of this commission.

31. William Walton, "Recent Mural Decorations by Mr. E. H. Blashfield," *Scribner's Monthly* 37 (March 1905): 382.

32. Robert A. M. Stern, Gregory Gilmartin, and John Montague Massengale, *New York 1900: Metropolitan Architecture and Urbanism, 1890–1915* (New York: Rizzoli, 1983), 181–83.

33. Lucas, *Edwin Austin Abbey*, 1:231–32. For the most complete discussion of Abbey's murals, see Hirshler, "Quest for the Holy Grail," 35–49.

34. Will H. Low, "The Story of a Painted Ceiling," *Scribner's Magazine* 29 (April 1901): 510.

35. Carol Troyen, "Sargent's Murals for the Museum of Fine Arts, Boston," *The Magazine Antiques* 156 (July 1999): 75. Troyen's article is the essential source for that commission.

36. Promey, *Painting Religion in Public*, chapter 7.

37. King, *American Mural Painting*, 124, 139. Charles H. Caffin, "The Beginning and Growth of Mural Painting in America," *Bookman* 28 (October 1908): 37.

38. Sally M. Promey, "Sargent's Truncated Triumph: Art and Religion in the Boston Public Library, 1890–1925," *Art Bulletin* 79 (June 1997): 217–50.

39. Isham, *History of American Painting*, 553. Isham says that Whistler "no longer had enthusiasm or physical force for long continued application."

40. [Russell Sturgis?], "Mural Painting in American Cities," *Scribner's Magazine* 25 (January 1899): 14–15. The article was signed R. S.

41. "Proposed Competition for Mural Paintings in the Massachusetts State House," *Artist* 25 (May–June 1899): xiv.

42. Ibid.

43. Frank Millet to Edwin H. Blashfield, Feb. 12, no year, but before 1913, Blashfield papers, NYHS.

44. Files on Reid's "James Otis" at Massachusetts Art Commission, Massachusetts Statehouse, Boston.

45. *The American Renaissance, 1876–1917*, 46.

46. Edwin Howland Blashfield, "Mural Painting," *Municipal Affairs* 2 (March 1898): 98.

47. His solution was akin to Saint Gaudens's sculptures of Admiral Farragut (1881), and even more so of General Sherman (1903), both in New York.

CHAPTER 3

1. "Cass Gilbert Believed Minnesota Capitol Was Best Work He Ever Did," *St. Paul Pioneer Press*, May 24, 1934, Channing Seabury Papers, MHS. For more discussion of Gilbert and

mural painting, see Bailey Van Hook, "High Culture by the Square Foot," in Barbara S. Christen and Steven Flanders, eds., *Cass Gilbert, Life and Work: Architect of the Public Domain* (New York: Norton, 2001).

2. Neil B. Thompson, *Minnesota's State Capitol: The Art and Politics of a Public Building* (St. Paul: Minnesota Historical Society, 1974), 5–6.

3. Several artists lobbied Gilbert unsuccessfully. Will Low, wrote Gilbert in 1898 asking to be considered: Low to Gilbert, March 25, 1898, Gilbert papers, MHS. Other letters in the files include one signed by four individuals recommending Carl Gutherz (who had done a decoration for the Library of Congress) on the basis of his residence in the state and, more ominously, that Gutherz "has many friends in the State, including relatives who are prominent citizens": A. R. McGill, W. W. Dunn, John C. Hardy, and Stiles H. Stanton(?) to Channing Seabury and Cass Gilbert, March 12, 1903, MHS; see also Bernard Green, superintendent, Library of Congress, to Gilbert, January 23, 1904, Gilbert papers, NYHS.

4. Thompson, *Minnesota's State Capitol,* 59.

5. Kenyon Cox to Louise Cox, April 21, 1906, Kenyon Cox papers, Avery Library, Columbia University.

6. Elizabeth Luther Cary, "John La Farge's Decorations at St. Paul," *Scrip* 1 (February 1906): 139–40. The titles are *The Divine and Moral Law: Moses, Aaron, and Joshua on Mount Sinai; The Recording of the Precedents: Confucius and His Pupils Collating and Transcribing Documents; The Relation of the Individual to the State: A Political Discussion by Socrates and His Friends;* and *Adjusting of Conflicting Interests, Raymond of Toulouse Swearing at the Altar to Respect the Liberties of the City.*

7. Channing Seabury to De Laittre, March 8, 1906, MHS. A letter offering a big historical picture was from Miss E. N. Cardizo, January 31, 1905, to Channing Seabury.

8. Channing Seabury to Cass Gilbert, January 12, 1904, Gilbert papers, NYHS.

9. Gilbert to Seabury, January 12, 1904, MHS.

10. Gilbert wrote to Seabury estimating the cost of La Farge's, Blashfield's, and Simmons's murals at $39.30 per square foot: Gilbert to Seabury, August 27, 1903, MHS. Seabury wrote of the muralists being "about equally compensated, upon a uniform or general average basis, per square foot": Seabury to Gilbert, August 20, 1903, MHS.

11. Cass Gilbert to Edward Simmons, June 7, 1904, MHS.

12. Idem, July 23, ibid. On a copy of the letter for Seabury, Gilbert wrote, "This is plain talk—do you think it is too plain?"

13. Gilbert to Charles F. Owsley, January 18, 1908, Gilbert papers, NYHS.

14. The paintings were Frank Millet's *The Foreman of the Grand Jury Addressing the Chief Justice of New Jersey in 1774 Voices the Dissatisfaction of the Colonies with the Government,* Charles Yardley Turner's *The Landing of the New Englanders on the Banks of the Passaic River in 1666,* and Howard Pyle's *Captain Peter Carteret Appointed Governor of the Colony of New Jersey Landing in Newark Bay in 1665.*

15. Charles H. Caffin, "The New Capitol of Pennsylvania," *World's Work* 13 (1906-7): 8195.

16. *Preserving a Palace of Art: A Guide to the Projects of the Pennsylvania Capitol Committee* (Harrisburg, Pa.: Capitol Preservation Committee, n.d.), iii.

17. *New York Times,* July 20, 1902, clipping, Pennsylvania State Archives, Harrisburg.

18. *Preserving a Palace of Art*, xxv.

19. Huston papers, Pennsylvania State Archives, Harrisburg.

20. Newspaper, source unknown, May 30, 1902, in Pennsylvania State Archives, Harrisburg.

21. Abbey also painted *William Penn's Treaty with the Indians* for the house and *Valley Forge* for the senate. *Valley Forge* was later moved to the house.

22. *Preserving a Palace of Art*, xix.

23. Diana Strazdes, *American Painting and Sculpture to 1945 in the Carnegie Museum of Art* (New York: Hudson Hills Press, 1992): 46.

24. Various people have suggested to me that this is a reference to the Knights of Labor, the labor organization, founded in 1869. Although it did begin in Pennsylvania, it seems highly unlikely that Alexander meant the knight in his mural to be so interpreted. The Knights of Labor were one of the most radical labor groups, and not only was Alexander not known for his radical politics but the inclusion of that reference would have been akin to Diego Rivera's infamous portrait of Lenin in the Rockefeller Center murals. I think the ambiguity of the image shows, instead, Alexander's disregard and even ignorance of contemporary labor issues.

25. Material provided at site.

26. "The Decorations," *South Dakota Historical Collections* 5 (1910): 239.

27. Ibid., 240.

28. Edward Simmons, *Seven to Seventy: Memoirs of a Painter and a Yankee* (New York, 1922), 332.

29. Blashfield to "Dearie," March 4, 1910, Blashfield papers, box 1A, NYHS.

30. *Wisconsin State Capitol: Guide and History* (Madison: State of Wisconsin Admin. Dept., 1991): 23. Perhaps taking his cue from Blashfield, Hugo Ballin painted twenty-six murals in the governor's conference room, the central one being *Wisconsin Surrounded by Her Attributes, Beauty, Strength, Patriotism, Labor, Commerce, Agriculture, and Horticulture;* others illustrated important people places and events in the history of the state.

31. Mowbray was originally offered the commission for the pendentives but turned it down: George P. Post to Mowbray, August 25, 1911, and September, 1911, H. Siddons Mowbray papers, AAA, reel 1898, frames 264–65. In September, Post wrote, "I cannot let you off so easily. . . . *We must* have some of your work in the capitol."

32. Perhaps Herter's panels were in homage to Millet since his were strictly historical, as Millet's late works had been, ranging from ancient to nineteenth-century history. These were *The Signing of the American Constitution, The Signing of the Magna Carta, The Appeal of the Legionary to Caesar Augustus,* and *The Trial of Chief Oshkosh by Judge Doty.*

33. *Wisconsin Capitol*, 23.

34. In addition, in the Law Library Crowninshield painted two panels, *Persuasion* and *Knowledge.* In the district attorney's office, Rufus Zogbaum, an alumnus of Minnesota State Capitol, painted another historical scene, *The Battle of Lake Erie, September 10, 1813.*

35. C. Matlack Price, "The Late Francis Davis Millet—Notes on the Decorative Panels in the Cleveland Post Office," *International Studio* 48 (December 1912): xxxiv–xxxvii. The panels were removed during a 1937 restoration. Millet had also done a series of thirteen panels for the Cleveland Trust Company, illustrating the history of the settlement of Ohio; see Leila

Mechlin, "A Decorator of Public Buildings," *World's Work* 19 (December 1909): 12378–81. Millet had used a similar approach when he decorated the Baltimore customhouse in 1908 with a series of twenty-eight panels and five lunettes illustrating the history of shipping; see Mechlin, 12385–86.

36. Cynthia Sanford, *Heroes in the Fight for Beauty: The Muralists of the Hudson County Court House* (Jersey City, N.J.: Jersey City Museum, 1986), 9–10.

37. Pyle depicted *The Coming of the Dutch, The Coming of the English,* and *The First Settlement of Manhattan Island* for the freeholder's room. On the top floor, Millet painted twelve small panels for the second-floor corridor, illustrating scenes from Hudson County history, and two lunettes, *The Repulse of the Dutch, September 13, 1609* and *Paying for the Land, January 30, 1658.* Turner painted the remaining two lunettes on that floor, *General Washington at Fort Lee, November 16, 1776, Watching the Assault upon Fort Washington,* and *First Passage of the Steamer Clermont to Albany on the Morning of August 17, 1807.* See Sanford, *Heroes in the Fight for Beauty* for a much more complete history of this project.

38. Three other artists, Douglas Volk, Bert Phillips, and Charles A. Cumming, also contributed murals; see Gladys E. Hamlin, "Mural Painting in Iowa," *Iowa Journal of History and Politics* 37 (July 1938): 250–54. It must be noted, however, that Hamlin's dating of Simmons's murals is faulty. She cites the Massachusetts murals as 1914 and the Polk County Courthouse murals as 1912; in fact, Simmons's first Boston mural was completed in 1902. This is an important point since the Massachusetts statehouse murals may be the first for a public commission to depict purely historical events without the presence of allegory.

39. Eva Ingersoll Gatling, *Luzerne County Court House* (Wilkes-Barre, Pa.: Wyoming Historical and Geological Society, 1986), 5–9.

40. Brangwyn's murals were transferred to the Veterans' Building at the San Francisco War Memorial; see Francis V. O'Connor, "Notes on the Preservation of American Murals," in *Mortality/Immortality: The Legacy of Twentieth-Century Art* (Los Angeles, Calif.: Getty Conservation Institute, 1998), 156.

41. For example, La Farge exhibited one of his Saint Paul murals at the Fine Arts Building on Fifty-seventh Street on October 28 and 29, 1904. Walker exhibited his Saint Paul mural in the same place on May 4 and 5, 1905.

42. Low to Blashfield, n.d., Blashfield correspondence, box 2, NYHS.

43. Gatling, *Luzerne County Court House,* 9.

44. Gilbert to Seabury, June 14, 1904, MHS.

CHAPTER 4

1. I disagree with William Wilson's location of the beginnings of the City Beautiful movement later in the decade. Although the financial depression of the mid-1890s inhibited the growth of the movement, the ideals and visual appearance of the World's Columbian Exposition is so close as to seem its logical impetus; see William H. Wilson, *The City Beautiful Movement* (Baltimore, Md.: Johns Hopkins University Press, 1989).

2. Will H. Low, "National Expression in American Art," *International Studio* 3 (March

1901): 244–45. A writer in *Scribner's Monthly,* perhaps the architect Russell Sturgis, privileged architecture over painting: "The knowledge how to adapt his work to the hard, solid and opaque member of the building so as to adorn it splendidly while yet it remains hard, solid, and opaque, is the most important knowledge of all": R. S. [Sturgis?], "Mural Paintings in American Cities," 14.

3. Mowbray was given the commission that, more than any other, called for the artist to subjugate his own personality—that for the University Club in New York (Mowbray himself called it "self abnegation"). McKim hired him to decorate the club in the style of Pinturricchio's decorations for the Borgia apartments in Rome, which had recently been opened to the public. Although the initial idea was that Mowbray would copy the decorations, the differences in scale and shape made that impossible, and he did a free translation. Notable, however, was the complete unity of decoration, which would also be the case with his decorations for the Morgan Library and its addition: Mowbray autobiography, H. Siddons Mowbray papers, AAA, reel 1899, frame 141.

4. Charles H. Caffin, "Recent Mural Decorations at Boston," *International Studio* 17 (July 1902): lxxx.

5. Isham, *History of American Painting,* 556.

6. Post to Mowbray, August 25, 1911, Mowbray papers, AAA, reel 1898, frame 264.

7. For an account of the Detroit Library commission, see Peter Federman, "The Detroit Public Library," *Classical America* 4 (1977): 85–111.

8. Seabury to Gilbert, May 19, 1904, Gilbert papers, NYHS. Gilbert's annotation is dated May 31, 1904.

9. Gilbert to Seabury, June 14, 1904, MHS.

10. Amico, *Mural Decorations of Blashfield,* 28–29.

11. Gatling, *Luzerne County Court House,* 9.

12. Charles H. Caffin, *The Story of American Painting* (1907; Garden City [N.Y.]: Garden City Publishing, 1937), 311.

13. *Temple of Justice: The Appellate Division Courthouse,* 31.

14. Mowbray autobiography, H. Siddons Mowbray papers, AAA, reel 1890, frame 144.

15. "Proposed Competition for Mural Paintings in the Massachusetts State House," xiv–xv.

16. Burns, *Inventing the Modern Artist,* 30–34.

17. Gilbert to Seabury, August 27, 1903, May 5, 1903, June 14, 1904, MHS.

18. Low wrote in 1903 that $40 per square foot was the going rate (although he noted that Abbey had gotten $50 for his Harrisburg decorations): Blashfield and Low to William Bixby, president, City Art Museum, Saint Louis, January 20, 1913, Low papers, AIHA.

19. Seabury to Howard Pyle, July 6, 1906, MHS.

20. Telegram, Gilbert to Seabury, September 8, 1903, MHS.

21. Letter of agreement, December 20, 1902, MHS.

22. George L. Post to Cass Gilbert, February 16, 1903, MHS.

23. Promey, *Painting Religion in Public,* 99; Mary Crawford Volk, "Sargent in Public: On the Boston Murals," in Elaine Kilmurray and Richard Ormond, eds., *John Singer Sargent* (Princeton, N.J.: Princeton University Press, 1998), 53.

24. Royal Cortissoz, "Making of a Mural Decoration," 58, 60. Will Low built a studio in the country and in it had a large opening in the floor, eighteen inches wide and thirty feet long. He had to put the canvas on pulleys so it could be dropped through the floor so that work could be done at the top: Low, "Mural Painting," 175.

25. Carolyn Kinder Carr and Sally Webster, "Mary Cassatt and Mary Fairchild MacMonnies: The Search for Their 1893 Murals," *American Art* 8 (winter 1994): 52–69.

26. Troyen, "Sargent's Murals for the Museum of Fine Arts, Boston," 77; Edwin H. Blashfield to Channing Seabury, September 14, 1904, MHS.

27. Kenyon Cox, "Paul Baudry," in John Van Dyke, ed., *Modern French Masters* (1896; rpt., New York: Garland Publishing, 1976), 67–68. The Panthéon in Paris was a laboratory of the state of mural painting in France in the 1870s. Decorated by six French artists, it contained a diverse range of stylistic solutions. Also though each concentrated on historical events, Puvis was more flat and decorative and Jean Paul Laurens more illusionistic. Likewise, the Hotel de Ville presented a panoply of mural styles in the next decade, when it was decorated by more than forty artists.

28. *Puvis de Chavannes* (1977), 22, and Aimee Brown Price, *Puvis de Chavannes* (New York: Rizzoli, 1994): 14–15.

29. Webster, *William Morris Hunt,* 169–70.

30. Henry Van Brunt, "The New Dispensation of Monumental Art: The Decoration of Trinity Church in Boston and of the New Assembly Chamber at Albany," *Atlantic Monthly* 43 (1879): 638.

31. Amico, *Mural Decorations of Blashfield,* 3.

32. *Puvis de Chavannes* (1977), 58. The French government bought *Peace,* so Puvis donated *War.* He did *Work* and *Repose* before he had seen Amiens, but once the first two were installed he presented the next two. Other panels were installed in 1865, 1882, and 1888.

33. Amico, *Mural Decorations of Blashfield,* 3.

34. Price, *Puvis de Chavannes,* 21. More recently, some art historians have challenged this predominantly formalist approach, finding a wide range of politicized meanings in Puvis's murals. Jennifer L. Shaw, for example, has documented how critics with divergent political views embraced Puvis's *Summer* (at the Hotel de Ville [1891]), seeing it as evidence of both feudalism as natural and appropriate and as a harbinger of the socialism of the future. Such readings, however, often reinforce the perceived fluidity and ambiguity of Puvis's murals: Shaw, "Imaging the Motherland," *Art Bulletin* 74 (December 1997): 608.

35. Roger Riordan, "Puvis de Chavannes," *Art Amateur* 24 (December 1890): 5–7; and ibid. (January 1891): 34.

36. Low, "Story of a Painted Ceiling," 510.

37. Frank Fowler, "Mural Painting and a Word to Architects," *Architectural Record* 11 (July 1901): 514.

38. King, *American Mural Painting,* 140.

39. Ibid., 5.

40. According to La Farge, this tendency toward flatness came from his teacher Thomas Couture, who also taught Puvis. Couture was painting murals for the Chapel of Saint Eustache

in Paris when La Farge was his student. Puvis's color in his mature murals, however, was much lighter than the rich Venetian tones preferred by Couture. Although he claimed he was not influenced by the Italian primitives, that was the source most often quoted for those pale colors: John La Farge, "Puvis de Chavannes," *Scribner's Monthly* 28 (December 1900): 674; Weinberg, "John La Farge," 164.

41. *Puvis de Chavannes* (1977), 21.

42. This effect is, of course, the very antithesis of what had been achieved in the premier mural project before the American Renaissance, the decoration of the United States Capitol by John Trumbull, John Vanderlyn, William Henry Powell, Robert F. Weir, and John G. Chapman in the first half of the nineteenth century. Their works were not only easel paintings but they were framed and presented as such. They also were predominantly narrative, telling stories from American history, and setting figures in a three-dimensional space that, in the contemporary decorator's eyes, created holes in the wall. In an article that appeared early on in the movement entitled "The Outlook for Decorative Art in America," the artist Frank Fowler cited the precedent of the Trumbull canvases, but said that, strictly speaking, the paintings were "not decorations at all" since the paintings were not subordinated to their surroundings. Fowler, "Outlook," 686.

43. "A Decorative Painting by Robert Blum," *Scribner's Magazine* 19 (January 1896): 8–9.

44. Russell Sturgis, "John La Farge," *Scribner's Magazine* 26 (July 1899): 17–18.

45. William A. Coffin, "Decorations in the Congressional Library, Washington D.C.," *Harper's Weekly* 40 (October 17, 1896): 1029.

46. For a further discussion of this issue, see Van Hook, *Angels of Art*, chapters 1 and 6.

47. "Decorative Painting in America," *Scribner's Magazine* 19 (February 1896): 259.

48. Saint-Gaudens, "Edwin Howland Blashfield," lxix.

49. Cortissoz, *The Works of Edwin Blashfield*, n. p. For a more extended discussion of this issue, see Van Hook, *Angels of Art*, chapter 6.

50. Lucas, *Edwin Austin Abbey*, 1:255–56.

51. Cortissoz, "Mural Decoration in America," 115.

52. Isham, *History of American Painting*, 550.

53. Elmer E. Garnsey, "Mural Painting in Its Relation to Architecture," *American Architect and Building News* 66 (December 2, 1899): 77; Caffin, "Beginning and Growth," 134; see also Kenyon Cox, "Some Phases of Nineteenth Century Painting, Part III: Mural Painting in France and America," 15, and Greta, "The Boston Public Library Decorations," *Art Amateur* 34 (January 1896), 49, as cited in Hirschler, "Quest for the Holy Grail," fn. 28.

54. Elizabeth Alexander, wife of the muralist John White Alexander, who knew Puvis when the couple lived in Paris, said that Puvis had plans for the library but did not find out until after the decorations were done that the marble was yellow: John White Alexander papers, AAA, reel 1727, frame 173.

55. Ernest Fenollosa, *Mural Painting in the Boston Public Library* (Boston, 1896), 19. Charles Caffin also contrasted Puvis and Abbey's decorations, finding in Puvis "noble serenity," while Abbey, "for all his affinity with the past, is a modern, and his work partakes of the present confusion of issues." Caffin noted that some have found that Abbey's decorations "have more

of the picture quality than the mural," but emphasized that the Italians did not make that distinction, citing Pinturicchio as not worrying about working in a certain way to make sure his painting was read as a mural: Caffin, "Recent Mural Decorations," lxxx–lxxxi. Sargent's murals with their deliberate archaism were flat, yes, but so artificial as to be greeted by stupefaction or puzzlement. Cortissoz said their "purely decorative character [is] somewhat obscure" and found "a symbolism that is too symbolical becomes opaque after the first gloss has disappeared; it becomes a puzzle to the profession and a terror to the illiterate or only moderately educated person": Cortissoz, "Mural Decoration in America," 112. Fenollosa, on the other hand, waxed poetic saying that "this is the very meaning of symbolism as the inmost soul of art": Fenollosa, *Mural Painting in the Boston Public Library*, 21.

56. Russell Sturgis wrote that color was the most important aspect of La Farge's art and that the artist realized the desideratum of decoration, "richness or refinement of coloring, or both. If one has a wall to decorate, the first idea of the true decorator is to invest it with splendor or with delicate strength of color": Sturgis, "John La Farge," 17. Barbara Weinberg has cited La Farge's experience in Couture's studio for his use of rich Venetian color: Weinberg, "John La Farge," 164.

57. Frank Jewett Mather Jr., "Kenyon Cox," *Scribner's Magazine* 65 (June 1919): 766.

58. West, *Walker Art Building*, 6–7.

59. King, *American Mural Painting*, 10. Again, there are sometimes protomodernist sentiments expressed by artists who in retrospect seem otherwise highly conservative. Fowler's early article on mural painting said that "the power of abstraction" is what distinguishes decorative compositions: Fowler, "Outlook," 689. Violet Oakley was praised by another critic for finding devices "for using men and women as accessories to design. No sacrifice of character or of action has been needed to bind the human figure into its subordinate place as a unit in a work whose aim is decoration, and whose every element must express that idea": Harrison S. Morris, "Miss Violet Oakley's Mural Decorations," *Century* 70 (June 1905): 268.

60. James William Pattison, "Blashfield's Mural Decorations in the Capitol of Minnesota," *International Studio* 24 (February 1905) sup. lxxxviii.

61. Description of Blashfield's *Westward* on a placard at Iowa State Capitol, Des Moines.

62. *Washington Star*, November 28, 1896, in Alexander scrapbook, John White Alexander papers, AAA, reel 1729, frame 1005. Charles H. Caffin received the opposite impression, however, from the artist's Carnegie Institute decorations: see Caffin, "John Alexander," *Arts and Decoration* 19 (February 1911): 147–49, 178.

63. For an extended discussion of this issue, see Van Hook, *Angels of Art*, chapter 6.

64. But there were some variations: Edward Simmons placed a hard, flat, emblem-like device above his male figures, which identified them; Walter Shirlaw painted a spider-like web, and Beckwith a circular burst of lightning with a small boy representing Electricity.

65. Cox once referred to Simmons's style in Saint Paul as "too modern-French." He was probably referring to the graceful elegance of Simmons's figures, very different from his own weighty classicism: Cox to Louise Howland Cox, April 21, 1906, quoted in Morgan, *Kenyon Cox*, 155. Circles or ovals were most often embedded in larger designs, as in Abbey's in Harrisburg, Simmons's in South Dakota, and Cox's, just mentioned, in Jersey City. The circle or oval

that stood on its own was rare. One example was Cox, *Passing Commerce Pays Tribute to the Port of Cleveland,* which was designed as a panel over the fireplace in the customs collector's room in the Cleveland federal building. Commerce is a Mercury-like figure who flies over the seated Cleveland, dropping the tribute of coins in her lap.

66. Garnsey, "Relation to Architecture," 77.

67. Russell Sturgis, although he had misgivings about the overuse of symbolic or metaphorical personification, felt that, if it was necessitated, it should be done in a style like Vedder's at the Library of Congress (fig. 43): "Those straightforward, manly, but hard and harsh presentations by Vedder . . . such set drawing, such firm and decided outline, such a denial of color and of the higher charm of light and shade, go to make up the style which best fits such metaphysical subjects." Sturgis, "Mural Painting," *Forum* 37 (January 1906): 369. The strict symmetry was invariably the design chosen by lesser artists with big commissions, like William Smedley at Wilkes-Barre or Arthur Willet at Youngstown, since the precise symmetry made the composition relatively logical and easy to design. Other devices for the lunette included strong vertical elements to anchor it to the wall. Abbey did this with the trees and wings in *Science Revealing the Treasures of the Earth* in Harrisburg.

68. Sturgis recognized his imagination and intuition when he said that La Farge "knows how to tell a story in pictures, which have very much, if not all, of his highest artistic qualities, and this he would hardly be capable of were he more fettered than he is by the rules of the academies as to how the action of man should be put into form and color": Sturgis, "John La Farge," 13. Both La Farge and Blashfield in Saint Paul had to contend with how the complicated designs of the lunette related one to the next within the same room. As I suggest, La Farge did it primarily through color, since otherwise his designs are quite different from each other. In the lunette depicting Moses (fig. 16), the eye is forced sharply up the sharp incline of Mount Sinai. In *Recording the Precedents,* there is a snake-like pattern formed by the placement of the figures. The room that houses Raymond of Toulouse is a more traditional Renaissance, box-like space. Blashfield, like La Farge, relied mostly on color to unite each of his lunettes to each other and to the room. In *Minnesota, Granary of the World,* the personification of Minnesota is in the center of the composition, with many other figures arrayed to left and right, not in a strict symmetry but a noticeable balance. In *Discovers and Civilizers Led to the Source of the Mississippi,* the figure of the Great Manitou, who dominates the composition since all sight lines are directed to him, is nevertheless slightly to the right of center.

69. Lucas, *Edwin Austin Abbey,* 2:404.

70. Oakley's panels in the governor's reception room in Harrisburg formed a frieze, but it was divided as pages of a book (fig. 34). Each contained a historical episode separated from the rest by a painted border. Some artists, like Mowbray, Reid, and Metcalf at the appellate courthouse, treated the frieze as though it was a centralized composition and placed a figure in a dominant position, to which the others reacted. This is perhaps part of the reason the entry hall at the courthouse is so discordant. The centralized figures all compete for the viewer's attention.

71. Pyle had been a friend of Abbey's when both were young illustrators in New York. His work bears a resemblance to the mural of Bowling Green that Abbey did for the Hotel Imperial.

72. Many disagreed with Pyle's compositional choices, however. Frank Millet, who was in charge of the decoration of the entire building, wrote to Blashfield that Pyle's decoration was a "great disappointment to the architect." Pyle himself, in a letter to Blashfield, admitted: "I think they are fairly good in certain ways but are not quite so decorative as I hoped they would be": Millet to Blashfield, n.d. but before April 1912; and Pyle to Blashfield, October 13, 1910, Blashfield papers, NYHS.

73. Garnsey, "Relation to Architecture," 77.

74. Walter Shirlaw and George Barse also used the same device there. When more figures were added, however, the vertical panels invariably retained a strongly symmetrical orientation, as in Cox's *Beneficence of the Law* at the Essex County Courthouse in Newark and Simmons's *Justice* (fig. 61) for the criminal courts in Manhattan. The rare square panels often employ the same symmetrical orientation, as in Simmons's *Justice of the Law* for the appellate courthouse, as well as the contributions of the other muralists there, Blashfield and Henry Oliver Walker (fig. 11).

75. Blashfield essayed compromise between the symbolic and the contemporary in *The Law,* in the court of the federal building in Cleveland, *Justice,* in the Luzerne County Courthouse in Wilkes-Barre, and most notably in his panel *Westward,* for the Iowa State Capitol (fig. 46). A shape midway between the rectangle and the lunette was the "depressed lunette," with a rounded top and straight side edges. Blashfield and Cox each did allegorical compositions (*The Sources of Wealth* and *The Uses of Wealth*) for the depressed lunettes at Citizens' Savings and Trust Company, and Blashfield decorated one with Wisconsin for the assembly chamber in Madison. Blashfield's compositions got more dynamic, however, as he gained in experience, and later he did not always rely on strict symmetry, as he had in Baltimore and Saint Paul.

76. Cass Gilbert to Seabury, October 23, 1903, MHS.

77. Millet to Cass Gilbert, August 11, 1907, Gilbert papers, NYHS.

78. *Boston Transcript,* December 20, 1901, in Massachusetts Art Commission files, Massachusetts State House.

79. Irene Sargent, "Mural Paintings by Robert Reid in the Massachusetts State House," *Craftsman* 7 (March 1905): 701.

80. William Walton, "Pictures of the American Navy by R. T. Willis," *Scribner's Magazine* 43 (June 1908): 767.

81. Blashfield, *Mural Painting in America,* 265.

82. Like Abbey's in Boston, Alexander's designs for the Library of Congress were sometimes criticized as not pictorial enough, although Oakley's and Pyle's seem to have been painted after the tide had changed, late enough to escape that criticism. Simmons, however, trying to keep up with both the changing aesthetic and the move toward historical subjects, was the victim of scathing criticism for his Boston design for *Return of the Battle Flags.* His attempt at radical foreshortening and abrupt perspective were derided by Charles Caffin as a "sartorial arrangement of overcoats in perspective seen from the rear . . . the painting would arouse derision but for the stronger feeling of regret": Caffin, "Mural Decorations in the State House, Boston," *International Studio* 17 (July 1902): sup. lxxxii.

CHAPTER 5

1. Frederic Crowninshield, "Mural Painting I," *American Architect and Building News* 19 (January 9, 1886): 19.

2. Fenollosa, *Mural Painting, Boston Public Library,* 6.

3. Blashfield, "Mural Painting" (1898), 102; see also Blashfield, "A Word for Municipal Art," *Municipal Affairs* 3 (December 1899): 582–83. Blashfield's phrasing echoed the U.S. Constitution. Low used the same phrasing to describe in retrospect the art at the World's Columbian Exposition: Low, *Painter's Progress,* 251, 269.

4. Low, "National Expression," 235.

5. Ibid., 239.

6. Gustav Stickley, founder of the *Craftsman,* used the term *democratic art* for his furniture, which he wanted to be made widely available (nevertheless, it was always too expensive for the working class and even for the middle classes). In 1905 a column in the magazine spoke of the corruption of art through wealth and commercialism: Barry Sanders, *A Complex Fate: Gustav Stickley and the Craftsman Movement* (New York: John Wiley & Sons, 1996), 48, 82. Elsewhere in the *Craftsman,* that position was taken to advocate public mural painting. The muralist Charles Shean echoed Low when he wrote in an article that monumental art in the United States was not only for the rich: Shean, "Mural Painting from the American Point of View," *Craftsman* 7 (October 1904): 21. In a commentary on Shean's article, published in the same issue, editor Irene Sargent claimed that, since the public owned it, mural decoration was the "strongest expression after architecture of democratic art": Sargent, "Comments on Mr. Shean's 'Mural Painting from the American Point of View,'" 28–34.

7. Coffin, "Decorations in the Congressional Library, Washington, D.C." *Harper's Weekly,* 1029.

8. Habakkuk, ch. 2, v. 2: "Write the vision, and make it plain upon tables, that he may run that readeth it." From the Saint Joseph edition (New York: Catholic Book Publishing, 1963).

9. Low, "National Expression," 240.

10. Michelle H. Bogart, *Advertising, Artists, and the Borders of Art* (Chicago, Ill.: University of Chicago Press, 1995), 213. See ibid., 212–20, for a more extended discussion of these ideas. Bogart believes that the advertising men's more forthright attitude toward "their commercial interests and more realistic" expectations about their public meant that they were able to perform more consistently.

11. For a more extended discussion of this issue, see Van Hook, *Angels of Art,* chapter 5.

12. Low, *Painter's Progress,* 294.

13. Low, "Mural Painting," 164–65.

14. Will H. Low, "The Mural Painter and His Public," *Scribner's Magazine* 41 (February 1907): 253.

15. Edwin H. Blashfield, "Mural Painting in America," *Scribner's Magazine* 54 (September 1913): 353.

16. Edwin H. Blashfield, *Mural Painting in America,* 98.

17. Gilbert to Channing Seabury, September 30, 1902, NYHS.

18. Crowninshield, "Mural Painting I," 19. Also, early on, Frank Fowler, writing on the outlook for mural painting in 1895, said that railroad stations and banks should be considered for mural painting: Fowler, "Outlook," 692. An article on Low in 1895 said that art must become necessary to the American people and that the demand for mural painting was a hopeful sign in that direction: Cleveland Moffett, "Will H. Low and His Work: The Career of an American Artist," *McClure's Magazine* 5 (September 1895): 307.

19. Coffin, "Decorations, Congressional Library," 711.

20. Charles H. Caffin, "Baltimore Municipal Art Conference," *Harper's Weekly* 43 (December 30, 1899): 1322.

21. Charles H. Caffin, "Municipal Art," *Harper's New Monthly Magazine* 100 (April 1900): 655–59.

22. Low, "Mural Painting," 177.

23. Low, "Painter and Public," 254.

24. Low, "National Expression," 248.

25. "Mural Painting: An Art for the People and a Record of Our Nation's Development," *Craftsman* 19 (April 1906): 59.

26. J. W. Pattison, "The Mural Decorations of C. Y. Turner at Baltimore, Maryland," *International Studio* 24 (January 1905): lix.

27. Allen French, "Municipal Art in Italy," *New England Magazine,* n.s. 18 (March 1898): 52.

28. Mary Lackritz Gray, *A Guide to Chicago's Murals* (Chicago, Ill.: University of Chicago Press, 2001).

29. French, "Municipal Art in Italy," 52.

30. E. Graves, "Municipal Art," *American Journal of Sociology* (March 1901): 676.

31. Gregory Gilmartin, *Shaping the City: New York and the Municipal Art Society* (New York: Clarkson Potter, 1975), 226.

32. Ibid., 227.

33. Royal Cortissoz, "Abbey's Last Mural Paintings," *Scribner's Magazine* 51 (January 1912): 10.

34. Low, *Painter's Progress,* 282, 294.

35. Edward Hale Brush, "American History and Mural Painting," *Review of Reviews* 34 (December 1906): 689. Furthermore, mural painting itself was typified as a form of civic patriotism. An article in *Harper's Weekly* in 1901 credited contemporary artists with having taught the public that the fine arts could serve in that ideological capacity. As evidence of progress, it cited the Library of Congress and courthouses in New York and Baltimore: A. D. F. Hamlin, "Architecture and Civic Duty," *Harper's Weekly* 45 (July 13, 1901): 705. It is unclear from the context whether the author is referring to the criminal courts building or the appellate courthouse in New York.

36. French, "Municipal Art in Italy," 52.

37. "Everett Shinn's Paintings of Labor in the New City Hall at Trenton, New Jersey," *Craftsman* 21 (January 1912): 384.

38. "Decorative Art in America," 260.

39. Low, "National Expression," 247.

40. Caffin, "Baltimore Conference," 1322.

41. Caffin, "Beginning and Growth," 132.

42. Blashfield, "A Word for Municipal Art," 582.

43. Blashfield, *Mural Painting in America*, 46.

44. Crowninshield, "Mural Painting XII," 255.

45. Charles H. Caffin, "Frank D. Millet's Mural Painting for Pittsburg," 1294.

46. Blashfield, "Mural Painting" (1898), 106. The very professional Blashfield was popular with commercial patrons. Along with H. Siddons Mowbray, he was hired to decorate the boardroom of the Prudential Insurance Company, in Newark, where on the ceiling he painted *Industry and Thrift Leading the People to Security* and two lunettes representing *Thrift Driving the Wolf from the Door* and *Prudence Binding Fortune* (1901).

47. Walton, "Recent Mural Decorations, Blashfield," 384.

48. Marstine, "Working History," 304.

49. These included the Brooklyn Trust Company (Elmer Garnsey), Chemical National Bank (270 Broadway, Taber Sears), the Cunard Building (25 Broadway, Barry Faulkner and Ezra Winter), Edison Electric Illuminating Company (Irving Place and Fifteenth Street, Van Ingen), Guaranty Trust Building (Elmer Garnsey), and the National Bank of Commerce (31 Nassau Street, Charles Y. Turner). For others, see "Mural Paintings in Public Buildings in the United States," *American Art Annual* 19 (1922): 407–38.

50. Shean, "From the American Point of View," 23.

CHAPTER 6

1. Other examples include Shirlaw's *Peace and Plenty* for D. O. Mills (c. 1880), Blashfield's decorations for H. McK. Twombly (1886) and Adolf Lewisohn (1899), Low's *Homage to Woman* (1892) for the ladies' reception room at the Waldorf Hotel, and his and Blashfield's later decorations for the Astoria addition (1897).

2. In "Story of a Painted Ceiling," Low said that "history for a private drawing room, was of course out of the question" (511).

3. Caffin, "Beginning and Growth," 133.

4. Wells, "Some of the Aesthetic Requirements and the Technical Difficulties Peculiar to Mural Painting," 228.

5. William Walton, "Mural Painting in This Country since 1898," *Scribner's Magazine* 40 (November 1906): 637.

6. Bailey Van Hook, "From the Lyrical to the Epic," *Winterthur Portfolio* 26 (1990): 63–80. There is no easy answer to the question of who chose the symbolism for the Library of Congress: one chronicler said, "The answer to that question is not crystal clear, nor is it brief. Many hands were involved": Helen-Ann Hilker, "Monument to Civilization: Diary of a Building," *Quarterly Journal of the Library of Congress* 29 (October 1972): 235–70. The architect who prepared preliminary sketches for the decorations retired in 1892. His successor, Edward Pearce Casey, supervised all the interior decoration, but it is to be supposed that he gave the

artists wide leeway since their styles and subjects seem close to both what they had done pre-
viously (if they had previously painted murals) and to their subsequent stylistic and thematic
choices. The most detailed exegesis of the Library of Congress murals to date is Marstine,
"Working History," chapter 2; see also Murray, "Painted Words," in Cole and Reed, eds., *Library
of Congress*, 193–225.

7. Marstine, "Working History," 133.

8. He claimed, however, that it was the small scale that mandated female figures. The
lunettes were only four feet six inches high, and he did not want to paint figures full-scale and
have them appear dwarf-like, as he claimed Vedder's did. Apparently, only women were ap-
propriate for small-scale spaces; see Simmons, *From Seven to Seventy*, 233.

9. Other compositions were departures from such strict academic regularity and straight
one-on-one interpretation. Gari Melchers's lunettes, for example, in creating mise-en-scènes
that represented War and Peace, are closer to Puvis. Melchers also painted those two themes
at the World's Columbian Exposition. In the Northwest Pavilion, William de Leftwich Dodge
created four lunettes, monumental in size and complexity of composition, on the subjects of
Literature, Music, Science, Art and, in the ceiling, Ambition. Dodge's contributions, however,
were rarely mentioned in the critical responses of the period—perhaps because the location
of the murals made them less accessible. He also created female types, whose sensual propor-
tions might have been more appropriate to the kinds of locations he usually painted, public
rooms in New York hotels.

10. Sargent depicted Britain in his murals in the Widener Library at Harvard; see Mary
Crawford Volk, "Sargent in Public: On the Boston Murals," in Kilmurray and Ormond, *John
Singer Sargent*, 49.

11. Russell Sturgis, "Miss Oakley's Pictures in the Harrisburg Statehouse," *Scribner's Maga-
zine* 41 (May 1907): 637.

12. Russell Sturgis, writing on Puvis's murals at Amiens, observed that "it is easy to tire
the mind and confuse the patient observation of the student by leaving him to find out for him-
self which figure of those half hundred figures is meant for Eloquence and which for Physics,
and whether there is any profound significance in the dipping of the water from the Fountain
of Knowledge by a youth who hands it to a laurel-wreathed old man": Russell Sturgis, "Mural
Painting," *Forum* 37 (January 1906): 373.

13. Channing Seabury to John La Farge, December 1904, MHS.

14. Herbert Small, *The Library of Congress: Its Architecture and Decoration* (1901; rev. ed.,
New York: Norton, 1982), 131.

15. Gilbert to Seabury, November 16, 1904, MHS.

16. Walker to Gilbert, October 17, 1906, NYHS.

17. The artist who was most often cited for obfuscation was Sargent, whose *Triumph of
Religion* (fig. 32), for the Boston Public Library, was a compendium of eclectic references to
the history of religion, including figures like Astarte and Moloch. Although Ernest Fenollosa,
in his handbook on the murals in the library rhapsodized that Sargent's inclusion of many
truths into a single illumination was "the very meaning of symbolism as the inmost soul of
art," others were more critical. Cortissoz, for example, faulted Sargent's mural for obfuscation.

Fenollosa, *Mural Painting, Boston Public Library*, 21; Royal Cortissoz, "Mural Decoration in America," 112.

18. Coffin, "Decorations, Congressional Library," 711. See also the 1898 lecture by Barre Feree cited in Marstine, "Working History," 300. For a discussion of the reception of the Library of Congress murals, see Sarah J. Moore, "In Search of an American Iconography: Critical Reaction to the Murals at the Library of Congress," *Winterthur Portfolio* 25 (winter 1990): 231–40.

19. Sturgis, "Miss Oakley's Pictures," 637.

20. Sturgis, "Mural Painting," 369–70. Sturgis was citing a mural by Frederic Crowninshield in a Manhattan residence.

21. W. B. Van Ingen, "Mural Painting and Dramatic Art," *Scribner's Magazine* 41 (June 1907): 768.

22. Blashfield, *Mural Painting in America*, 195. Despite such proscriptions against modernity, Sargent did not hesitate to use members of the Ziegfeld Follies, in town for performances, as models for the figures in his Museum of Fine Arts, Boston, murals: Troyen, "Sargent's Murals for the Museum of Fine Arts, Boston," 78.

23. Cited in Marstine, "Working History," 309–10.

24. Blashfield, "A Word for Municipal Art," 587–88.

25. "Mural Painting: An Art for the People," 59.

26. Low, "National Expression," 234, 249, 251. Low had not received as many commissions as had his contemporaries and soulmates Cox and Blashfield, and it is possible that he was distancing himself from them and positioning himself for the changes he already saw taking place.

27. Charles M. Shean, "The Decoration of Public Buildings: A Plea for Americanism in Subject and Ornamental Detail," *Municipal Affairs* 5 (September 1901): 712.

28. Shean, "From the American Point of View," 25.

29. Royal Cortissoz, "Abbey's Latest Mural Paintings," *Scribner's Magazine* (December 1908): 662.

30. G. B. Zug, "American Painting VIII: Contemporary Mural Painting," *Chautaquan* 50 (April 1908): 245.

31. "Reid's Mural Painting," *Boston Transcript*, December 20, 1901, Massachusetts State Art Commission files, Massachusetts State Capitol, Boston.

32. Hamilton Bell, "Recent Mural Decorations in Some State Capitols," *Appleton's Booklover's Magazine* 7 (1906): 725.

33. "Two Paintings in Memorial Hall at the State House Unveiled and the Other Two of the Four are Still being Painted," *Boston Herald*, May 30, 1902, 12.

34. Sturgis, "Mural Painting," 376.

35. Blashfield, "Mural Painting in America," 364.

36. Ada Rainey, "The Mural Decoration in the State Capitol of Wisconsin painted by Hugo Ballin," *International Studio* 51 (February 1914): clxxxix.

37. Gilbert to Seabury, August 27, 1903, MHS.

38. Gilbert to Seabury, December 27, 1904, MHS.

39. The archbishop of Saint Paul, John Ireland, wrote to Gilbert, "That discovery was re-

ally the initial point in the civilization of the Northwest. It was a historical occurrence. There has been in the story of Minnesota no other occurrence more worthy of being remembered": Ireland to Gilbert, February 24, 1904, MHS.

40. La Farge to Gilbert, September 7, 1905, MHS.

41. Cary, "John La Farge's Decorations at Saint Paul," 139.

42. "Mural Painting: An Art for the People," 54.

43. Russell Sturgis, "Mr. Van Ingen's Lunettes in the Harrisburg State House," *Scribner's Magazine* 41 (April 1907): 510. In the contemporary novel by Robert W. Chambers, *The Common Law* (New York, 1911), the protagonist, a mural painter named Louis Neville, is painting a series of lawgivers for a courthouse. The description (166–67) seems similar to descriptions of La Farge's murals.

44. See Weinberg, "John La Farge," 190.

45. Ibid., 191.

46. Joseph Dannenberg, "The Advance of Civic Art in Baltimore," *Craftsman* 9 (1905): 217. Other artists followed La Farge's example in presenting a broad spectrum of history to symbolize universal truths. For the federal courthouse in Chicago, William Van Ingen painted a frieze of eight panels: *The Divine Law; The Discussion of the Principles of Justice by Socrates; The Roman Law; The Institution of the Circuit Court by Henry II of England; The Signing of the Magna Carta by King John; the Promulgation of the Constitution of the United States; Lincoln Reading His First Law Book;* and *Lincoln and the Emancipation Proclamation.* At the Wisconsin State Capitol in Madison, Herter painted Caesar Augustus in a scene in *Roman Law,* the signing of the Magna Carta in *English Law,* the Constitutional Convention in *American Law,* and finally, for *Local Law,* he used the example of the trial of Chief Oshkosh by Judge Doty in 1830. Likewise, but in a more ideal vein, for a courtroom in the Cleveland federal building Mowbray painted *Common Law,* which showed the agreement between a noble and a commoner.

47. Grace Whitworth, "Mural Decorations by C. Y. Turner," *Appleton's Magazine* 8 (July 1906): 8.

48. Brush, "American History and Mural Painting," 97. The other competition was won by Edward Deming, who painted (for Morris High School in the Bronx) *Governeur Morris Addressing the Constitutional Convention* and *1642: William Kieft's Treaty with the Indians.*

49. Walton, "Mural Painting since 1898," 637.

50. Sturgis, "Mural Painting," 380–81.

51. Weinberg, "Career of Millet," 13.

52. "The Decorative Work in the Hudson County Court House," *New York Architect* 4 (October 1910): n.p.

53. Price, "The Late Francis Davis Millet," xxxvi.

54. Mechlin, "Mr. F. D. Millet's Decorations in the Baltimore Custom House," 108.

55. Pyle planned to continue painting murals, but he died, in Italy, in 1911. His trip to Italy, ironically, was intended to familiarize him with Italian decorations so that he could pursue more mural commissions.

56. In the hallway, Van Ingen painted fourteen lunettes on the subject of religious development in Pennsylvania, which depicted recognizable historical persons as well as generic

types of, for example, Quakers and Mennonites. Sturgis called them "studies in historical sociology": Sturgis, "Van Ingen's Lunettes," 510.

57. Richard Guy Wilson, in *American Renaissance,* 41. It is noteworthy that, before they painted murals, Blashfield and Low painted colonial scenes, Millet was a near-specialist in the colonial genre, and Abbey and Pyle had done illustrations of the period.

58. Sources for the colonial revival include William B. Rhoads, *The Colonial Revival* (New York: Garland, 1977), and Alan Axelrod, ed., *Colonial Revival in America* (New York: W. W. Norton, 1985).

59. One exception was Herter's contribution to the Wisconsin State Capitol, which depicted, among other episodes, the Continental Congress, representing American Law.

60. Bell, "Recent Mural Decorations," 715–16.

61. The Hotel Manhattan murals represented a seated symbolic figure of Manhattan, who was, however, surrounded by Indians, Colonials, and portrait groups of distinguished citizens.

62. Charles H. Caffin, "Mural Decorations by Edwin H. Blashfield," *International Studio* 18 (January 1903): sup. cix.

63. Dannenberg, "The Advance of Civic Art in Baltimore," 217.

64. Walton, "Recent Mural Decorations, Blashfield," 382. This approach was not for everyone, however, and Russell Sturgis was a nonbeliever. He was cheered by Blashfield's Iowa panel, citing its "newborn beauty of color," but still groused that the sky was filled with imaginary beings "which seem to have been thought as essential here as in other such public works": Sturgis, "Mural Painting," 379–80.

65. *Wisconsin State Capitol: Guide and History,* 37–39. In his courtroom murals in the Cleveland federal building and the Luzerne County courthouse in Wilkes-Barre, Blashfield subsequently depicted iconic figures of Law surrounded by lawyers, judges, plaintiffs, and defendants, in contemporary garb. In *The Graduate,* at City College in New York City, the male figure in black graduation gown is surrounded by allegorical figures representing the great universities of Europe.

66. For a discussion of these murals, see Emily Fourmy Cutrer, "Negotiating Nationalism, Representing Region: Art History and Ideology at the Minnesota and Texas Capitols," in Patricia M. Burnham and Lucretia Hoover Giese, *Redefining American History Painting* (New York: Cambridge University Press, 1995), 277–93.

67. Walton, "Mural Painting since 1898," 637.

68. Sturgis, "Miss Oakley's Pictures," 639.

CHAPTER 7

1. The classic discussion of woman as other is Simone de Beauvoir, *The Second Sex* (New York: Vintage, 1952).

2. Marstine, "Working History," 22.

3. King, *American Mural Painting,* 72, 74.

4. For a full discussion of images of industry in the decade after the World's Columbian Exposition, see Marstine, "Working History."

5. Blashfield used it again in his sweeping composition *Westward* for the Iowa State Capitol; he painted the westward movement of prairie schooners accompanied by female spirits holding a steam engine and a dynamo symbolizing the changes that would come with the advance of "civilization."

6. Marstine, "Working History," 273.

7. I am grateful to Barbara Wolanin for this observation.

8. The introduction of electric lighting, in fact, had been a subject proposed for the appellate courthouse in New York: H. K. Bush-Brown, "New York City Monuments," *Municipal Affairs* 3 (December 1899): 615. Frederick Dielman painted a series of seven murals in 1900/1901 for the Evening Star building in Washington, D.C. They included allegorical figures of Steam and Electricity.

9. Caffin, *Story of Painting,* 324, 329, 331. Caffin's section on mural painting was excerpted and published the following year in *Bookman* 28 as "The Beginning and Growth of Mural Painting."

10. George Santayana, "The Genteel Tradition in American Philosophy," in *The Genteel Tradition,* ed. Douglas Wilson (Cambridge: Harvard University Press, 1967), 40.

11. Robert Henri, *The Art Spirit,* Margery A. Ryerson, comp. (1923; rpt., New York: Harper & Row, 1984), 198.

12. I am indebted to Barbara Wolanin for her pointing out to me that the library was built with electric lighting.

13. Fowler, "Outlook," 693.

14. Gatling, *Luzerne County Court House,* 9–10. It could be argued that Low and Smedley went further than most of their contemporaries in acknowledging the industrial base of the local economy. In an industrial belt in Pennsylvania and Ohio, county courthouses were erected in Wilkes-Barre, Mercer, Youngstown, and Cleveland. Only murals in Wilkes-Barre at all acknowledged the industrial base of that economy. In Mercer and Youngstown, allegorical and historical scenes were chosen, while in the Cuyahoga County Courthouse, in Cleveland, three historical murals were commissioned. Blashfield had depicted a miner in *The Uses of Wealth*—a work done for a bank, the Citizens' Savings and Trust Company (1903) in Cleveland.

15. N.N., "Mr. Abbey's Decorations for Harrisburg," *Nation* 86 (April 23, 1908): 384.

16. Royal Cortissoz, "Abbey's Latest Mural Paintings," 663.

17. Blashfield to Abbey, January 7, 1909, quoted in Lucas, 2:454. Abbey had earlier sent Blashfield sketches, evidently wanting the artist's approval.

18. Other artists represented localities, but with the exception of several figures/stages in Blashfield's *Evolution of Civilization,* they were all female, as they would continue to be: Low's *Cleveland, Supported by Federal Power, Welcomes the Arts Bringing the Plan for the New Civic Center* and Cox's *Passing Commerce Pays Homage to the Port of Cleveland* (both at the federal building, Cleveland), Dewing's *Commerce and Agriculture Bringing Wealth to Detroit* (State Savings Bank, Detroit, now in private collection), Abbey's *Apotheosis of Pennsylvania* (Pennsylvania

State Capitol, Harrisburg), and Blashfield's *Minnesota, Granary of the World* (Minnesota State Capitol, Saint Paul) and *Wisconsin* (Wisconsin State Capitol, Madison).

19. William Walton, "Alexander's Decorations: The Crowning of Labor in the Carnegie Institute, Pittsburgh," *Scribner's Magazine* 45 (June 1909): 46–47.

20. Charles H. Caffin, "The New Mural Decorations of John W. Alexander," *Harper's Monthly* 114 (May 1907): 848.

21. Zug, "American Painting VIII," 246.

22. Walton, "Alexander's Decorations," 46.

23. Zug, "American Painting VIII," 245–46.

24. William L. Price, "Is American Art Captive to the Dead Past?" *Craftsman* 15 (February 1909): 517. Price, however, had no respect for either Alexander or Abbey; see his "Mural Painting in Relation to Architecture: The Importance of Establishing an Intimacy between the Two Arts," *Craftsman* 16 (April 1909): 3–12.

25. Edith Deshazo, *Everett Shinn, 1876–1953* (New York: Clarkson N. Potter, 1974), 89–100.

26. Thomas Folk thought there might have been significance in Ferdinand Roebling being on the building committee for the new city hall; see Folk, "Everett Shinn: The Trenton Mural," *Arts Magazine* 56 (Oct. 1981): 138.

27. "Everett Shinn's Paintings of Labor in the New City Hall at Trenton, New Jersey," 378.

28. Marstine, "Working History," 105. In her study of World's Columbian Exposition murals, Marstine cites a representation by Lawrence Earle of Pottery and notes that he had traveled to Trenton to research the mural.

29. There is some indication, however, that Shinn's first conception was indeed allegorical. Folk, "Everett Shinn, The Trenton Mural," 137, reproduces a sketch for the mural that the author claims is allegorical, but it is difficult to analyze given the poor quality of the reproduction. Folk calls attention to the fact that Shinn's murals recall the eighteenth- and nineteenth-century iconography of industry by British painters like Joseph Wright of Derby and Ford Madox Brown.

30. Melissa Dabakis has documented the public reception to Belgian artist Constantin Meunier's images of labor that were exhibited in the United States in 1913–14. She notes that his images of labor were similarly divorced from actual labor conditions, which reached a peak of unrest during that decade. See Dabakis, "Formulating the Ideal American Worker: Public Responses to Constantin Meunier's 1913–14 Exhibition of Labor Imagery," *Public Historian* 11 (fall 1989): 113–32.

31. Mrs. John White Alexander, interview with Dewitt Lockman, 1928, in John White Alexander papers, AAA, reel 1727, frame 180.

32. Melissa Dabakis, *Visualizing Labor in American Sculpture: Monuments, Manliness, and the Work Ethic, 1880–1935* (New York: Cambridge University Press, 1999), 91.

33. The language of many passages extolling modern subjects is not only gendered but even has a faintly homoerotic flavor. When Blashfield's *Mural Painting in America* was published in 1913, he framed modernity in such a way that it seemed to describe the murals under discussion: "I say again that we must be modern, and we must be American . . . we must re-

member that naked bodies bow themselves to dig *our* trenches and puddle *our* steel, work among *us* today": Blashfield, *Mural Painting in America*, 198–99.

CHAPTER 8

1. Burns, *Inventing the Modern Artist*, 30–34.

2. When the artist did not function this way he was, often, older, like La Farge—a vestige of the romantic tradition that an artist could be cantankerous and difficult because of his innate genius.

3. "Mural Painting in America: Some Notes of a Talk with E. H. Blashfield," *Arts and Decoration* 4 (December 1914): 60.

4. Soria, *Elihu Vedder*, 213.

5. Marstine, "Working History," 317.

6. Frank Millet's *Paying for the Land, January 30, 1658*, in Jersey City; Edward Simmons's *Advent of Commerce*, in the South Dakota State Capitol in Pierre; Millet's *Treaty of the Transverse des Sioux*, in Saint Paul; Abbey's *Penn's Treaty with the Indians*, in Harrisburg; Turner's *Treaty of Calvert with the Indians*, in the Baltimore courthouse; Herter's *Local Law (The Trial of Chief Oshkosh by Judge Doty)*, in Madison; and Turner's *First Trial in the County*, in Youngstown.

7. "Mural and Sculptural Decoration of the St. Paul Capitol," *International Studio* 26 (1905): sup. lxxxi–xciv.

8. See *Wisconsin State Capitol*, 39.

9. Low, "Painter and Public," 256.

10. Low rather disingenuously stated that modern clothing was at odds with the claims of decoration. He claimed that while the world has "grown sadder and more somber," architecture has become more colored and gilded. This made subjects like the Emancipation Proclamation virtually impossible since "the frock coat and trousers" banishes them from decorative paintings: Low, "Painter and Public," 256.

11. Vivian Green Fryd, *Art and Empire: The Politics of Ethnicity in the United States Capitol, 1815–1860* (New Haven, Conn.: Yale University Press, 1992), 208. Barbara Wolanin has pointed out to me, however, that while the abstract concept of Liberty may be missing, liberty caps are depicted on the Senate pediment and appear in many of Brumidi's murals.

12. Low, "Mural Painting," 171.

13. Blashfield to Mowbray, Mowbray papers, AAA, reel 1901, frame 191.

14. For a reproduction of the mural, see Richard Murray, "H. Siddons Mowbray: Murals of the American Renaissance," in Irma Jaffe, ed., *The Italian Presence in American Art, 1860–1920* (New York: Fordham University Press, 1992), 109.

15. William A. Coffin to Mowbray, April 9, 1920, Mowbray papers, AAA, reel 1898, frame 296.

16. Bogart, *Advertising, Artists, and Borders of Art*, 216–18.

17. See, for example, Parker and Pollock, *Old Mistresses*.

18. Van Hook, *Angels of Art,* chapter 4.

19. Herbert Small, *Handbook of the New Library of Congress* (Boston, 1897), 71.

20. Blashfield may have been influenced in his choice of single-figure allegories by the sculpture in the lower part of the reading room, which also employed them. The artist also wanted to continue the upward movement of the dome, and single figures visually took over from the dome's ribs in moving the eyes in that direction: Amico, *Mural Decorations of Blashfield,* 16.

21. Others include Mowbray, *Transmission of the Law* (appellate courthouse, New York), showing eight groups, Mosaic Law through Modern Law; Blashfield's series on law—the pendentives of the Law in remote antiquity, classical antiquity, the Middle Ages, and modern times; and his *Power of the Law* (appellate courthouse, New York), which included figures representing Roman Law, Common Law, and Canon Law. In the background of the latter are Moses, Mahoment, Justinian, a bishop and a knight, Alexander the Great, Charlemagne, Napoleon, and Lord Mansfield. In Van Ingen's murals for the Federal Building in Chicago are Socrates, Henry II, King John signing the Magna Carta, and Lincoln with the Emancipation Proclamation.

22. Typescript, with annotations, Cass Gilbert papers, Essex County Court House Murals, #1 folder, NYHS.

CHAPTER 9

1. Cass Gilbert to Blashfield, July 9, 1912, Blashfield papers, NYHS; Blashfield to H. Siddons Mowbray, Dec. 31 (year unclear; may be 1913), Mowbray papers, AAA, roll 1898, frame 277.

2. Ernest Peixtoto, "The Future of Mural Painting in America," *Scribner's Magazine* 69 (May 1921): 535–40.

3. Bailey Van Hook, "Beaux-arts Murals: Why No Respect?" paper delivered at American Studies Association Conference, Detroit, October, 2001.

4. Lloyd Goodrich, "'33 Moderns' and Violet Oakley," *The Arts* 16 (February 1930): 423.

5. Lincoln Kirstein, *Murals by American Painters and Photographers* (New York: Museum of Modern Art, 1932), 9.

6. Ironically, beaux arts architects continued to build. Cass Gilbert's West Virginia State Capitol in Charleston (1932) is a curious example of beaux arts building in the tradition of Gilbert's Minnesota State Capitol, but nearly void of decorative detail, creating an eerie and strange sight, as though the building is really waiting for the painter-decorators to show up.

7. Mary Lackritz Gray, *A Guide to Chicago's Murals* (Chicago, Ill.: University of Chicago Press, 2001).

SELECTED BIBLIOGRAPHY

ARCHIVAL SOURCES

Albany Institute of History and Art
 Will H. Low papers
Archives of American Art, Smithsonian Institution
 John White Alexander papers
 H. Siddons Mowbray papers
 Violet Oakley papers
 Francis Millet Rogers papers
Columbia University
 Kenyon Cox papers
Iowa State Capitol
Massachusetts Art Commission, Massachusetts State Capitol
 Files on individual murals
Minnesota Historical Society
 Board of State Capitol Commissioners papers
 Cass Gilbert papers
 Channing Seabury papers
New-York Historical Society
 Edwin H. Blashfield papers
 Cass Gilbert papers (also at MHS)
Pennsylvania State Archives
 Joseph M. Huston papers

SOURCES TO 1917

Bell, Hamilton. "Recent Mural Decorations in Some State Capitols." *Appleton's Booklover's Magazine* 7 (June 1906): 715–25.

Blashfield, Edwin H. "Mural Painting." *Municipal Affairs* 2 (March 1898): 98–109.

———. "Mural Painting in America." *Scribner's Magazine* 54 (September 1913): 353–65.

———. *Mural Painting in America.* New York: Charles Scribner's Sons, 1913.

————. "A Word for Municipal Art." *Municipal Affairs* 3 (December 1899): 582–93.

Brinton, Selwyn. "Modern Mural Decoration in America." *International Studio* 42 (January 1911): 175–90.

Brush, Edward Hale. "American History and Mural Painting." *Review of Reviews* 34 (December 1906): 689–97.

Burnham, Daniel. *Final Report of the Director of Works, World's Columbian Exposition.* 1893; rpt., New York: Garland, 1989.

Bush-Brown, H. K. "New York City Monuments." *Municipal Affairs* 3 (December 1899): 602–15.

Caffin, Charles H. "Baltimore Municipal Art Conference." *Harper's Weekly* 43 (December 30, 1899): 1322.

————. "The Beginning and Growth of Mural Painting." *Bookman* 28 (October 1908): 127–39.

————. "Frank D. Millet's Mural Painting for Pittsburg." *Harper's Weekly* 41 (December 25, 1897): 1294–95.

————. "John Alexander." *Arts and Decoration* 1 (February 1911): 147–49, 178.

————. "Municipal Art." *Harper's New Monthly Magazine* 100 (April 1900): 655–66.

————. "Mural Decorations by Edwin H. Blashfield." *International Studio* 18 (January 1903): sup. 59, n.p.

————. "Mural Decorations in the State House, Boston." *International Studio* 17 (July 1902): sup. 81–82.

————. "The New Capitol of Pennsylvania." *World's Work* 13 (November 1906–April 1907): 8195–210.

————. "The New Mural Decorations of John W. Alexander." *Harper's Monthly* 114 (May 1907): 845–56.

————. "Recent Mural Decorations at Boston." *International Studio* 17 (July 1902): sup. 59–61.

————. *The Story of American Painting.* 1907; Garden City [N.Y.]: Garden City Publishing, 1937.

Cary, Elizabeth Luther. "John La Farge's Decorations at St. Paul." *Scrip* 1 (February 1906): 137–42.

Coffin, William A. "The Decorations in the Congressional Library." *Century* 53 (March 1897): 694–711.

————. "Decorations in the Congressional Library, Washington D.C." *Harper's Weekly* 40 (October 17, 1896): 1028–29.

Cortissoz, Royal. "Abbey's Last Mural Paintings." *Scribner's Magazine* 51 (January 1912): 1–16.

————. "Abbey's Latest Mural Paintings." *Scribner's Magazine* 44 (December 1908): 656–69.

————. "The Making of a Mural Decoration: Mr. Robert Blum's Paintings for the Mendelssohn Glee Club." *Century* 59 (n.s. 37) (November 1899): 58–63.

————. "Mural Decoration in America—First Paper." *Century* 51 (n.s. 29) (November 1895): 110–21.

Cox, Kenyon. *The Classic Point of View.* 1911. rpt. New York: Norton, 1980.

————. "Some Phases of Nineteenth Century Painting: Part III: Mural Painting in France and America." *Art World* 2 (April 1917): 11–16.

Crowninshield, Frederic. *Figure Painting as Applied to Architecture*. New York, 1888.

———. "Mural Painting I." *American Architect and Building News* 19 (January 9, 1886): 19–21.

———. "Mural Painting XII." *American Architect and Building News* 19 (May 29, 1886): 255–59.

Dannenberg, Joseph. "The Advance of Civic Art in Baltimore." *Craftsman* 9 (1905): 202–17.

"Decorative Painting by Robert Blum, A." *Scribner's Magazine* 19 (January 1896): 3–9.

"Decorative Painting in America." *Scribner's Magazine* 19 (February 1896): 259–60.

"Decorative Work in the Hudson County Court House, The." *New York Architect* 4 (October 1910): n.p.

"Decorations, The." *South Dakota Historical Collections* 5 (1910): 239–45.

"Decorations for the Library of Congress, The." *Scribner's Magazine* 20 (August 1896): 257–60.

deKay, Charles. "The Ceiling of a Café." *Harper's Weekly* 36 (March 12, 1892): 257–58.

"Everett Shinn's Paintings of Labor in the New City Hall at Trenton, New Jersey." *Craftsman* 21 (January 1912): 378–85.

Fenollosa, Ernest. *Mural Painting in the Boston Public Library*. Boston, 1896.

Fowler, Frank. "Mural Painting and a Word to Architects." *Architectural Record* 11 (July 1901): 510–24.

———. "The Outlook for Decorative Art in America." *Forum* 18 (February 1895): 686–93.

French, Allen. "Municipal Art in Italy." *New England Magazine,* n.s. 18 (March 1898): 33–52.

Garnsey, Elmer E. "Mural Painting in Its Relation to Architecture." *American Architect and Building News* 66 (December 2, 1899): 76–78.

Graves, E. "Municipal Art." *American Journal of Sociology* (March 1901): 673–81.

Greta [pseud.?] "The Boston Public Library Decorations." *Art Amateur* 34 (1896): 49.

Hamlin, A. D. F. "Architecture and Civic Duty." *Harper's Weekly* 45 (July 13, 1901): 705.

Isham, Samuel. *The History of American Painting*. 1905; enl. ed. New York, 1927.

James, Henry. *The American Scene*. 1907; rpt., Bloomington: Indiana University Press, 1968.

King, Pauline. *American Mural Painting*. Boston, 1902.

Knaufft, Ernest. "An American Decorator: Edwin H. Blashfield." *International Studio* 13 (March 1901): 26–36.

La Farge, John. "Puvis de Chavannes." *Scribner's Monthly* 28 (December 1900): 672–84.

Low, Will H. "The Art of the White City." *Scribner's Magazine* 14 (October 1893): 504–12.

———. *A Chronicle of Friendships, 1873–1900*. New York, 1908.

———. "The Mural Painter and His Public." *Scribner's Magazine* 41 (February 1907): 253–56.

———. "Mural Painting—Modern Possibilities of an Ancient Art." *Brush and Pencil* 11 (December 1902): 161–77.

———. "National Expression in American Art." *International Studio* 3 (March 1901): 231–51.

———. *A Painter's Progress*. New York, 1910.

———. "The Story of a Painted Ceiling." *Scribner's* 29 (April 1901): 509–12.

Mechlin, Leila. "A Decorator of Public Buildings." *World's Work* 19 (December 1909): 12378–86.

————. "Mr. F. D. Millet's Decorations in the Baltimore Custom House." *Architectural Record* (August 1908): 98–108.

Millet, F. D. "The Decoration of the Exposition." *Scribner's Monthly* 12 (December 1892): 692–709.

Moffett, Cleveland. "Will H. Low and His Work: The Career of an American Artist." *McClure's Magazine* 5 (September 1895): 290–312.

Morris, Harrison S. "Miss Violet Oakley's Mural Decorations." *Century* 70 (June 1905): 265–68.

"Mural and Sculptural Decoration of the St. Paul Capitol." *International Studio* 26 (1905): sup. 81–94.

Mural Painters, The. *Constitution and By-Laws: The Mural Painters, a National Society.* New York, c. 1895.

"Mural Painting: An Art for the People and a Record of Our Nation's Development." *Craftsman* 10 (April 1906): 54–66.

"Mural Painting in America: Some Notes of a Talk with E. H. Blashfield." *Arts and Decoration* 4 (December 1914): 60.

"Mural Painting in the United States." *American Art Annual* 9 (1911): 13–33.

N.N. "Mr. Abbey's Decorations for Harrisburg." *Nation* 86 (April 23, 1908): 384–85.

Pattison, James William. "Blashfield's Mural Decorations in the Capitol of Minnesota." *International Studio* 24 (February 1905): sup. 87–91.

————. "The Mural Decorations of C. Y. Turner at Baltimore, Maryland." *International Studio* 24 (January 1905): 57–61.

Portfolio of Photographs of the World's Fair. Chicago, Ill.: Werner, 1893.

Price, C. Matlack. "The Late Francis Davis Millet—Notes on the Decorative Panels in the Cleveland Post Office." *International Studio* 48 (December 1912): sup. 34–37.

Price, William L. "Is American Art Captive to the Dead Past?" *Craftsman* 15 (February 1909): 515–19.

————. "Mural Painting in Relation to Architecture: The Importance of Establishing an Intimacy between the Two Arts." *Craftsman* 16 (April 1909): 3–12.

"Proposed Competition for Mural Paintings in the Massachusetts State House." *Artist* 25 (May–June 1899): 14.

"Public Art in American Cities." *Municipal Art* 2 (March 1898): 1–13.

Rainey, Ada. "The Mural Decoration in the State Capitol of Wisconsin Painted by Hugo Ballin." *International Studio* 51 (February 1914): sup. 187–92.

Riordan, Roger. "Puvis de Chavannes." *Art Amateur* 24 (December 1890): 5–7; (January 1891): 34.

Saint-Gaudens, Homer. "Edwin Howland Blashfield." *International Studio* 35 (September 1908): sup. 69–77.

Sargent, Irene. "Comments on Mr. Shean's 'Mural Painting from the American Point of View.'" *Craftsman* 7 (October 1904): 28–34.

————. "Mural Paintings by Robert Reid in the Massachusetts State House." *Craftsman* 7 (March 1905): 699–712.

Shean, Charles M. "The Decoration of Public Buildings: A Plea for Americanism in Subject and Ornamental Detail." *Municipal Affairs* 5 (September 1901): 710–21.

———. "Mural Painting from the American Point of View." *Craftsman* 7 (October 1904): 18–27.

Small, Herbert. *Handbook of the New Library of Congress*. Boston, 1897.

———. *The Library of Congress: Its Architecture and Decoration*. 1901; rev. ed., New York: Norton, 1982.

Sturgis, Russell. "John La Farge." *Scribner's Magazine* 26 (July 1899): 3–19.

———. "Miss Oakley's Pictures in the Harrisburg State-house." *Scribner's Magazine* 41 (May 1907): 637–40.

———. "Mr. Van Ingen's Lunettes in the Harrisburg State House." *Scribner's Magazine* 41 (April 1907): 509–12.

———. "Mural Painting." *Forum* 37 (January 1906): 367–84.

[Sturgis, Russell?]. "Mural Painting in American Cities." Article signed R. S. *Scribner's Magazine* 25 (January 1899): 14–17.

Van Brunt, Henry. "The Columbian Exposition and American Civilization." *Atlantic Monthly* 71 (May 1893): 577–88.

———. "The New Dispensation of Monumental Art: The Decoration of Trinity Church in Boston and of the New Assembly Chamber at Albany." *Atlantic Monthly* 43 (1879): 633–41.

Van Dyke, John, ed. *Modern French Masters*. 1896; rpt. New York: Garland, 1976.

Van Ingen, W. B. "Mural Painting and Dramatic Art." *Scribner's Magazine* 41 (June 1907): 765–68.

Walton, William. "Alexander's Decorations: The Crowning of Labor in the Carnegie Institute, Pittsburgh." *Scribner's Magazine* 45 (June 1909): 45–57.

———. "Mural Painting in this Country Since 1898." *Scribner's Magazine* 40 (November 1906): 637–40.

———. "Pictures of the American Navy, by R. T. Willis." *Scribner's Magazine* 43 (June 1908): 767–68.

———. "Recent Mural Decorations by Mr. E. H. Blashfield." *Scribner's Monthly* 37 (March 1905): 381–84.

Wells, Newton A. "Some of the Aesthetic Requirements and the Technical Difficulties Peculiar to Mural Painting." *Brush and Pencil* 6 (August 1900): 228–36.

Wheeler, Candace. "A Dream City." *Harper's New Monthly Magazine* 86 (May 1893): 831–46.

Whitworth, Grace. "Mural Decorations by C. Y. Turner." *Appleton's Magazine* 8 (July 1906): 3–8.

Zug, G. B. "American Painting VIII: Contemporary Mural Painting." *Chautaquan* 50 (April 1908): 229–47.

SOURCES FROM 1918 TO 2001

American Renaissance, 1876–1917, The. Brooklyn, N.Y.: Brooklyn Museum, 1978.

Amico, Leonard. *The Mural Decorations of Edwin Howland Blashfield, 1848–1936*. Williamstown, Mass.: Sterling and Francine Clark Art Institute, 1978.

Appellate Division of the Supreme Court of the State of New York, First Judicial Department. Pamphlet, n.d.

Beauvoir, Simone de. *The Second Sex*. New York: Vintage, 1952.

Bogart, Michele H. *Advertising, Artists, and the Borders of Art*. Chicago, Ill.: University of Chicago Press, 1995.

———. *Public Sculpture and the Civic Ideal in New York City, 1890–1930*. Chicago, Ill.: University of Chicago Press, 1989.

Burnham, Patricia M., and Lucretia Hoover Giese. *Redefining American History Painting*. New York: Cambridge University Press, 1995.

Burns, Sarah. *Inventing the Modern Artist: Art and Culture in Gilded Age America*. New Haven, Conn.: Yale University Press, 1996.

Carr, Carolyn Kinder, and Sally Webster. "Mary Cassatt and Mary Fairchild McMonnies: The Search for Their 1893 Murals." *American Art* 8 (winter 1994): 52–69.

Christen, Barbara S., and Steven Flanders, eds. *Cass Gilbert: Life and Work*. New York: Norton, 2001.

Cole, John Y., and Henry Hope Reed, eds. *The Library of Congress: The Art and Architecture of the Thomas Jefferson Building*. New York: Norton, 1997.

Cortissoz, Royal. "Mural Painting at a Parting of the Ways." *New York Herald Tribune*, February 10, 1935, 10.

———. *The Works of Edwin Howland Blashfield*. New York: Charles Scribner's Sons, 1937.

Curran, Kathleen. "The Romanesque Revival, Mural Painting, and Protestant Patronage in America." *Art Bulletin* 81 (December 1999): 693–722.

Dabakis, Melissa. "Formulating the Ideal American Worker: Public Responses to Constantin Meunier's 1913–14 Exhibition of Labor Imagery." *Public Historian* 11 (fall 1989): 113–32.

———. *Visualizing Labor in American Sculpture: Monuments, Manliness, and the Work Ethic, 1880–1935*. New York: Cambridge University Press, 1999.

Dearing, Albin Pasteur. *The Elegant Inn: The Waldorf-Astoria Hotel, 1883–1929*. Secaucus, N.J.: Lyle Short, 1986.

Deshazo, Edith. *Everett Shinn, 1876–1953*. New York: Clarkson N. Potter, 1974.

Federman, Peter. "The Detroit Public Library." *Classical America* 4 (1977): 85–111.

Fischer, Diane P. *Paris 1900: The "American School" at the Universal Exposition*. New Brunswick, N.J.: Rutgers University Press, 1999.

Folk, Thomas. "Everett Shinn: The Trenton Mural." *Arts Magazine* 56 (October 1981): 136–38.

Franchi, Pepi Marchetti, and Bruce Weber. *Intimate Revelations: The Art of Carroll Beckwith, 1852–1917*. New York: Berry Hill Galleries, 1999.

Fryd, Vivian Green. *Art and Empire: The Politics of Ethnicity in the United States Capitol, 1815–1860*. New Haven, Conn.: Yale University Press, 1992.

Gatling, Eva Ingersoll. *Luzerne County Court House*, Wilkes-Barre: Wyoming Historical and Geological Society, 1986.

Gilmartin, Gregory. *Shaping the City: New York and the Municipal Art Society*. New York: Clarkson Potter, 1995.

Goodrich, Lloyd. "'33 Moderns' and Violet Oakley." *The Arts* 16 (February 1930): 423–24.

Gray, Mary Lackritz. *A Guide to Chicago's Murals*. Chicago, Ill.: University of Chicago Press, 2001.

Hamlin, Gladys E. "Mural Painting in Iowa." *Iowa Journal of History and Politics* 37 (July 1938): 250–54.

Henri, Robert. *The Art Spirit.* Comp. Margery A. Ryerson, 1923; rpt. New York: Harper & Row, 1984.

Hilker, Helen-Ann. "Monument to Civilization: Diary of a Building." *Quarterly Journal of the Library of Congress* 29 (October 1972): 235–70.

Hirshler, Erica E. "A Quest for the Holy Grail: Edwin Austin Abbey Murals for the Boston Public Library." *Studies in Medievalism* 6 (1994): 35–49.

Hobbs, Susan. *The Art of Thomas Wilmer Dewing: Beauty Reconfigured.* Washington, D.C.: Smithsonian Institution Press, 1996.

Jaffe, Irma, ed. *The Italian Presence in American Art, 1860–1920.* New York: Fordham University Press, 1992.

John La Farge. Exhibition catalog. Pittsburgh, Pa.: Carnegie Museum of Art; Washington, D.C.: National Museum of American Art, 1987.

Kilmurray, Elaine, and Richard Ormond. *John Singer Sargent.* Princeton, N.J.: Princeton University Press, 1998.

Kirstein, Lincoln. *Murals by American Painters and Photographers.* New York: Museum of Modern Art, 1932.

Kunzle, David. *The Murals of Revolutionary Nicaragua, 1979–1992.* Berkeley: University of California Press, 1995.

Landau, Sarah Bradford. *George B. Post, Architect: Picturesque Designer and Determined Realist.* New York: Monacelli Press, 1998.

Lucas, E. V. *Edwin Austin Abbey.* 2 vols. London: Methuen, 1921.

Marstine, Janet Cecilia. "Working History: Images of Labor and Industry in American Mural Painting, 1893–1903." Ph.D. dissertation, University of Pittsburgh, 1993.

Mather Frank Jewett, Jr., "Kenyon Cox." *Scribner's Magazine* 65 (June 1919): 766.

Moore, Sarah J. "In Search of an American Iconography: Critical Reaction to the Murals at the Library of Congress." *Winterthur Portfolio* 25 (winter 1990): 231–40.

Morgan, H. Wayne, ed. *An Artist of the American Renaissance: The Letters of Kenyon Cox, 1883–1919.* Kent, Ohio: Kent State University Press, 1995.

———. *Kenyon Cox, 1856–1919: A Life in American Art.* Kent, Ohio: Kent State University Press, 1994.

"Mural Paintings in Public Buildings in the United States." *American Art Annual* 19 (1922): 407–38.

O'Connor, Francis V. "Notes on the Preservation of American Murals." In *Mortality/Immortality: The Legacy of Twentieth-Century Art.* Los Angeles, Calif.: Getty Conservation Institute, 1998.

Parker, Roszita, and Griselda Pollock. *Old Mistresses: Women, Art, and Ideology.* New York: HarperCollins, 1981.

Peixtoto, Ernest. "The Future of Mural Painting in America." *Scribner's Magazine* 69 (May 1921): 535–40.

Preserving a Palace of Art: A Guide to the Projects of the Pennsylvania Capitol Committee. Harrisburg, Pa.: Capitol Preservation Committee, c. 1992.

Price, Aimee Brown. *Puvis de Chavannes*. New York: Rizzoli, 1994.

Promey, Sally M. *Painting Religion in Public: John Singer Sargent's "Triumph of Religion" at the Boston Public Library*. Princeton, N.J.: Princeton University Press, 1999.

————. "Sargent's Truncated Triumph: Art and Religion in the Boston Public Library, 1890–1925." *Art Bulletin* 79 (June 1997): 217–50.

Puvis de Chavannes. Ottawa: National Gallery of Canada, 1977.

Rolston, Bill. *Politics and Painting: Murals and Conflict in Northern Ireland*. Rutherford, N.J.: Fairleigh Dickinson University Press, 1991.

Sanders, Barry. *A Complex Fate: Gustav Stickley and the Craftsman Movement*. New York: John Wiley & Sons, 1996.

Sandler, Irving. *The Triumph of American Painting: A History of Abstract Expressionism*. New York: Harper & Row, 1970.

Sanford, Cynthia. *Heroes in the Fight for Beauty: The Muralists of the Hudson County Court House*. Jersey City, N.J.: Jersey City Museum, 1986.

Shaw, Jennifer L. "Imagining the Motherland: Puvis de Chavannes, Modernism, and the Fantasy of France." *Art Bulletin* 79 (December 1997): 586–610.

Simmons, Edward E. *From Seven to Seventy: Memoirs of a Painter and a Yankee*. New York, 1922.

Soria, Regina. *Elihu Vedder*. Fairfield, Conn.: Fairleigh Dickinson University Press, 1970.

Stern, Robert A. B., Gregory Gilmartin, and John Montague Massengale. *New York 1900: Metropolitan Architecture and Urbanism, 1890–1915*. New York: Rizzoli, 1983.

Strazdes, Diana. *American Painting and Sculpture to 1945 in the Carnegie Museum of Art*. New York: Hudson Hills Press, 1992.

Temple of Justice: The Appellate Division Courthouse. New York: N.Y.C. Bar Association, 1977.

Tharp, Louise Hall. *Saint-Gaudens and the Gilded Era*. Boston Mass.: Little, Brown, 1969.

Thompson, Neil B. *Minnesota's State Capitol: The Art and Politics of a Public Building*. Saint Paul: Minnesota Historical Society, 1974.

Troyen, Carol. "Sargent's Murals for the Museum of Fine Arts, Boston." *The Magazine Antiques* 156 (July 1999): 72–81.

Van Hook, Bailey. "Edwin H. Blashfield." In *American Dreams: American Art to 1950*. Williamstown, Mass.: Williams College Museum of Art, 2001.

————. *Angels of Art: Women and Art in American Society, 1876–1918*. University Park: Pennsylvania State University Press, 1996.

————. "Clear-eyed Justice: Edward Simmons's Mural in the Criminal Courts Building, Manhattan." *New York History* 73 (1992): 443–58.

————. "From the Lyrical to the Epic." *Winterthur Portfolio* 26 (1990): 63–80.

————. A Mural by Thomas W. Dewing "Commerce and Agriculture Bringing Wealth to Detroit." New York: Spanierman Gallery, 1998.

Webster, Sally. *William Morris Hunt*. New York: Cambridge University Press, 1991.

Weinberg, H. Barbara. "The Career of Francis David Millet." *American Art Journal* 17 (1977): 2–18.

————. "John La Farge: Pioneer of the American Mural Movement." In *John La Farge*. Exhibition catalog. Pittsburgh: Carnegie Museum of Art; Washington, D.C.: National Museum of American Art, 1987.

West, Richard V. *The Walker Art Building Murals*. Brunswick, Maine: Bowdoin College, 1972.

Wilson, Douglas, ed. *The Genteel Tradition*. Cambridge: Harvard University Press, 1967.

Wilson, William H. *The City Beautiful Movement*. Baltimore, Md.: Johns Hopkins University Press, 1989.

Wisconsin State Capitol: Official Guide and History. Madison, Wis., 1991.

INDEX

Note: Pages on which murals or buildings are reproduced are in italics. If an artist did more than one mural at a site and the murals do not have a collective title, then the name *of the site* (not the individual titles) is listed as a subentry under the artist's name.

All murals listed by title *in the text,* however, are also listed individually by title in the index. The artist's name is not given in the title entry unless there is more than one mural with the same title.